ROCOCO TO REVOLUTION

ROCOCO TO REVOLUTION

Major Trends in Eighteenth-Century Painting

MICHAEL LEVEY

NEW YORK AND TORONTO
OXFORD UNIVERSITY PRESS

Contents

Preface

This book is based on a series of lectures given at Cambridge during my tenure there as Slade Professor of Art. I hope I did not choose the subject because it was somehow my 'field' – not wishing to be treated like a donkey, I deny having a field – but because I still think eighteenth-century art largely misunderstood, and under-estimated as a result. Since I was not compiling a history of painting during that century, I had often to omit artists, even great artists, from my discussion of some selected themes. I could not force them into the lectures; and in the case of Gainsborough I have thus lost one of the clearest demonstrations that the eighteenth century did produce great art.

Of course I do not really believe that I shall convert any unbelievers. Puritan prejudice dies hard against an age that so often frankly expressed its intention to enjoy itself. And its painting suffers in comparison with the articulate brilliance of its literature and the supreme accomplishment of its music – suffers all the more in that few intellectuals of the period esteemed contemporary painting very highly. Some people too will always feel secretly that older works of art are finer than more recent ones; to them Chartres *must* be greater than Vierzehnheiligen.

There was certainly appropriateness in dealing with a century of elegance as well as talent while enjoying the privilege of a Fellowship at King's. I shall always be grateful for that pleasant social time, and for the kindness and help I received from so many people. Such as it is, this book is dedicated as a token of gratitude – and with a tag construed as the eighteenth century construed it – to the Provost and Fellows of King's: *Et in Arcadia ego.*

1966 M. L.

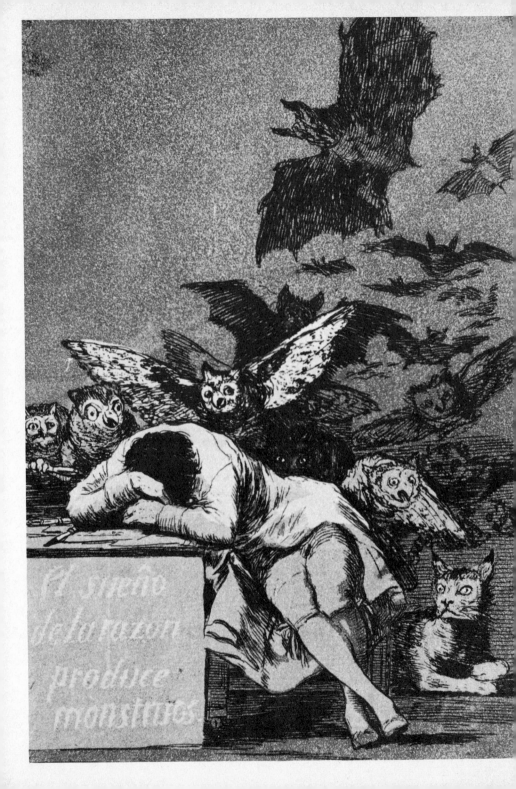

Introduction

The eighteenth century started with a dilemma; and it ended with a Revolution. Throughout the period it had been revolving at a furious pace, in a series of cartwheels of which the final, least foreseeable, was Napoleon. He might seem almost to return the century to the point from which it had started. 'I purified the Revolution,' he declared, 'dignified Nations and established Kings.' Another turn of the wheel was to show that there was no going back to such simple, autocratic solutions, propounded by one man. Nineteenth-century Europe had become too complex and too realistic.

The dilemma of the eighteenth century was political, philosophical and artistic. Assuming that what was natural was right, the period concentrated on the definition of Nature. Constant re-definition of this term led to a steady series of miniature artistic revolutions of which the latest coincided with political Revolution and produced the perfect political artist in David. The rococo itself had been a 'natural' reaction against formality, and by another definition it was to appear artificial and unnatural. It was not *true*; but then art that was true was not always adequate, for it might be undignified or might fail to contain the higher truth of morality. Perhaps moral truth lay only in antiquity, in a world undisturbed by the Christian religion, or perhaps it lay in the sheer scientific facts newly discovered by the eighteenth century.

What was not in doubt was the increasingly violent collision of opposing forces, whether politically they were autocracy and liberty, or artistically rococo and neo-classicism, or the ancients versus the moderns. These were all to some extent labels for the basic clash between conscious and unconscious mind. Something was all the time felt to be suppressed, and therefore always threatening to rise. Like the Lisbon earthquake, the fall of the Bastille was tremendously important merely as a symbol. Optimism and belief in nature as a guide

9

1 FRANCISCO DE GOYA *The Sleep of Reason produces Monsters*

were to be shot to pieces by the fusillades which followed. Goya records – more clearly and more tragically than any other artist – the mad new world where men massacre men. Thence onwards European affairs are conducted like a symphony of artillery; old ideals, old régimes, old confidence, and old art forms too, disappear in the smoke of battle which clears only after Waterloo.

Modern consciousness, in literature not history, might be said to have been born there. Two great novels, *Vanity Fair* and *La Chartreuse de Parme*, make brilliant use of the battle. Both Thackeray and Stendhal are partly of the eighteenth century; they set out from that premise, as it were, guided by reason but aware of its frailty; and they end up in profound irony bordering upon despair. Waterloo marks the end of so many illusions – not least those of George Osborne 'lying on his face, dead, with a bullet through his heart'. And it is on that battlefield that Stendhal sets wandering a positive anti-hero in Fabrizio del Dongo, the Candide of the nineteenth century.

The problem that had faced the previous century was really humanity's. Nature was connected with knowledge; what was desperately needed, increasingly so, was art that mirrored the interests of ordinary people and ceased to be merely decoration for aristocratic settings. In very different ways this requirement was pressed by Diderot, Reynolds, Winckelmann – and is particularly the characteristic of the second half of the century. A French historian, Rulhière, on being welcomed in 1787 to the Académie singled out the year 1749 as that when love of *belles-lettres* was exchanged for love of philosophy, when the desire to instruct replaced the desire to please.

But the problem lay in the possibility of other, less laudable desires which might be equally natural and quite conceivably stronger. In some ways there was more free fantasy in the rococo than in the moral, more 'truthful' art which replaced it. A rational mental structure could be constructed by the eighteenth century as beautifully as its buildings were; yet this structure was known to be raised on potentially dangerous foundations. The situation was perfectly expressed by Pope who asked a question to which nobody knew the answer:

> *With terrors round, can reason hold her throne,*
> *Despise the known, nor tremble at the unknown?*
> *Survey both worlds, intrepid and entire,*
> *In spite of witches, devils, dreams and fire?*

This was expressing partly, but in more urgent form, an awareness which Addison had shown in his essay on *Pleasures of Imagination* in speaking of the way the

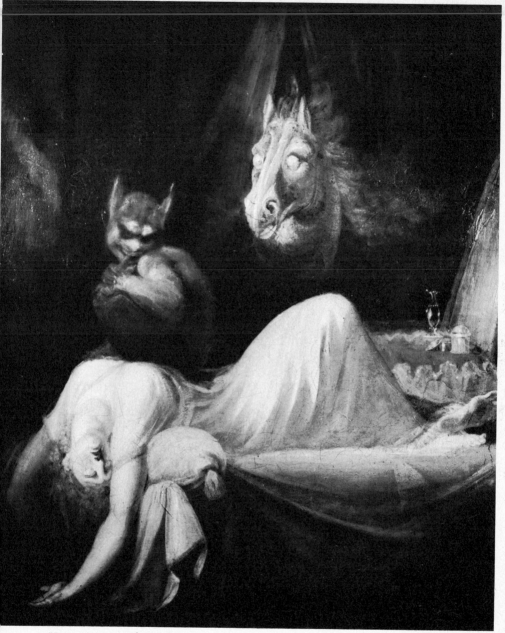

2 HENRY FUSELI *The Nightmare*

fancy can be overrun by monsters of its own framing. Addison's essay was translated into Spanish at the end of the eighteenth century and may well have been known to Goya. Certainly it is Goya who takes up the idea, no longer asking but stating: 'The sleep of reason produces monsters.' This is the caption used for the etching in the *Caprichos* series (*Ill. 1*) which was originally intended, significantly, to be the title plate of the whole book. While the artist dreams, deserted by reason, night monsters float frighteningly about him. Perhaps it is not too wild to suppose that the actual cat, with its startlingly large ears, has suggested the cluster of owl-like creatures who in turn seem to blend into long-eared bats.

An ordinary domestic creature is transfigured, when reason is relaxed and the mind a prey to sick fancy, into a flock of evil things – all connected with darkness and night – which come in a filmic way to haunt the exhausted artist who is Goya himself. Other painters, such as Fuseli, had shown an interest in 'witches, devils, dreams...', but Fuseli's *The Nightmare* (*Ill. 2*) is ludicrously rational when compared with the genuine psychological sense of oppression conveyed by Goya's composition – with its ceaseless beat of wings darkening the air, and with, too, its suggestion that these horrible creatures come from within the mind.

It is just this sort of psychological awareness that so often eluded the eighteenth-century artist – or which he preferred to let elude him. Reason and sanity kept him sober, and sober work usually turned out to be much better than attempts at the highly emotional or deeply dramatic. Tragedies like those of Voltaire and Dr Johnson are intolerably boring, whereas even the slightest comedies retain some charm and ability to please. Beaumarchais, creator of the great comic figure of the eighteenth-century stage, Figaro, no hero but a valet-cum-barber, was also the author of the tearful inanities of *La Mère coupable* – a play more heartless and artificial in its sentimentality than any rococo piece of *marivaudage*.

Nevertheless, *La Mère coupable* represents conscious reaction, as much as do the comparable pictures of Greuze. Since reason did not seem to solve the century's problems, neither political nor artistic ones, it was replaced by a cult of feeling. Reason requires some sort of intellect and discipline. Feeling is everyone's prerogative – and excuse: 'his heart's in the right place'. Unfortunately, feeling may be as strong in those whose hearts are in the wrong place. If, at the worst, eighteenth-century art was all boudoir prettiness and rouge and fans, it at least avoided the blood and carnage of Romantic painting – in which it is often hard to tell if the artist is condemning or enjoying cruelty.

Between these extremes of the trivial and cruel Goya was neatly placed by the accident of birth, but he made perfect use of the accident: he bridged the rococo and the revolutionary in a unique way. Though it is customary to say, and it is undoubtedly true, that he influenced Delacroix and Manet, and can be claimed as a forerunner of modern art, neither of these artists had anything like his penetration into the situation of mankind. Indeed, such painters had little interest in it; it was left to Van Gogh to be concerned with states of mind, and with mankind. Goya himself remained basically of the century into which he was born; he carried forward into a period of romantic irrationalism some sort of belief in reason as a guide, even while depicting the horrific results of reason's breakdown.

There is perhaps more continuity in his art than the history of events during his lifetime would suggest. The rococo world which represented fashionable art when he was young had itself been part of a revolution concerned with people and behaviour. When still novel it had aimed to be more realistic than the grandiose concepts of the baroque. Instead of autocratic art it produced the social art of Watteau, replacing, as it were, Versailles by Paris. When Goya executed his early decorative tapestry cartoons for the Spanish royal palaces the subjects of these were not patriotic in the sense Louis XIV would have understood; instead of victories and rulers, they depict the ordinary life of Spanish people. The land is tacitly revealed as belonging not to the ruler but to everyone. Watteau's people are elegant where Goya's are peasant-clumsy; Watteau's are idlers, leisure-lovers, peacocks beside Goya's busy barnfowls who scrape for a living. But then Watteau has already achieved a revolution, an elegant and civilized one, by escaping from the huge gilded palace of baroque art into the natural atmosphere of parks and gardens. It was *natural* to ask for air and lightness and grace. This naturalness belonged to the rococo painters; they, like the rest of their century, were following Nature. But they were not imitating natural appearances. They invoked imagination; and thus a period supposedly restricted by its rationality saw the triumphant careers of Boucher and Tiepolo.

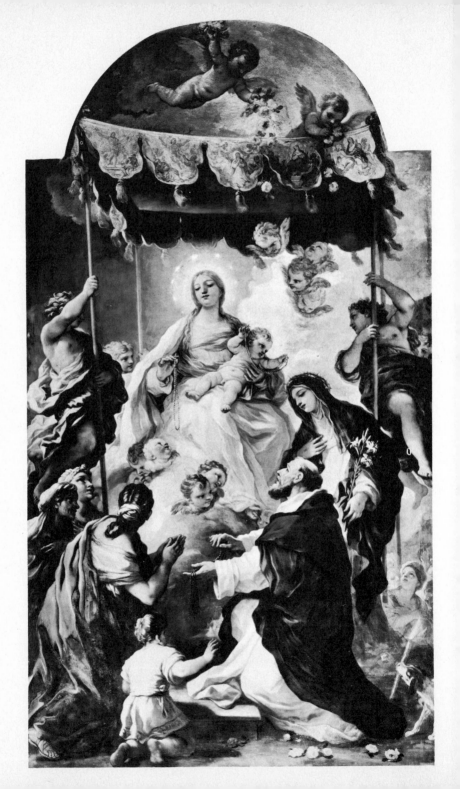

Intimations of Rococo

Perhaps it is untrue that there ever was any rococo painting; and certainly it is one of the most puny styles in the brood spawned by art-historians. It could not exist without the baroque and is conceivably no more than the baroque tamed and cut down for a more civilized age, one with a sense of humour too. Wit plays a new part in art in the eighteenth century, respecting neither Church nor State; the rococo is a sort of wit, in its movement and economy and surprise. This became, if not a style, at least an anti-style. Looking back to the seventeenth century it dared to see something absurd in the pomposities and grandeur that men like Urban VIII or Louis XIV had striven so hard to achieve. Already when Matthew Prior visited Versailles he judged it by reasonable standards and found the king ludicrous: 'His house at Versailles is something the foolishest in the world; he is galloping in every ceiling, and if he turns to spit he must see himself in person, or his Vice-regent the Sun...'

That may be the extreme of English commonsense when confronted by the baroque. But even in France and Italy, the eighteenth century opened with some diminution of reckless splendour – forced on France by near-bankruptcy if by nothing else – and a growing uneasiness about too-grand gestures. Reason had finally to trickle in, even in countries sworn to combat it by every form of superstition and still engaged in losing the battle today. England was to have no native baroque or rococo painting. Even Italy, which might claim to be the home of the baroque, did not provide such splendid opportunities for its greatest decorative painter of the period, Tiepolo, as did both Germany and Spain.

Nearly everywhere there was a tendency for decorative painting to be less solemn, to prefer themes of love to those of glory. Rulers themselves not only laid less emphasis on allegories of their own power but in some instances – like those of Frederick of Prussia and Catherine the Great – they conformed to

3 LUCA GIORDANO *Madonna del Baldacchino*

a more enlightened and less despotic concept of the ruler. Though the child Louis XV was to be portrayed in virtually the pose and trappings worn by his predecessor, he grew up to be an enlightened ruler in the sense of being a less public person, though perhaps also a less responsible one. Reason had taken the wind out of the sails both of baroque art and of the chief people who supported it. The standards set by the baroque were essentially those that are unattainable for ordinary humanity; it does not please or amuse but stuns the spectator. The rococo treats a solemn theme light-heartedly, if it has to treat one at all, and prefers to evoke a civilized climate with emphasis on those things that education can give. It may be an absurdly rose-tinted view of life, but it has some connection with experience; it may even express a quite profound truth about the human heart – one more profound than can ever be detected in miles of battle pictures. Montesquieu, so much wiser than the majority of his countrymen at any period, struck the eighteenth-century humanist note: '*Je suis homme avant d'être Français.*' If reason rejects the idea of self-glorification which is Versailles, the reaction of Romanticism was to turn back to the seventeenth century, stirred by martial associations, and to dedicate the palace to what is still patently proclaimed on the building: '*A toutes les gloires de la France.*' Shameful years of civilized peace are thus abolished.

But it was in those very years that art had enjoyed a genuine freedom: from autocratic propaganda, from being historically true or didactically moral. They did not last long, at least in France, but the sense of liberation is amusingly conveyed in Charles Coypel's *Painting ejecting Thalia* (*Ill. 4*) which was executed in 1732 and which is as lively and unprejudiced as were Coypel's writings at the period before he became Director of the Académie Royale and first painter to the King. The Muse of History is shown by Coypel hurrying off with her attendants, trying to gather up what learned tomes they may, all summarily ejected from the studio by Painting. Coypel made his point in words too; he recognized the social nature of art, its aim, and the fact that therefore everyone, not only the connoisseur, is entitled to give his opinion: '*Les beaux-arts sont faits pour toutes les personnes de bon sens et d'esprit…*'

With that criterion it was obvious that the grand manner of the baroque must give way as art catered for a wider audience. Freedom from academic learning encouraged the utterly un-serious classical mythologizing of Boucher in which antiquity becomes an excuse for not wearing clothes. In Venice, where there was a long tradition of unlearned painting, Tiepolo was able to create his vision of an impossible antique world, fused from Veronese, the opera, and his own

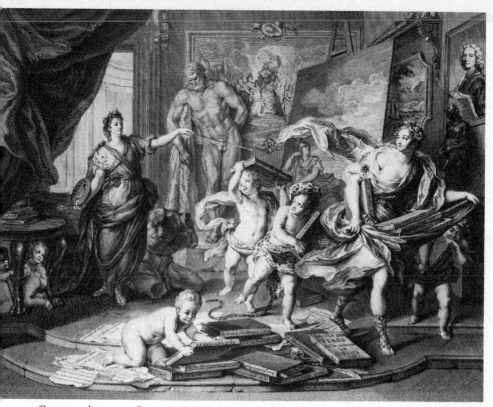

4 CHARLES-ANTOINE COYPEL *Painting ejecting Thalia*

imagination. Lesser painters could produce charming decorations with barely any serious subject-matter at all – Pellegrini is an example of a painter who worked with success throughout Europe and whose style is almost *tachiste*.

The new sense of art's freedom is conveniently symbolized on the threshold of the new century by the election to the Académie at Paris in 1699 of Roger de Piles. At first de Piles had appeared to be simply an intelligent amateur who pleaded the cause of colour and championed Titian's art. Then he challenged the superiority of the Roman School; he attacked Poussin and was sub-acid about antiquity: '*Il n'est pas nécessaire d'estre toujours parmi les dieux ni dans la Grèce.*' He raised the cry in favour of a new artist – new in French academic circles – Rubens. The hegemony of Italy, combined with the ancients, was rudely challenged by claims for a painter who was not even French. The opposing party

naturally rallied to the cause of Poussin, and de Piles' championship of Rubens continued to bring him into bitter conflict with the Académie throughout the late years of the seventeenth century. The sheer violence his opinions met prepares the way for much later attacks on rococo decorative art; and how could a painter like Pellegrini escape abuse when Rubens was under attack? Conservatism not only clung to the bulwark of the ancients (throwing in Poussin quite as if he had been Apelles' contemporary) but became hysterical at the possibility of artistic freedom. The crime of Rubens was *cette grande liberté* in his art which is not only the essence of his genius but which could also serve to justify the liberties taken by the rococo.

Both parties in the quarrel appealed to tradition. The rococo went forward not out of reaction but in emulation of the baroque. Far from totally rejecting the art of the past, it merely picked out those painters who had been unwitting pioneers of it, showing a preference for those painters who had been most painterly. The admission of de Piles to the Académie gave respectable recognition to what had already become an artistic tendency. *Rubénisme* was in effect a European movement, practised by artists not only in France but in Italy. From the late years of the seventeenth century must date Luca Giordano's *Allegory of Rubens* (Prado, Madrid) which is frank homage to a painter whose impact had been particularly marked on the Neapolitan School since the arrival there about 1640 of his sumptuous large-scale *Feast of Herod*.

In France *Rubénisme* triumphed explicitly, and *Poussinisme* was defeated. Neither camp had really comprehended the true natures of the artists they warred over (for Rubens was a serious student of antiquity and Poussin possessed a vein of wild poetry) and the battle itself was only one incident in the clash between ancients and moderns which was to break out again in the late eighteenth century. Then *Poussinisme* had its revenge.

Perhaps the rococo – in so far as it was a movement at all – had too little vitality because of its typically eighteenth-century consciousness of tradition. There is a certain frightening truth in Voltaire's comment to Madame du Boccage: '*Notre siècle vit sur le crédit du siècle de Louis XIV.*' Taste might prefer to be overshadowed by the greatness of Rubens instead of that of Poussin, but the overshadowing was still there. Refining and diluting the baroque, fitting it for smaller rooms and a more light-hearted atmosphere, was soon to lead to artistic extinction.

Reason did play its part, first in requiring so many pictures to be just decoration, and then in making such work seem intolerably trivial and ephemeral.

Failure to try to touch the heart was likely to lead to a fashion for wearing hearts on sleeves. The rococo world of beauty, confidence, health, could easily be shown to be false – no one had ever believed it was literally true – and guilty because of its traditional role: propaganda for keeping things as they are, lulling people by fairy stories of visions. (The neo-classic was to be guilty too, in a different way; and it too was to possess no more vitality than the rococo.) If the rococo seemed alluring, the more need to denounce it. The eighteenth-century moralist must have felt in front of it something of the disgust which fills us when we see the facts of our civilization glamourized in glossy magazines. The discrepancy is disgusting, but art has no duty to reflect life in the way increasingly required by the eighteenth century. It has no duty but to be art; when it failed to possess a social purpose – when, that is to say, it was often at its most imaginatively inspired – it was at its most vulnerable. The dilemma of art and life was merely part of the century's basic dilemma. It drove Romantic artists on to the deliberate un-socialness of much of their art and eventually, in some cases, to suicide. Among other victims was to be Ruskin, driven insane by the irreconcilability.

It is sometimes easier to appreciate why the rococo was attacked than to appreciate the art itself. The conventions which governed it can easily be made to seem as absurd as operatic conventions, understandably enough, for the two were closely connected. Yet it should nowadays be possible for us to respond to art that has deliberately removed itself from the task of recording natural appearances. The canon of rococo realism – decorative realism – was to be clearly defined by Braque when he said: 'A vase in one of my paintings is not a utensil which will hold water, but an object re-created for a new purpose.' All the vases in the work of rococo decorators could not hold water for a moment; they have been re-created in art, and so has the water which flows like watered silk in rococo paintings.

The tradition tacitly invoked by the rococo went back far beyond Rubens and could claim two great *cinquecento* founder-painters in Correggio and Veronese. Though they had never lost their fame, they were particularly to be appreciated, with renewed warmth, in an age that looked for freedom, colourfulness, and charm in art. Above all, it looked for allure rather than instruction, and the delight it found in Correggio's *Leda and the Swan* (*Ill. 5*) was not connected with learned mythology but frank enjoyment of the playfully erotic. It was right that this picture should belong to the Duc d'Orléans, then Regent of France, and notorious for his dissoluteness. Partly repainted by Charles Coypel,

it must have exercised a decisive influence on Boucher and provided Fragonard with several hints. So perfectly *dix-huitième* does it at first glance appear that it is hard to believe it originated about 1530. In fact, its melting mood is not truly rococo but the picture is full of rococo themes, with its smiling naked girls and saucy swans (both sinuously swaying in those typical Correggio curves which Mengs was to be among the first to analyse) set in an enchanted countryside of placid water and thick-foliaged trees: an afternoon idyll where a bathe and rape become almost the same thing, both to be enjoyed. Love's suggestiveness is everywhere – not only in the lyre-playing Cupid who serenades the couple but in the very uprights of the tree trunks and the channel of the river.

Although Veronese was assiduously collected, especially in France, the key picture by him remained in Venice, in Palazzo Pisani: *The Family of Darius before Alexander (Ill. 6)*. Probably this was the most famous and popular picture in the whole city during the eighteenth century. It is, as it were, the *Oath of the*

5 ANTONIO CORREGGIO *Leda and the Swan*

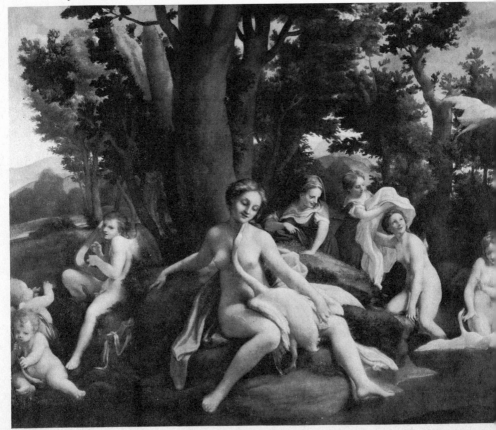

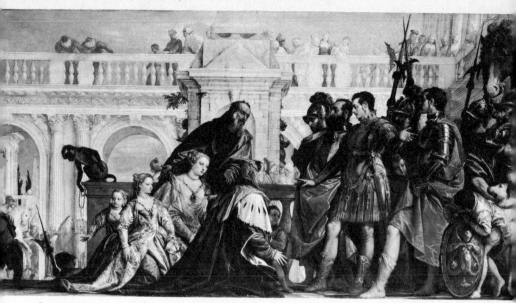

6 PAOLO VERONESE *The Family of Darius before Alexander*

Horatii for the rococo – and it survived that fashion. Its influence on the new generation of Venetian painters, on Tiepolo above all, was enormous. It was copied and pastiched. The Président de Brosses believed he owned Veronese's original sketch for it – as did many other gullible people. Goethe learnedly analysed what was happening in the picture. So many people paused before it, and it is worth pausing before. It represents at its most splendid the Shakespearean anachronism of an antique historical subject treated as a Renaissance pageant. Like *Antony and Cleopatra*, it is concerned with the meeting of East and West; it shows Greece conquering Persia, but conquered by magnanimity. A great empire has been reduced to the kneeling women at Alexander's feet. In the sheer shock of contact and contrast there is glamour, and also perhaps a lesson, for the eighteenth century – less certain than Veronese that the West stands for civilization. There is a moral exemplum in the picture: it depicts – on a world stage and on enormous, crowded scale – clemency at the moment of victory, courtesy rather than bravery. For *his* period Veronese tells the right story. The eighteenth century, liking to reverse the effect (as in Cleopatra's conquest of Antony), reversed the clemency theme as well. Frederick the Great wrote an opera about the Incas in which Montezuma is noble and the Christian Pizzaro a tyrant. And in *Die Entführung aus dem Serail* Mozart pointed his plot with badly behaved Christians and a most magnanimous hero in the Turkish Pasha.

21

Veronese catered for all tastes. He was unlearned, brilliantly free in handling and rich in tonality – no one who knows the picture can forget the sketch-like spontaneity of the pink-cloaked rider on a white horse in the left background – and yet his composition is carefully planned and weighted by a deliberate moral. And then, by a paradox, the setting and the figures of this meeting of two worlds recalled *cinquecento* Venice; and the picture enshrines the myth of that empire, a myth with so much power that it is almost true. It was, said contemporaries, as if the sleeping beauty of Veronese's art had awoken to life again when in the early eighteenth century Venetian decorative painters travelled and were welcomed in England, France, Germany and Spain.

The decorative ideals which might be represented by blending Correggio and Veronese had never really died out. Carried into Northern Europe most supremely by Rubens, they were positively localised in Paris in the Marie de Médicis series painted for the Luxembourg Gallery and which were to exercise a potent influence on diverse artists. One of the most splendid of the series, the *Coronation of Marie de Médicis (Ill. 8)* is a picture which cuts across all the preconceptions of art history. The brilliance of its colour, the authority of its design, its combination of the allegorical and the natural – from light-bathed, radiant, winged genii to the casual dogs – appealed to David almost as much as to Watteau. Watteau was to borrow the curled-up dog; and David was to utilize the design for his *Sacre de Napoléon*.

For many French artists the seeds of the rococo style lay in Rubens; sometimes they experienced his work before they reached Italy or, as in the case of Watteau and Nattier, they never reached Italy at all. Nattier himself was to be a direct disseminator of the Luxembourg Gallery by his drawings of the Rubens compositions which were engraved with the permission of Louis XIV. But there was also Italy, not only as a place of pilgrimage for young foreign painters but in its own tradition of the rococo that can be traced from Correggio and Veronese to Pietro da Cortona and thence directly to Giordano and Sebastiano Ricci. In this quite closely linked chain the merging of baroque into rococo can hardly be detected, and if any century is significant it is the hundred years that run from 1633 to 1733: from the Barberini ceiling (*Ill. 7*) to the death of Ricci (actually occurring in May 1734).

All these painters had been concerned with problems of decoration in actual rooms, with the necessary tricks of perspective and illusionism, glorying in being false as conjurers do. Cortona's Barberini ceiling initiates, with a thunderous crash, the high baroque style; though so crushing and autocratic in its total effect,

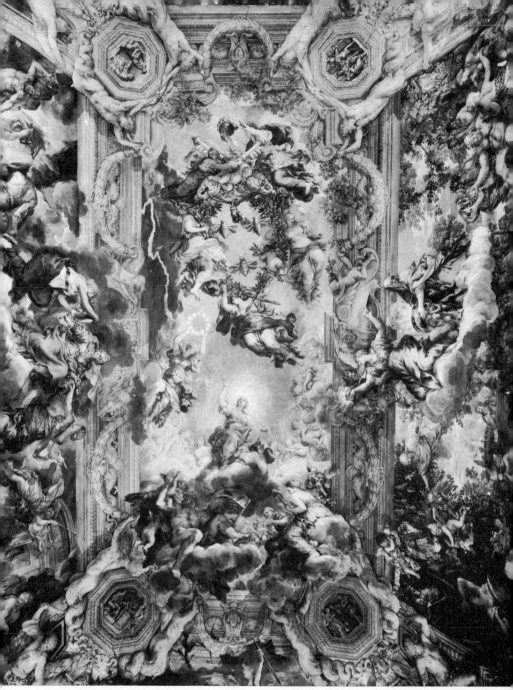

7 PIETRO DA CORTONA *Ceiling of the Palazzo Barberini, Rome*

8 PETER PAUL RUBENS
The Coronation of Marie de Médicis

the right-hand portion is more lyrical and charming, playful for all its sup-
posedly serious subject. It hardly matters what is being depicted amid so many
birds and *putti*, flowers, a fountain, clouds, and a graceful, air-borne vision. All
the elements are present that will serve to make magic gardens for Armida, set-
tings for other allegories, of love rather than dynastic ambitions; the vocabulary
is here, and was to be provided by Cortona even more plentifully in his easel
pictures, which was borrowed down to the very poses and gestures, by Luca
Giordano. When Pietro da Cortona died in 1669, Giordano was already well-
launched on a career of great fame and wide travel.

Giordano was the ideal rococo painter, speedy, prolific, dazzling in colour,
assured in draughtsmanship, ever-talented and never touching the fringe of
genius. Cortona's mood was often disconcertingly light-hearted, his Rapes
and Sacrifices looking like ballets performed by over-eager amateurs, but

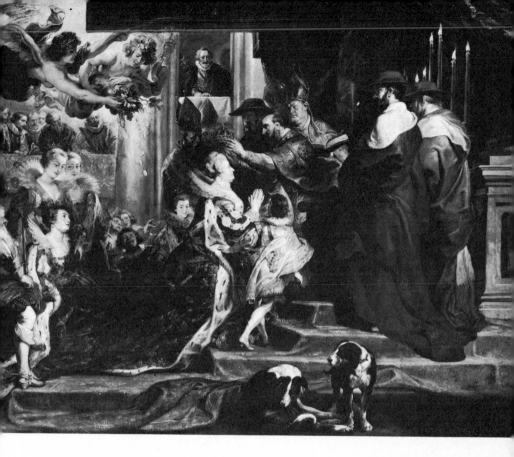

Giordano's fluent brush-strokes created pictures without any heart at all. Everything is excited but nothing is really happening of any significance. Nobody cares and there is anyway hardly any individual present: for Giordano refines the persons of Cortona's invention into positive types, often only a summary elegant gesture and, significantly, a head turned away completely hiding the face. These are the economies which Giordano judges must be made in the interests of decoration; he made them increasingly, never failing to fill the largest spaces with something delightfully silvery and inventive, preferably with banks of convenient cloud, fluttering *putti*, and the promise of blue sky beyond. The lack of intellectual power his work displays – its sheer brilliant brainlessness – is itself admirable and perhaps the necessary concomitant of such tireless productivity.

Working in Naples and Rome and Florence and Venice, and then active for a decade in Spain, Giordano disseminated a manner which could hardly fail to

allure when combined with his speed and *serviable* quality. He took the baroque and painlessly squeezed profundity out of it, twisting the style to make its effects by economical means, astonishing and delighting but never imposing, and himself always producing a virtuoso solution. Part of his success undoubtedly lay in the fact that he was moving in the direction that taste was already going (he was by no means the only Neapolitan painter to lighten his palette and shift into a Venetian-Rubensian idiom from a Caravaggesque one). His paintings express a wish above all to please – whatever their destination.

The series of twelve small pictures at Hampton Court of the story of Cupid and Psyche shows Giordano's ability to play a tune of infinite variations around the theme of love; the pitch between solemn and trivial is exactly observed, chromatically charming but never forced. The *Psyche Feasting* (*Ill. 9*) is a typically magic moment, with music sounding and flowers falling about the surprised girl, mysteriously served in Cupid's palace by butterfly-winged attendants. The essence of the story is vividly and easily conveyed; the composition is uncluttered, and the final effect is of charm – charmed girl and charmed spectator. It is a rococo spell that is cast. The Psyche story itself is like an allegory of the whole style, with its fairy belief in immortality through love and personal apotheoses finally for all of us. For those who could not get as far as Cupid's palace there was to be supper with Louis XV and another version of the meal served on a *table volant*.

Equally, on a huge scale Giordano could beautifully decorate the religious myth. His *Madonna del Baldacchino* (*Ill.3*) is a blaze of blue and white, a paean of joy in light and colour which makes the vision something delightfully visionary for the spectator. The baldacchino is held over the Madonna with tremendous panache, and is itself agitated, slightly awry – as if it had caught the excited atmosphere of the picture where angel heads and roses tumble in delight as heaven hovers close to earth. The worshippers are more solidly painted, forming a ring about the central brightness of the actual vision. Giordano's world has somehow banished death and made age picturesque; the majority of its inhabitants are blonde and smiling, dressed in pale colours and each moving in an aura of luminosity – as if motes in the white radiance of eternity. Such pictures are like great windows of glass erected where previously there were walls; nothing in them is too substantial in form, nor in colouring, and for all their virtuoso tricks they are seldom mechanical or dull. It no longer matters whether Giordano actually enjoyed painting them; it is enough that he conveys a sense of enjoyment that might be emulated, but seldom achieved, by the rococo

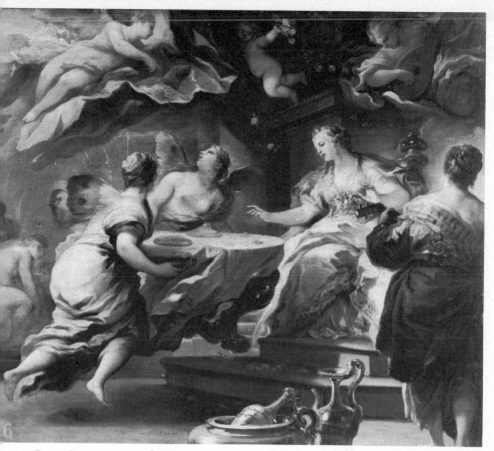

9 LUCA GIORDANO *Psyche Feasting*

decorators who followed him. Perhaps no French eighteenth-century painter, not at least until Fragonard, dared to let spontaneity bubble from his brush in this way – or dared to trust his talent so far. It is this basic confidence that is Giordano's final message to the rococo style he had done so much to create; Tiepolo alone was successfully to take up the full challenge and achieve something finer.

When Giordano died in 1705, the rococo was poised ready to pervade all Europe. If Germany and England had nothing to contribute artistically, they could provide, did provide, splendid opportunities for foreign decorative painters. Nor of course is it true of Germany that it had nothing to contribute; though its marvellous rococo architecture and sculpture cannot be discussed here, they are

27

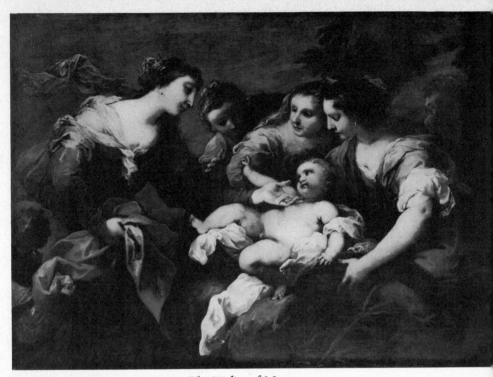

10 Valerio Castello *The Finding of Moses*

perhaps the best proof that there *was* a rococo movement. There is no need of definition before the perfect spectacle of the Amalienburg at Nymphenburg. France may have played its part in the style, but architecturally it could produce nothing to rival that beauty.

But in painting the tissue of the rococo style was woven in France and Italy and then exported elsewhere. Giordano is remarkably behind so much: naturally sparking off at Venice a whole group of painters but equally to leave behind in Spain hints for the young Goya in, for example, the brilliant frescoes of San Antonio de los Portugeses at Madrid. Other more completely *seicento* figures were to anticipate rococo elegance, indebted rather to Van Dyck than to Rubens, orientated more towards Correggio than Veronese. The pictures and frescoes of the Genoese painter Valerio Castello (1624–59, *Ill. 10*) are the quintessence of this delicate manner, with swaying, cloudy forms and highly individual, almost flicked-on pigment which look forward particularly to the Guardi (*Ills 67–71*) and Pittoni.

28

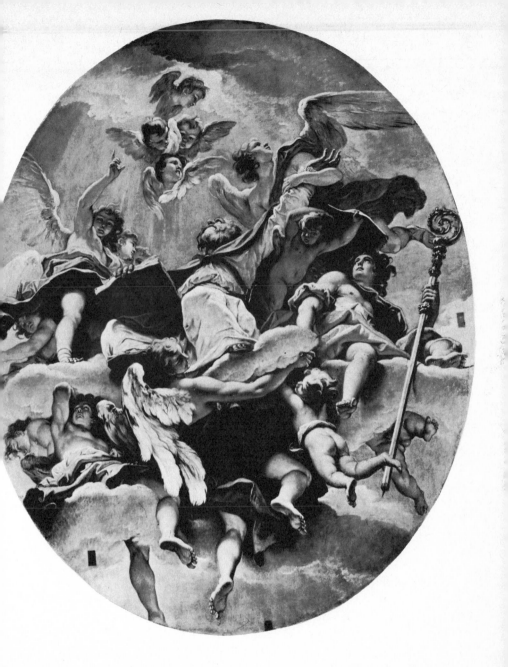

11 SEBASTIANO RICCI *Apotheosis of S. Marziale*

In saying France and Italy one means, as the eighteenth century opens, Paris and Venice in a quite special way. The two cities were in close artistic contact, made exciting by the abrupt renaissance of native Venetian painting after a dreary period, but the contact does not mean that there were not great differences of style. Interaction was not mutual, for while Paris welcomed and employed Rosalba Carriera, Pellegrini, Sebastiano Ricci – those heirs of Correggio and Veronese – Venice offered scarcely any employment to visiting French artists, and French art exercised only a faint influence on one or two exceptional pictures. Their different interpretations of the rococo are made patent in the differences between Boucher and Tiepolo, accentuated of course by the different demands of patronage.

Venice naturally stood closer to the sixteenth and seventeenth century inheritance. It had possessed Veronese and felt no need for, and not much interest in, Rubens. Out of an Italian tradition, and with the help of Giordano, a specific Venetian style had been created before Giordano's death by Sebastiano Ricci (1659–1734). The decorations for the ceiling of S. Marziale at Venice reveal Ricci's ability to draw the spectator into a new and exciting heaven. The ascent of S. Marziale (Ill. 11) is designed to give an almost dizzy spiralling effect. The saint himself is compacted into being hardly more than a knee, a piece of tilted head and that long, dislocated, uplifted arm so ardently clasped by an angel. Like the saint, the spectator goes for a ride in space, sucked up into this complex whorl of swirling but carefully organized shapes. Depth is emphasized by the dramatic pattern of light and shade, increasing the deeply-cut *sotto in sù* effect. The rococo shares its mood, exhilarating but not annihilating. And to stumble on Ricci's ceiling in the otherwise uninteresting church is to experience this mood quite spontaneously, to be agreeably jolted out of reality.

So many eighteenth-century themes, though not originating with Ricci, are given currency by him and set on the path of popularity. In some ways he is like Handel in his ever-recognizable style, his monotony, his stiffness when contrasted with later developments in the century. Something in both men is always reminding one that they were born in the seventeenth century; there is something more vigorous than elegant in their art, and a touch of simplicity which is more enchanting in the composer than in the painter. Yet pictures like the *Continence of Scipio* (Ill. 12) are already blends of Veronese and the new century's interests. It is almost a scene from opera, with the basic theme of clemency which had been Veronese's in the *Family of Darius*. Scipio sits like a judge, a tender-hearted one, between the uninteresting fiancé on the right and the

12 SEBASTIANO RICCI *The Continence of Scipio*

brilliantly-clad blonde heroine on the left – a heroine who actually does nothing heroic but merely touches the emotions as she waits hopefully. Scipio overcomes his baser passions and hands her back to her fiancé; virtue conquers love, and morality triumphs. Although Scipio takes a central place, interest concentrates on the heroine, sole woman and very much *prima donna*, dressed in Giordanesque white and gold and blue. There is a seriousness in Ricci's still static composition – operatically very much conceived in a series of solo arias without the complexity of *ensembles* – which is made quite explicit when it is compared with the treatment by François Le Moyne (1688–1737) of the same subject some twenty years later (*Ill. 13*).

This is rococo in movement, almost nervously so, and less solemn as well as less static. Le Moyne has failed to convey the effect of isolating the girl among warriors, and the scene is alive with a positive chorus of girls and mothers and playful children. So promiscuously feminine is the atmosphere that Scipio himself seems to have lost virility; tall as a castrato, he looks oddly ambiguous and *en travesti* in martial armour. A somewhat exaggerated emotionalism agitates the crowded scene – summed up in the intendedly affecting embrace given by the girl's fiancé to Scipio – and the crouching group of mother and child at the right anticipates Greuze. To French eyes Ricci was soon to seem rather bloodless and uninspired, heavy in colour and handling of paint, and too obviously in Veronese's debt. Le Moyne cannot be accused of those faults, indebted though he was to Venetian art. In sheer competence, invention, draughtsmanship, he is Ricci's superior. His picture is typically French, typically of its century – even to the presence of classical draperies (so much less particularized than Ricci's) in a rococo picture. It aims at prettiness rather too patently; and in its determination not to be dull it falls into a triviality which was to prove typical of the eighteenth-century French history picture.

Ricci's later work was to capture a more rococo rhythm and to show, perhaps under the influence of Pellegrini, a livelier handling of actual paint. Although able as a decorator of large surfaces, he was more refreshing on the small scale which was becoming popular through new interest in collecting sketches and *modelli*. Ricci himself wrote that these were really the artist's originals – Diderot was to say much the same thing – and his late *modello* of *S. Helena finding the True Cross* (*Ill. 15*) has an excitement of surface, with paint splintering under the impact of light, which suits its triumphant subject. It is, of course, a miracle. The tall Cross serves, like some holy lightning conductor, to connect heaven and earth: wrapped about at the top by angels and held by a mortal below. It is a triumphant moment rather than a 'human' one; Ricci remains unpsychological and unemotional, but these negatives in fact help him to create a perfectly acceptable idiom for rococo religious art – the most difficult problem faced by the period. Glory and excitement serve him instead, and the *S. Helena* continues the tradition of Giordano.

In France, religious pictures were to fall into a confused welter of insipid piety and misguided prettiness which was to lead to adverse comment even at the time.

As early as 1704 the *Susanna at the Bath* (*Ill. 14*) of Jean Santerre (1658–1717) reveals an almost disturbing eroticism and something of that peculiarly chilly

13 FRANÇOIS LE MOYNE
The Continence of Scipio

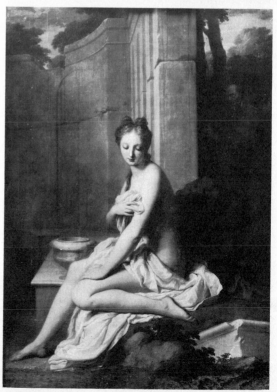

14 JEAN-BAPTISTE SANTERRE
Susanna at the Bath

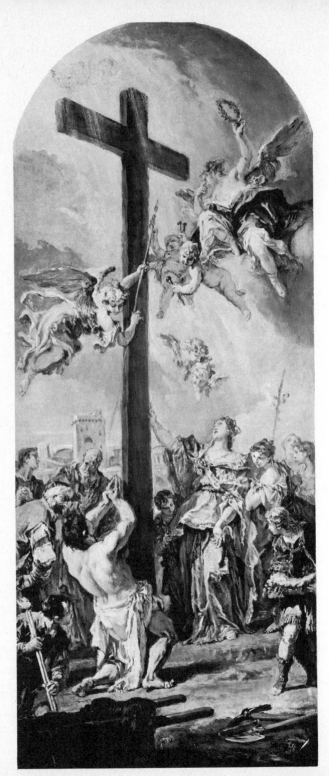

15 SEBASTIANO RICCI
*S. Helena finding the
True Cross*

rococo quality which is to be found in Falconet's nude statuettes. Few comparable pictures were to be produced at Venice, whereas Santerre initiates a whole troop of *baigneuses* who go on dabbling with the erotic possibilities of water as late as Fragonard, all seeming ultimately to derive from Correggio's *Leda*. And out of this revolution was to come the achievement of Boucher as well as Fragonard.

While Venice continued to emphasise the traditional, Paris was eager to make a break with the anyway immediate past. The political conservatism of Venice tinged its art; the highest compliment paid to Tiepolo was to say he was another Veronese. But Boucher was not thought to be, nor was he, like any figure of the past. Even if France had wished to stand still as the eighteenth century advanced, it was impossible for the country to do so. The death of Louis XIV in 1715, the Regency, the emergent character of Louis XV and the consequent reign of Madame de Pompadour: these were events which marked the evolution of the century, proclaiming that time passes. The most successful painting in eighteenth-century France was not that which evoked the baroque but that which, sometimes without realizing it, revolted against the past. It is a good symbol, even if not strictly true, that the pupils of Boucher should be said to have thrown bread pellets at the pictures of Le Brun. The whole duty of the rococo there was to release art from being the carrier of preconceptions; it need not contain a religious message, nor a moral one, and ultimately need not be serious at all. The disturbing quality in Santerre's picture, which remains remarkable at its early date, is that it ostensibly continues to serve religion while implying a belief in very different values. Perhaps in the case of Susanna this hardly matters; Santerre's *S. Theresa*, however, painted a few years later for the chapel at Versailles, created a scandal owing to its erotic nature. The majority of French religious pictures of the period hardly create that, inhibited perhaps partly by fear of being too frank, or of being thought absurd. The century could not deny its inherent preference for pagan rather than Christian religion. An interesting passage in Daniel Webb's *Enquiry into the Beauties of Painting* (1760) states this quite openly; having explained why the subject of S. Andrew about to be martyred causes little emotional response, he goes on: 'We are not so calm at the sacrifice of Iphigenia; beautiful, innocent, and unhappy; we look upon her as the victim of an unjust decree; she might live the object of universal love; she dies the object of universal pity.'

It was indeed a woman's death which inspired one of the few successful French religious pictures painted during the first half of the century: the *Death of*

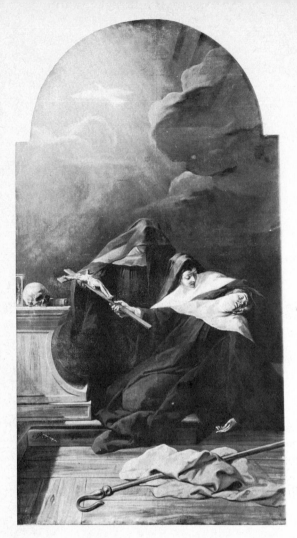

16 JEAN RESTOUT
The Death of S. Scholastica

S. Scholastica (1730; *Ill. 16*) by Jean Restout (1692–1768). This is a baroque shock cutting across many preconceptions of the period. Much more obviously 'engaged' than Ricci's art, and much more powerfully emotional than Le Moyne's, Restout's is a highly personal return to the standards of his uncle Jouvenet. The violence of the effect is the more striking because of the economy of means; the three sombre figures, one completely shrouded like some Gothic *pleurant*, are shaken by a drama of sensibility which is restricted, and made poignant, by the bare record of their environment. Nothing mitigates the lonely moment of death: no miracle intervenes, and heaven remains silent.

Restout's picture is an isolated achievement, just as he was an untypical artist. Despite his *memento mori*, the feast went on recklessly. It hardly matters with some painters where they were trained; they were travelling throughout Europe – or sending their pictures in place of themselves. The rococo became fully international. Painters like Jacopo Amigoni (1682–1752) and Charles de La Fosse (1636–1716) are almost bewilderingly peripatetic: Amigoni was at work in London, then Paris, in Germany and finally in Spain, while La Fosse spent a significant period at Venice before returning to Paris and then working in London for some three years. With them the rococo remains solid and earthbound. Their subjects may be the doings of gods and goddesses, and the purpose of their pictures largely decorative, but they are still a little awkward and lacking in anything air-borne or enchanted. La Fosse's agreeable *Bacchus and Ariadne* (Ill. 17) is a memory of Venice but handled with a rather slack air; there is not much

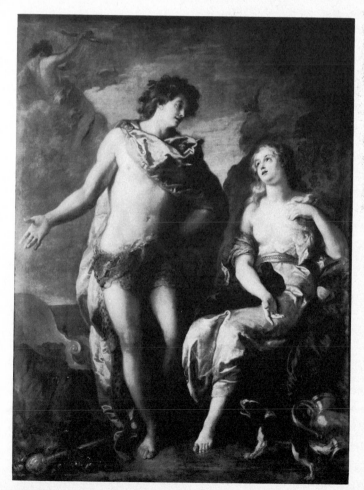

17
CHARLES DE LA FOSSE
Bacchus and Ariadne

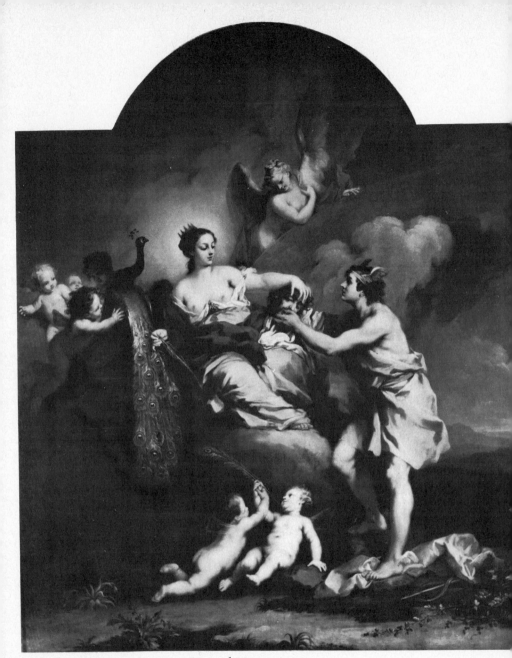

18 JACOPO AMIGONI *Juno and Mercury*

sense of contact between the two figures as they converse quietly – and only the barking spaniel (who has come from Titian's dynamic treatment of the theme) recalls that his mistress's virtue is in danger. La Fosse may have admired Titian, and certainly admired Rubens, but neither could galvanize his tepid talent into any vital action. Amigoni, even at his decorative best, shared this languor which is that of talents overshadowed, possibly bewildered, by the style they had helped to create. *Juno and Mercury (Ill. 18)*, one of four mythologies painted by Amigoni for Moor Park, remains too little idealized, and faintly ludicrous. Imagination has been less exercised than industry; Amigoni's people are real enough to be commonplace – and to feel somewhat ill at ease when shown sitting on clouds.

The true master of an air-borne, properly rococo manner in which to treat such subjects was Gian Antonio Pellegrini (1675–1741) who worked little in his native Venice but very widely in the rest of Europe. It was he, the brother-in-law of Rosalba, who was commissioned to paint a huge allegorical ceiling in the Banque de France at Paris in 1719, thus bringing the Venetian decorative style forcibly before Parisians. And when the ceiling was completed, its *modello* remained in the same room, as we know from Rosalba's diary of her triumphal French visit immediately afterwards. Thus Pellegrini's large-scale handling and his virtuoso brilliance in the sketch were proclaimed together. It is in sketches, in fact, that Pellegrini is at his most confident and most spontaneous. His sketch for the *Allegory of the Elector Palatine's Marriage (Ill. 19)*, another preparatory work for a large-scale commission, this time a German one, is virtuoso in its jagged, excited brushwork and its improvised but effective forms. Everything is faintly irridescent, bubble-blown, run up out of a few twists of silk and some feathers, but with an assurance which is itself attractive, and an economy of detail that delights the eye. Le Moyne, and most French rococo artists, left too little to the imagination; their competence showed itself in resolute recording of everything, and even their sketches are seldom as rapidly improvised, as full of suggestions, as are Pellegrini's.

Pellegrini probably never seemed an important painter to his contemporaries, and it is only very recently that he has attracted the attention he deserves – deserves as an artist, not merely because he is a link between Giordano and the Guardi brothers or helped to disseminate the rococo style throughout Europe. His range of pastel colours and his lively, calligraphic brushwork give his work much more freshness than Ricci's; he moves over surfaces with an effect of wit, cutting the corners so that we quickly arrive at comprehension of the shapes he is painting; once he has placed them, he passes on. In his world nothing is very

19 GIAN ANTONIO PELLEGRINI *Allegory of the Elector Palatine's Marriage*

20 GIAN ANTONIO PELLEGRINI *Bathsheba*

solemn, or solid, but it beautifully fulfils its function. There is even a sort of innocence about his *Bathsheba* (*Ill. 20*) who ogles the distant king high up on the balustrade of a flimsy Palladian palace. It seems a simple piece of typical Pellegrini decoration, markedly so when compared to the not very much later boudoir *Bathsheba* (*Ill. 21*) of Jean-François Detroy (1679–1752). This is more organized into being a composition, a complete *baignade* in which Bathsheba voluptuously reclines, displaying a generous expanse of thigh. It equally well fulfils its function, a more sophisticated one. Where Pellegrini is dreaming of

hardly more than some decorative patches of flesh-coloured and blue and white paint – textures being largely undifferentiated – Detroy aims to record real women's bodies and to place them in relation to each other and to their setting. It is no accident that he was a brilliant painter of genre; only the clothes in his picture here separate it from some *Déclaration de l'amour*, at once witty, topical, and preoccupied by the theme of love.

It was this sort of gallantry that was so lacking from Venetian rococo; even where lip-service was paid to the cult of women and love, it remained a matter largely of the lips. It is almost significant that Pellegrini's Bathsheba stops at the waist, dissolving thence onwards into a few folds of light drapery. At times the

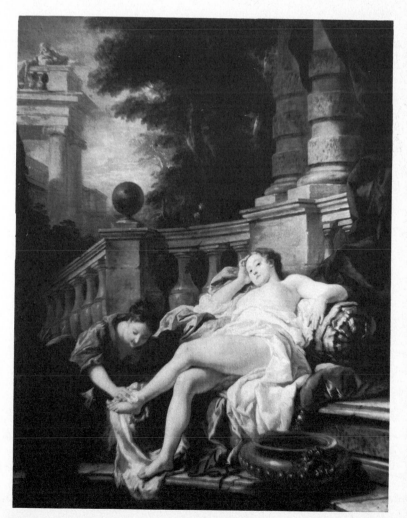

21
JEAN-
FRANÇOIS
DETROY
Bathsheba

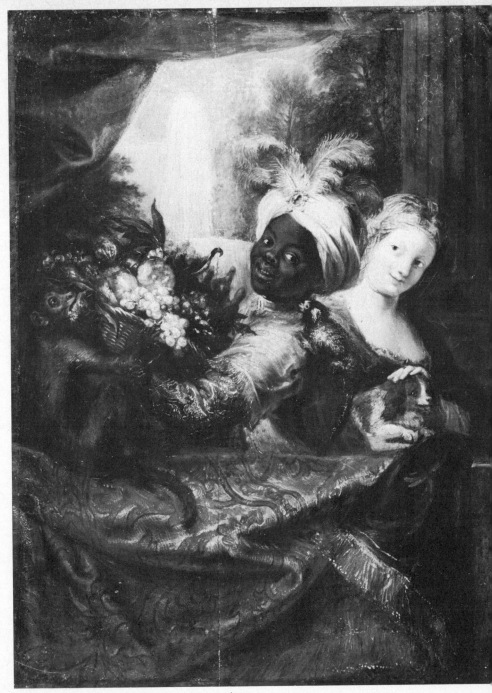

22 ANTOINE COYPEL *Negro with Fruit*

23 GIAN ANTONIO PELLEGRINI *Musicians*

two cultures could draw very close – not often as close as are Pellegrini's *Musicians* (*Ill. 23*) to the *Negro with Fruit* (*Ill. 22*) by Antoine Coypel (1661–1722). Even here, a graceful, beguiling female presence engages the spectator's attention, and the girl and Negro relate outwards, establishing an actuality that Pellegrini is not concerned with conveying. While Venetian painters continued to give serious attention to the more traditional themes of love and duty, French artists were dispensing with the aspect of duty and a rococo genre was evolving, well represented by Le Moyne's *Baigneuse* (*Ill. 24*), a version of which was publicly exhibited at the Salon of 1725. A leading painter of the day, younger than La Fosse and much more important than Antoine Coypel, the teacher of Boucher (as might be guessed) and finally *premier peintre du roi*, Le Moyne here asserts the

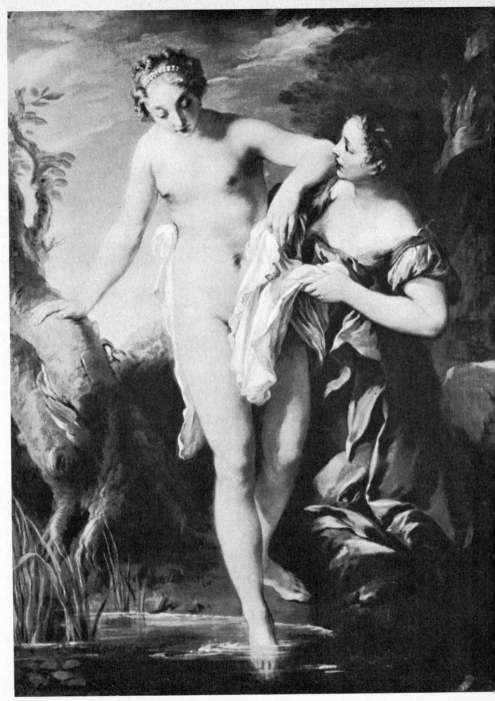

24 FRANÇOIS LE MOYNE *Baigneuse*

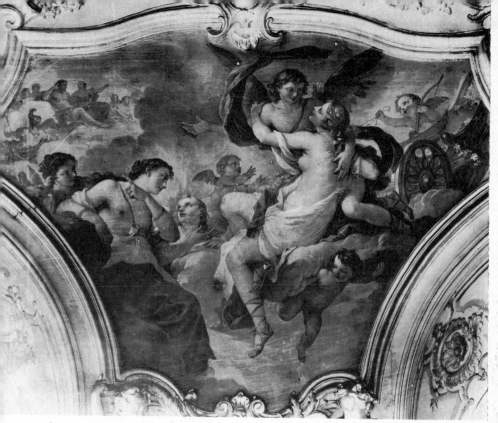

25 CHARLES NATOIRE *Cupid and Psyche*

new, almost frivolous, freedom. There is no longer any need to call his nude by
an Old Testament name; she steps forward simply as a bather, exploring the
frisson to be derived from the suggested contact of flesh and water.

Le Moyne's own career was abruptly cut short by suicide in 1737; Pellegrini
was to die four years later. Their deaths do not mark the end of the rococo
movement but they signal the end of its first, perhaps finest, flowering. The
high art of Boucher and Tiepolo had many years yet to run, and the variations
to be produced by Fragonard and the Guardi had not yet evolved. Apart from
all these the rococo was not exhausted and its practitioners continued with a
style that was to grow out of date, sometimes to lose its savour in their own
work, during their lifetimes. Whatever other new currents disturbed the cen-
tury, there remained a demand which was to be satisfied in France by Charles
Natoire (1700–77) and Carle van Loo (1705–65) – the latter one of those painters

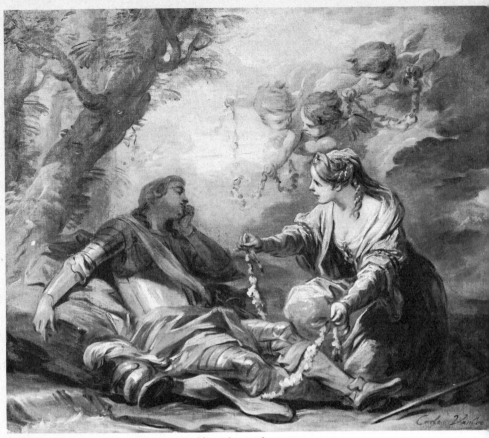

26 Carle van Loo *Rinaldo and Armida*

whose contemporary reputation was inexplicably high. It is a general style in
which such painters work. Natoire's re-telling of the Cupid and Psyche story
(*Ill. 25*) is helped by its gilded setting at the Hôtel de Soubise. Van Loo is more
tolerable in sketches than in his large-scale, dully-handled, insipid pictures; and
a last sigh of rococo grace can be detected in the *Rinaldo and Armida* (*Ill. 26*).

By the side of these painters, Italy continued to show more variety and vital-
ity. In Venice Giambattista Pittoni (1687–1767) worked in a sweetened decora-
tive style that proved popular outside the city as well. He was also capable of
unexpected spurts of vigour, of changing his usual formulae and producing
something at once effective as decoration and boldly handled. The robust drama
of the angel appearing to S. Jerome in Pittoni's *Three Saints* (*Ill. 27*) communi-
cates itself in a spiralling pattern all the way down the composition to the

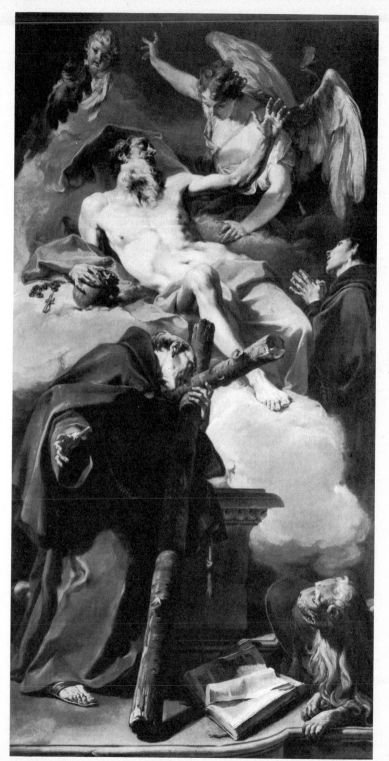

27
MBATTISTA PITTONI
Three Saints

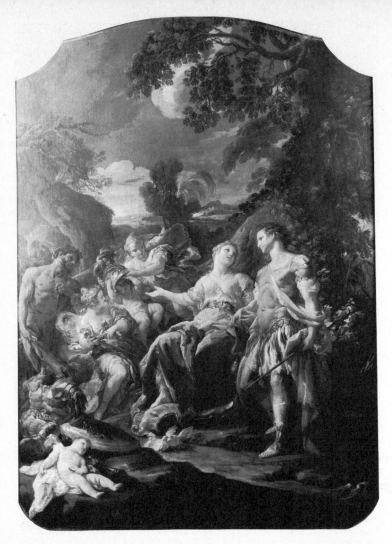

28 CORRADO
GIAQUINTO
*Venus presenting
Æneas with
Armour*

disturbed book and wary lion at the base. The saint not only receives a vision but
seems himself part of a vision, drifting on the long diagonal of cloud before the
adoring S. Peter of Alcantara. A more Frenchified rococo quality is apparent in
the work of the Neapolitan Corrado Giaquinto (1703–65) who succeeded Ami-
goni as court painter in Madrid and who was to exercise considerable influence
on the young Goya. His very individual tonality, with sea-greens and greys and
touches of coral-colour, is part of the complex circumstances of his formation,
and the Parisian sophistication of *Venus presenting Æneas with Armour* (*Ill. 28*)

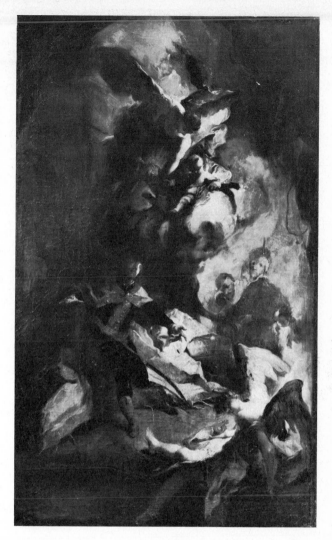

29 Franz Anton
Maulbertsch
Glorification of S. Stephen

is explicable through his contacts with Claudio Francesco Beaumont at Turin. There the court fostered a rococo manner into which Giaquinto's picture fits: decorative and not too serious, a mingling of Italian and French trends which results in a truly international style. It is playful but highly elegant mythologizing, suited to dealing with classical stories through, as it were, Ariosto's eyes.

This is the world that, even when still popular at courts, was soon to be under attack for lack of truthfulness, disregard of the classic canons even while relying on history and mythology. It remained very much a Southern European world,

centred on those absolutist courts which were themselves soon to be under attack. To some extent, the rococo required a suspension of disbelief which it was hardest to achieve in France; before such critical audiences the spell seldom worked. It is more than a coincidence that there religious pictures were so uninspired and that the best decorative schemes of, for instance, Le Moyne, remain dutiful covering of space in a basically monotonous way. When the rococo produced one last, unexpected and original flash it was in Austria, with the work of Franz Anton Maulbertsch (1724–96) which is almost the pictorial equivalent of some Bavarian, brilliantly-coloured, dazzling church interior. Maulbertsch's complete acceptance of the Catholic religion is expressed in excited visions (*Ill. 29*) with swooning mists of colour, like clouds of tinted incense. Dissolving forms and phosphorescent colour are used to beguile us into believing what we see – and we do believe it, thanks to the power of art. Beyond Maulbertsch there could be no development for the rococo; indeed, it was he who had kept the style in existence long after it had elsewhere succumbed.

In its haste to be decorative and light-hearted, the rococo had perhaps gone too far in its disengagement from reality – psychological as much as physical reality. It had no proper reply to the attacks on its frivolity, its mannered grace, its lack of moral purpose. It never in fact replied to attacks because the articulate parties were all in opposition to it. But without fully realizing it, it did possess the perfect answer to attack. The paintings of Watteau reveal that a decorative ideal need not forbid a profound sense of psychology and a response to humanity. Watteau 'arrived' as a personality on the artistic scene at Paris in the last years of La Fosse's life, just before Pellegrini began the Banque de France ceiling. Like these, and so many other rococo painters, Watteau was commissioned to paint decorative mythological pictures. His *Spring* (*Ill. 30*), one of a set of four for Crozat's dining-room, is an example of this type of work, not most typical of his genius. Yet it manages to be elegant and decorative with no refining away of humanity. His Zephyr and Flora are in contact, wonderfully, erotically, aware of each other. The graceful form is complemented by serious content. The two bodies are natural; they possess blood pulsing under the skin, vitality that flares their nostrils and sets their eyes sparkling (*Ill. 31*). Before this sheer jet of *joie de vivre*, much rococo decoration turns to soggy cardboard.

The real triumph of *Rubénisme* was that it made – if not Watteau, then Watteau's career, possible. He was not essentially a decorator, was not perhaps rococo at all. But he needed a period of freedom like the early years of the eighteenth century in which, though so briefly, to live and work.

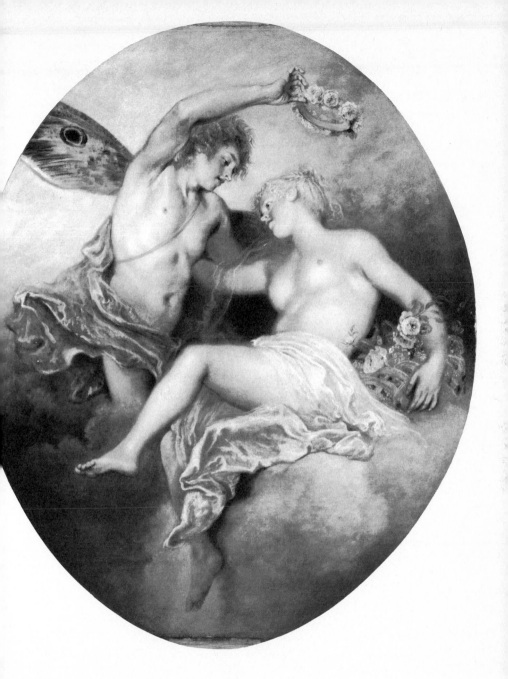

30 JEAN-ANTOINE WATTEAU *Spring*

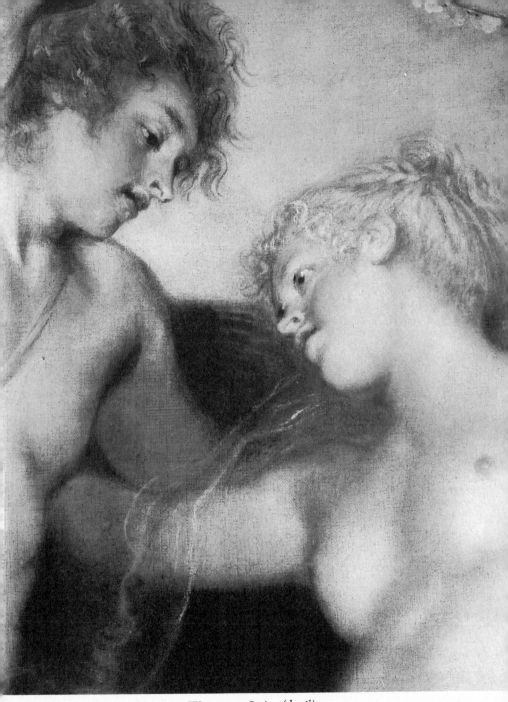

31 JEAN-ANTOINE WATTEAU *Spring (detail)*

The Importance of Watteau

Among the things that the eighteenth century did not understand about Watteau was the extent to which he was a rebel. Or perhaps it suspected this and for that reason was the more eager to accept him and his caprices, to receive him into the Académie Royale, and to include him within its social frame – from which he was always trying to escape. Placed in the early years of the nineteenth century, Watteau, with his aspirations and tart tongue, his evasions and illness, would have seemed one more rebellious, romantic figure. As it was, his contemporaries hardly understood him; and yet, significantly, those close to him felt an urge to put down on paper some description of his unusual character in a manner unprecedented. They at least understood that he was unique, and they certainly appreciated his revolutionary art.

Watteau had no public career, no great commissions from Church or Crown; he seldom executed large-scale pictures; he had no interest in painting historical subjects; the most official patronage he ever received was to produce a *morceau de réception* for the Académie who exceptionally left the subject unspecified (*à sa volonté*) – and even then he delayed the execution for years. Watteau should have been the great neglected genius of his age; but to its credit, he was a great applauded genius – appreciated, almost loved, far outside France. And outside France he was, perhaps, better understood. That he should have been so successful as an artist, where one might have expected non-comprehension if not active disapproval, shows how directly he spoke to the age. He was its poet, and he gave it an image in which it would have liked to believe.

There is something very moving in the international aspect of Watteau's fame. It crystallizes all the internationalism of the century. In France Watteau had some devoted patrons and friends. It was in an Italian dictionary that the first biography of him was printed, during his brief lifetime. In Germany Frederick

55

the Great (born in the year of Watteau's first public success) collected what remains unrivalled as the finest and most extensive group of his pictures. And England from the first responded to his art – during his lifetime and continuously thereafter. Reynolds and Gainsborough were united in admiration of him. Gainsborough borrowed from Watteau's compositions and inherited something of his felicity. Reynolds, so little given to enthusiasm or gush, went so far as to say: 'Watteau is a master I adore.'

The importance of Watteau was twofold. He created, unwittingly, the concept of the individualistic artist loyal to himself, and alone. When the well-meaning but basically uncomprehending Caylus – himself the narrator of this story – gave him a long sermon on his fecklessness and failure to look at the future, Watteau replied with Baudelairian logic: '*le pis-aller, n'est-ce pas l'hôpital? On n'y refuse personne.*' With this almost desperate sense of isolation there went for Watteau (just as for Baudelaire) a natural longing to rid himself of loneliness, to find some person or group to whom he could belong. His obsession in art with love is not merely the fashion of the moment. Everyone senses a seriousness in his pictures, an intensity under the elegance. Probably it is now possible, with new understanding of Mozart and Pope, to understand that sincerity in art does not have to be uncouth, and that perfection of form does not mean poverty of content.

The freedom that Watteau's life tragically achieved – having dodged obligations, changed his lodgings so often, escaped the importunity of friends, to slip out of life prematurely – was achieved without tragedy in his pictures. More important than any concept of the artist was the art he created. He invented in effect a new category of picture, the *fête galante*, which claimed complete freedom of subject-matter for the painter and which at the same time, while dispensing with overt 'story', treated human nature as psychologically as the novel was to do. *Fête* is only half his concern; it is given an ambiguous quality by the adjective which can tinge it just flirtatiously or dye it with the colour of deep passion: ripple a satin skirt to reveal a pretty ankle or isolate a pair of lovers in their own intense spell.

The earliest biographers of Watteau give a clue to what united people in their response to his work, and a clue also to what separated it from ordinary rococo decoration. This was his reaction to nature – that key word of the century. There were truths of human nature as well as those of the natural world. The truths that Watteau was concerned with are treated even more explicitly by his close contemporary Marivaux, equally a *modern* and associated with the group

who produced the *Nouveau Mercure*. Marivaux was to say of his own work: '*J'ai guetté dans le cœur humain toutes les niches différentes où peut se cacher l'amour.*' The very first biography of Watteau given by Orlandi in 1719 sums the artist up as indefatigable, '*sempre instancabile*', in his study of nature. The obituary notice written by his friend Antoine de La Roque, director of the *Mercure*, defines Watteau as '*exact observateur de la nature*'. This point needs stressing, because it is too easy to see Watteau as a frail, pale figure, wandered out of his century. If he is a poet, it is one akin to Pope rather than to Keats.

Watteau's art offers the first great alternative to the rococo – offering it during the very years the rococo was uncurling its decorative fronds. Almost under cover of that style Watteau comes forward, first as decorator, then as creator of *fêtes galantes*, and finally as the topical painter of the enchanted genre scene that is the *Enseigne de Gersaint*. Watteau's ideas of nature and reality retained until the end their decorative aspect; that aspect, like the marvellous glaze over finest porcelain, sometimes makes us forget the common materials which are the basic element.

By the middle of the eighteenth century and with the arrival of Diderot ('*il ne va pas plus loin que l'émotion*', said Mademoiselle de Lespinasse), the decorative aspects of Watteau's art militated against him. By a re-definition of the 'natural', it was the emotional sensibility of Greuze that seemed nearer the truth. It was Watteau's turn to look artificial and frivolous. In 1762 d'Argenville wrote of him: '*Le goût qu'il a suivi est proprement celui des bambochades et ne convient pas au sérieux.*' Even if what he depicted was true to society, it merely showed the dallying of a decadent society which did not deserve to be taken seriously. That attitude to the immediate past was to be typical of nineteenth-century views. Even now, knowing so much better, there is still a tendency with us not to take seriously the subjects depicted by Watteau. Yet, like Goya at the other end of the period, Watteau was concerned with reason and passion.

The importance of his ideas to Watteau is revealed, or rather it is confirmed, in that famous picture of which the subject was left '*à sa volonté*', and which is now known to represent the *Departure from the Island of Cythera* (*Ill. 44*). Personally timid, easily exacerbated in human relationships, Watteau was not timid about his art. In his first years in Paris when he was solitary, poor, probably friendless, he must have decided the direction of his own genius: it was to lead him to the quintessential statement of this picture. The circumstances surrounding it are almost part of its perfection, and are certainly part of its legend, a tribute to the perspicacity of the Académie and the liberal climate of the period,

symbolized by the attitude of Antoine Coypel, *premier peintre* when Watteau finally presented the *Departure* to that body.

It was himself that Watteau had presented in 1712, anxious to win a place at the French Academy in Rome. This was his second attempt; favoured by La Fosse and Coypel, he succeeded in winning instead a place in the Académie Royale – an extraordinary, unexpected event of which the early biographers catch an impressed echo. Invited to take the usual steps to join the Académie, Watteau was required to present a reception piece, the subject of which was customarily assigned by the Director: so customary was this procedure that the minutes for Watteau's reception on 30 July 1712 stated that he had been given his subject. But this phrase was deleted and the revolutionary words inserted that the subject of his composition was left to his own wish. Thus, even while Louis XIV still lived, a quiet blow was struck at the whole organized state institution of the arts in France. Watteau, without effort, had beaten the rules; it was the Académie which gave way.

The *Departure* was a large picture by Watteau's standards, measuring some six feet in length. It took him long to produce, perhaps through natural delays but also perhaps while he evolved the subject-matter and made it so completely personal. Not until 1717 did he submit the picture, '*représentant le Pèlerinage à l'isle de Cithère*'. That was how the Académie minutes recorded it; but once again a deletion took place, not to Watteau's advantage, and the words were substituted '*une feste galante*'. That is true as far as it goes. It may be a poor explanation of what Watteau has so carefully, and poignantly, depicted; but it grasps the essentials of a group of people enjoying themselves out of doors, involved in a cross between a dance and a picnic.

Though Watteau was to make this into a new category of picture, there were some prototypes. At least one of these was certainly known to him and they serve to emphasize the sheer difference – of mood as much as anything – manifested in the *Departure*; we feel this before we understand it, and that is a tribute to Watteau's subtle atmosphere. But no more than the rococo decorators was he without roots in the past. Like them he looked back to the twin stars – a place and a person – that were sixteenth-century Venice and Rubens. A Venetian painting which belonged to Louis XIV, and was then thought to be by Giorgione, was the *Fête champêtre* (*Ill. 32*), which ought ideally to have been known to Watteau. Perhaps it was; certainly it provides one of the first and most beautiful expressions of the freedom given by nature, with its group of idly amorous, relaxed, music-playing people. They are among the first people in painting to

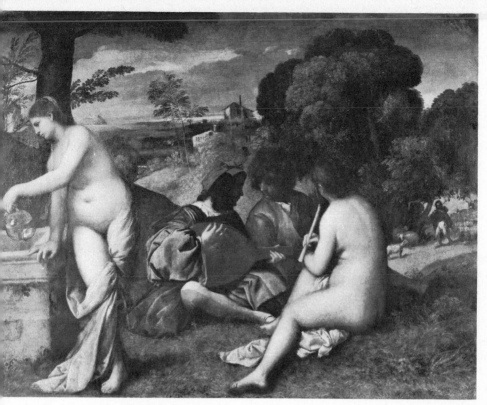

32 GIORGIONE (?) *Fête champêtre*

dare to do nothing, lilies of the field, conscious of their beauty and with an almost *fin de siècle* duty to that. And, just as in Watteau, music serves as the food of love.

But with him everything was to be less languorous. One is tempted to feel that this was because of Rubens. The history of the triumph of *Rubénisme* is really embarrassing until it reaches Watteau. There was by then no originality as such in being influenced by Rubens, especially as their common Flemish background perhaps encouraged Watteau's attention to him. What mattered was the result of this awareness. Rubens showed Watteau a way of assimilating the art of the past, especially that of the Venetians. Yet that was probably the least of his revelations. Through Rubens came the realization of the dynamism in nature: not only manifested in human beings but in the whole cosmos. Rubens' pictures embrace in subject-matter almost every aspect of the visible world. They

create new heaven and new earth, on a scale never equalled, and with a vitality that is Shakespearean. Through it all there crackles an electricity that seems powered by eroticism: love for all the tumbling, spilling cascades of fruit and flesh, intertwined bodies, gleaming materials, shafts of bright light, that is human experience at its most exciting. Rubens' sense of re-creation blazed out in the Marie de Médicis series on a huge scale. They are essentially actions, narrative pictures in which there is everywhere something happening. Watteau, we know, made friends with Audran, the Keeper of the Luxembourg, where the pictures then hung. He gazed at these pictures not with any wish to rival their tremendous pageantry (*Ill. 8*) but, as it were, with the intention of tapping off their vigour and vitality, avoiding the cosmic involvement, and charging with equal electricity merely a few ordinary people in a park or garden.

Even here, Rubens had been before him. He had transposed down the heroic to create the *fête champêtre* that is the *Garden of Love* (*Ill. 33*), one version of which was certainly known to Watteau who borrowed from it. What he copied is less important than what it inspired in him. It is a painted allegory that strangely recalls the psychological poems of the Middle Ages, notably the *Roman*

33 PETER PAUL RUBENS *Garden of Love*

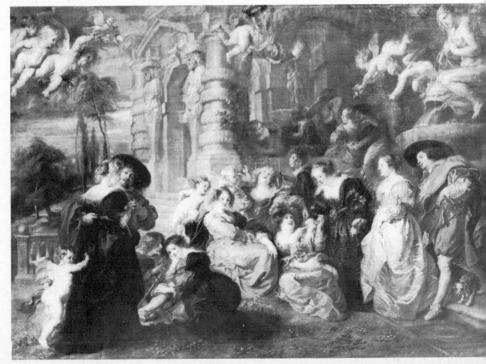

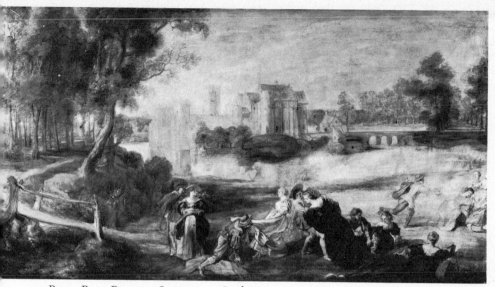

34 PETER PAUL RUBENS *Scene near a Castle*

de la Rose. And its elements are, more relevantly, those to be encountered again in Watteau's reception-piece. Women seem to matter more than men; in some undefined way it is they who control the proceedings, they who have states of mind; they are the Rose that must consider the pains and joy of surrender. Already in Rubens there is the shrine to Venus – in his composition a fountain – with couples surrounding it and love palpably in the air (in the shape of encouraging *amoretti*). A mythology is invented for the purpose of expressing the progress of mutual love; and the stages range from the bashful couple at the left to the pair who, their vows to love paid, confidently descend the steps close to the fountain's basin.

Other pictures by Rubens hint less obviously towards Watteau's ideas. The small *Scene near a Castle* (*Ill. 34*) exists in several versions and was also engraved. Quite possibly Watteau never saw either the print or one of the paintings; and yet it is tempting to think he did, so much does it contain already of his art. The pink evening light which is reflected in the moat has the tender tone of his skies. The black dresses of the women are anticipation of the marvellous decorative use he was to make of the same colour in costumes. Finally, Rubens takes as his subject here nothing more than a group of people enjoying themselves in pleasant, open-air surroundings – flirting boisterously with each other. Although the gestures are much cruder than Watteau usually devises for his people, the mood

is the same; the vivacity is a sexual one, with the countryside acting as an aphrodisiac. The closer people get to nature, the more natural their behaviour.

One returns to the nature depicted in the *Departure from Cythera* (*Ill. 44*). Until recently it was supposed that this picture represented a pilgrimage of lovers *to* the island of Cythera, with their gilded boat setting out into the promise of happiness on the misty horizon. However, it is now obvious that Watteau has depicted the pilgrims actually on the island, with the shrine of Venus at the right. A whole psychological chain of reaction is made up by the pairs of lovers – comparable to those in Rubens' *Garden of Love* – who extend from the statue down to the boat at the water's edge. The subject of setting out for the island, an earlier stage in the mythology as it were, was unmistakably depicted by Watteau in a composition which is probably earlier in date (*Ill. 35*). Here the men are proposing an amorous escapade, while the girls seem still rather hesitant. A cupid borrowed directly from the *Garden of Love* positively pushes the bashful girl at the left in the interlinked trio. Everything invites, in fact lights, the way to love. The lovers are going off in pilgrimage to a shrine where the reward is love itself; the girls may well hesitate before the adventure. The notoriously uninhibited effect of islands and pleasure-cruises is obvious enough and the dangers of Cythera had been advertised in a famous moral book, Fénelon's *Télémaque* (first published in 1698), in which the young hero describes in generalized chaste language the temptations he was there forced to undergo: '*On n'oublioit rien pour exciter toutes mes passions... et pour réveiller en moi le goût de plaisirs.*' What Fénelon calls temptation, Watteau makes a goal. It is not enough, however, to contrast serious *grand siècle* morality with the frivolous pleasure-loving Régence laxity that followed (like all such contrasts, it is only a half-truth, anyway). To Watteau the passions are important. It is true that he depicts his people on Cythera without any moral purpose but they have – or, rather, the painting is given – psychological purpose. It is concerned with a truth of human nature.

Usually concerned with love, love at work in society, Watteau usually paints a single psychological moment: the instant of music ceasing, of two people looking at each other as if for the first time. The ambitious intention of the *Departure* is to link a series of such moments into one artistic, psychological, whole: to create the perfect ensemble. The result is a miniature Mozart opera.

Mozart's theatre is removed from immediate reality by the convention of singing. Watteau too needs a convention, and his people are dressed in masquerade costume, pilgrims of the only god the eighteenth century really believed in,

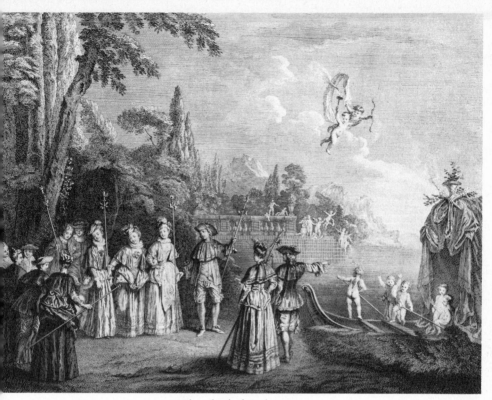

35 JEAN-ANTOINE WATTEAU *The Island of Cythera*

and set on a dream island to which they have been brought in a gilded boat. These things, like the rose-hung statue of Venus where the lovers pay their vows, become part of the allegory. Love's power is strongest at that place where the kneeling man and seated woman whisper, oblivious of the cupid (also in pilgrim costume) who tugs at the woman's skirt in an attempt to recall her to reality. In every way, the picture is imbued with a poignant sense of the losing battle love fights against the reality of time. Sunset marks the end of love's day, along with the end of the pilgrimage, and intimations of dispersal set everyone in motion except the pair seated under the statue's spell. Further away a pair of lovers get to their feet; and beyond them pause another pair with the woman caught still in the spell, turning back with a regretful smile before descending to the crowd and the boat that so inexorably waits. Less confident than Shakespeare, Watteau sees that love *is* time's fool. The three pairs of lovers are

63

merely the pictorial expression of the experiences of a single couple; and the reality they reach when they board the boat again is made quite explicit in Watteau's second version of the composition, that done for Jullienne and now at Berlin. Here the whole scene has become a touch more obvious, with an additional pair of lovers chained in rose garlands, and a little less evanescent. But beside the boat there is now also a pair of cupids, one of whom is shooting an arrow, feather-end foremost, at embarking lovers – as if threatening their disunity (*Ill. 36*). The return to the shores of reality will bring the lovers back to the point of the earlier composition (*Ill. 35*), to the point in fact before they become lovers.

In its own way, the *Departure from Cythera* is a history picture, but a modern one. Its mythology is of Watteau's creation but it manages to tell a completely comprehensible story – unlearned yet universal – and there need be little doubt that Watteau constructed this elaborate scene because of its final destination, the Académie. By his standards, it is unusually full of narrative content. His subject is more 'natural' than visions of gods and goddesses or scenes from classical history. It is concerned not with heroism but with passion.

Watteau was almost certainly indebted to the theatre for the actual machinery of pilgrim lovers, and perhaps even for the idea of a journey to Cythera. But the attraction of the theatre for him must have been stronger than this, and it extends to the actors themselves. They stand first for new freedom: to mock at society and not to conform with it. Then the actor disguises himself, plays roles, and is always involved in the game of appearances. The eighteenth-century theatre was to produce several sophisticated masterpieces where the characters within the play are disguised again – and from this disguise springs the psychological fact of love or unlove. Only a game of false appearances will show the final truth, as it is seen in *Le Jeu de l'Amour et du Hasard* or *Le Mariage de Figaro*.

The world especially of the Italian Comedians, satirical and topical and yet concerned with love, had already been utilized by Claude Gillot (1673–1722), under whom Watteau was to study. Gillot's *Quarrel of the Cab Men* (*Ill. 38*), though amusing and vivid, is hardly more than a transcript of the theatre. Watteau was to take this urban theatre, urban in its setting too, and set it free in parks and gardens (*Ill. 37*), converting grotesquerie into enchanted love-making. In a different way from the pair of pilgrim lovers in the *Departure*, the pair of the girl and Harlequin here are isolated from the rest of the group, seated under an antique statue that seems severely aloof from their vivacity, not presiding but

64

36 JEAN-ANTOINE WATTEAU *Departure from the Island of Cythera (detail)*

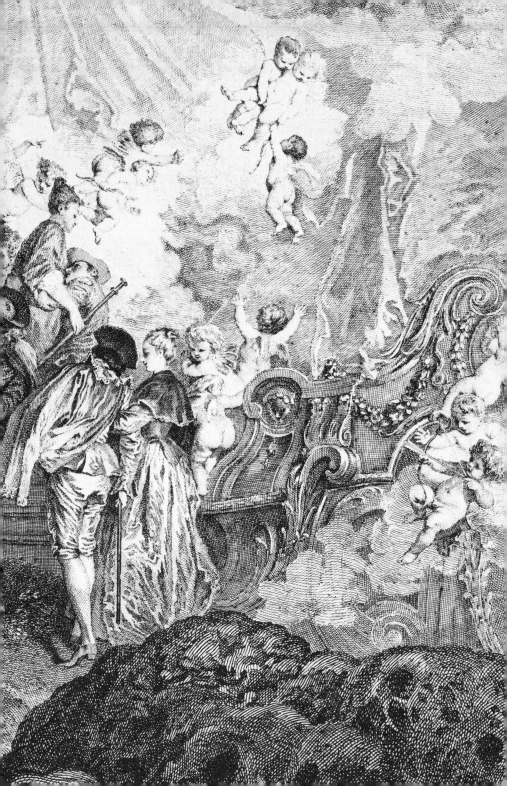

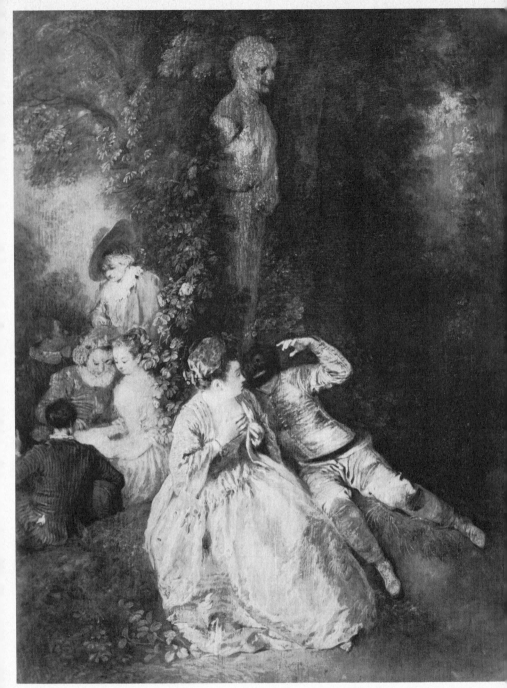

37 JEAN-ANTOINE WATTEAU *Voulez-vous triompher des belles?*

38 CLAUDE GILLOT *Quarrel of the Cab Men*

rather standing a stone reminder of what remains long after life and love are
ended ('*Le Buste/Survit à la cité*'). Harlequin is a comedian who is also a lover;
indeed, here perhaps it is a lover who has merely assumed his costume; or per-
haps the whole group are actors, strolling players who have paused to rehearse
a song in open air surroundings. What is very typical of Watteau is to depict a
group and yet isolate a pair within it. Across the general air of social gaiety there
blows a sudden current of serious love, putting two people on an island of
their own.

What is only a hint, a light-hearted one, in the *Voulez-vous triompher* becomes
almost the subject of the *Assemblée dans un parc* (*Ill. 39*) where a natural setting
is much more fully realized and the figures are framed by it, themselves almost
as much the product of a mood as the pale water and misty trees. It is wrong to

67

39 JEAN-ANTOINE WATTEAU *Assemblée dans un Parc*

think of such pictures as ones where nothing is happening. If one asks what this picture, what all Watteau's pictures, are *about*, they are about men and women falling in love, trying to make up a society of love which nothing will disturb. At the left stroll a pair who have achieved a relationship which eludes the central pair of the right-hand group: there rougher methods of love-making do not succeed. A woman well able to take care of herself repulses a clumsy, too-eager man. The landscape seems to side with the tranquil lovers; autumnal trees crowd about the long stretch of placid lake and, across the water, almost lost in the twilight, a third pair of lovers embrace.

This picture is unusual for the absence of music in it. For after the benevolent effect of nature on the heart there comes next in Watteau the effect of music, especially the entwined harmony of voice and instrument which becomes a symbol of love. Music is present not merely to suggest an amorous mood but because it was part of Watteau's own personality. To Caylus it seemed worthy

of note that someone basically uneducated, a yokel in upbringing, should have had this responsiveness; there is some supercilious surprise in his testimony but that makes it the more trustworthy: '*quoiqu'il n'eût point reçu d'éducation, il avoit de la finesse, et même de la délicatesse pour juger de la musique.*'

In Watteau it is usually the man who plays the musical instrument and the woman who sings. He is the serenader, and she joins in or not. Watteau's women are always courted and they have the power to refuse. This is probably never better suggested than in *Le Mezzetin* (*Ill. 45*), in which the Italian comedian's costume serves as half-disguise for the lonely serenader whose dependence on the unseen woman is wonderfully suggested – very much as it is in *Don Giovanni* during '*Deh vieni alla finestra*'. It is perhaps conscious irony that seems to convey that his plea is hopeless by placing a very modern-looking female statue with its back to the lonely mezzetin; she is deaf and stone, and perhaps the same is true of the living woman. Thus, there are times when music does not immediately bring harmony; it only invokes it.

40 JEAN-ANTOINE WATTEAU *L'Accordée de Village*

In his use of music in painting, Watteau must have been influenced by the use made of it in Dutch seventeenth-century genre pictures, which once or twice come very close to stating a Watteau theme. The *Terrace Scene* (*Ill. 41*) by Jan Steen assembles all the elements out of which Watteau was to construct something much more profound as well as elegant. But Watteau not only seemed, he really was, in this tradition. For all his homage to Venice, he belonged with the Northern artists who were just coming to be appreciated in Paris. Steen's picture is unenchanted reality – unfired, very human clay – which Watteau was to make the basis of his art, transmuting it as he built upon it. Some of Watteau's early pictures combine rural merry-making and music in a completely seventeenth century way, with recollections of Teniers rather than Steen, and yet they already have made something completely new and silken out of this homespun material. *L'Accordée de Village* (*Ill. 40*), damaged though it is, retains something of this refinement – very different from artificiality – with which Watteau is able to treat not only his peasants but their surroundings. Even the gaiety of the scene is muted accordingly, and there is a tender atmosphere about

41 JAN STEEN *Terrace Scene*

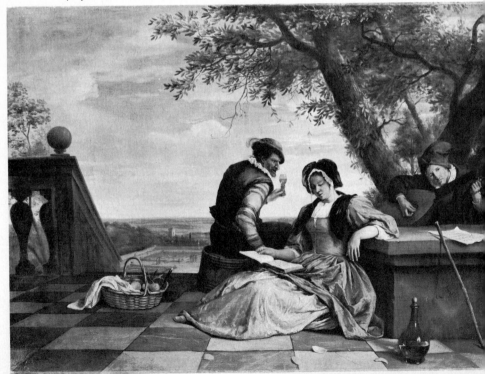

this microcosm of society, ranging across the composition from the children to the aged hurdy-gurdy man, with the future bride stiffly seated, rather solitary, in the centre. This picture alone is reminder of the peasant Watteau who had received no education; whatever refinement his art gives the scene, it is the world he knows and from which he sprang.

That knowledge is still present, lying behind the apparently much more idyllic, and much later, *Fête vénitienne* (*Ill. 43*) – a quite meaningless, or at least misleading, title. And here there is nothing rustic about the dancers or the handsome park in which the company has gathered. There is less ostensible subject too. Simply a group of people, in Watteau's usual way, is collected, talking, dancing, music-playing, in the open air. The superb handling of the paint hardly needs any comment; it is paint that seems inspired by vitality as well as beauty, moving with a sort of wit comparable to the wit displayed, or hinted, in the subject-matter. While the paint runs, neither too thick nor too thin, in an effortless creation of creased silks, copper-coloured, mauve-pink, olive green – like a fan of pigments suddenly extended – Watteau's imagination seems to create a completely fresh situation for his characters, taking puppet people and filling them with recognizable personalities.

Partly apparent to the naked eye, and confirmed by technical photographs, are several changes made by the artist while working on the picture. The most obvious is the change made in the male dancer, in profile at the left. Originally he was seen from the back, with one hand extended, his face turned towards the woman and quite anonymous, even insipid, in character. Although he appears to have been completely painted, the whole figure was drastically changed by Watteau. He substituted an easily recognizable portrait of his friend Vleughels, a painter with whom he had lodged, giving this figure a new, challenging (perhaps characteristic) pose. He no longer extends a gracefully inviting hand; and he seems to look across the picture, past the woman, to the seated bagpiper.

When this figure is examined, his incongruousness in the company becomes remarkable. The setting and costumes evoke an elegant society – at least, one fashionably if fancifully dressed. The majority are conversing among themselves; only he seems somewhat apart, an effect which his plain clothes emphasize, and an object of scrutiny by the naked fountain nymph. This statue, lazily coming to life, quizzes his presence, disturbed perhaps by the uncouth music of his bagpipes. In fact it is a portrayal of Watteau himself. When the picture was engraved, the very talented engraver (Laurent Cars) recognized the self-portrait of Watteau but made him look rather younger and less haggard. Watteau's

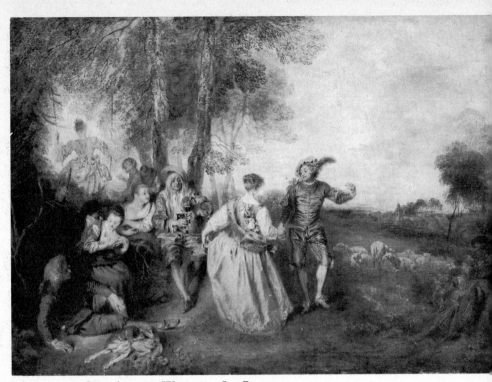

42 JEAN-ANTOINE WATTEAU *Les Bergers*

awareness of his own appearance is tragically closer to the truth. It must have been equal mordant awareness that made him paint himself in what are deliberately rustic clothes and playing an almost absurdly rustic instrument. He thereby seems to identify himself with the old shepherd who plays the bagpipes in a completely rustic picture, *Les Bergers* (*Ill. 42*), an almost clownish figure whose dancing days – if they ever existed – are long over. Watteau puts on the wide breeches and yellow leather apron which are the bagpiper's costume; he too wears a strap (of the instrument?) round his right arm.

Across the composition he gazes back at Vleughels. They are placed at almost equal distance from the woman who is herself probably a portrait, perhaps of Charlotte Desmares, an actress whom Watteau had certainly drawn. These three figures seem involved in more than the ostensible dance. Watteau sits out to play for his two friends; but though he may show himself in peasant disguise, they are not dancing the countrified measure of the pair with hands clasped in

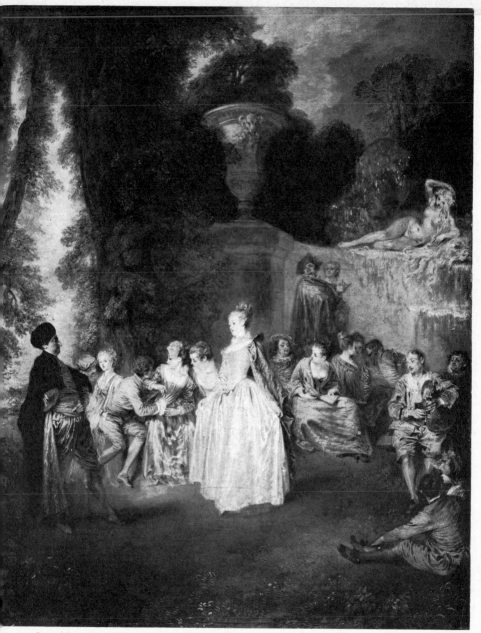

43 JEAN-ANTOINE WATTEAU *Fête vénitienne*

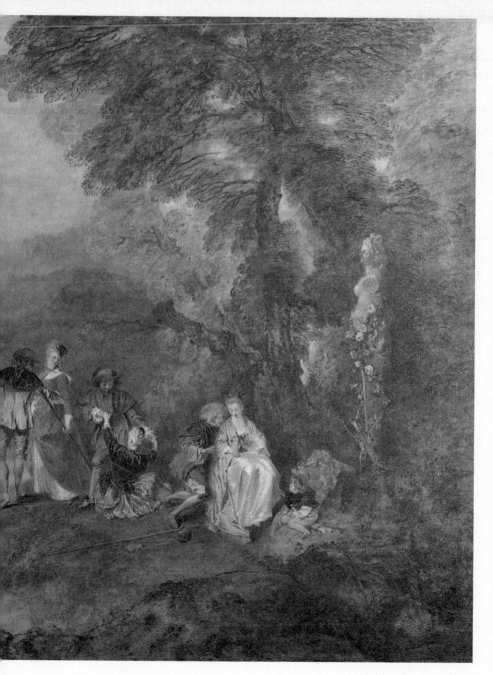

44 JEAN-ANTOINE WATTEAU *Departure from the Island of Cythera*

Les Bergers. They tread a more stately dance, perhaps emphasizing the incongruity of matching it to bagpipe music. The picture is shot through with gleams of irony, hints that are now hard to understand, and a tension that seems unmistakable and yet impalpable. Watteau's own portrayal of himself comes so close to the description of him given many years later by Caylus that it seems no accident, simply somewhat sardonic self-awareness of how he appeared to others: '*tendre et peut-être un peu berger*'.

This late picture shows Watteau moving beyond the enchanted mythology of Cythera – not into deeper dreams but closer to disenchanted reality. To some extent the lonely *Mezzetin* (*Ill. 45*) was in the same mood. Both pictures are quite small and it was on a large scale that he summed up the sense of isolation and odd man out, in the *Gilles* (*Ill. 46*). Though this is no self-portrait, the sense of self-identification is very strong and adds to the poignant effect. The group of laughing actors in the background, with a clown tugged along Silenus-like on a donkey, is probably inspired by an engraving of Gillot's; but what had been his main subject is deliberately reduced by Watteau to a frieze of busts that do not interfere with the tall white figure of Gilles, perfectly still, posed frontally against the empty sky. Once again, a figure seems to assume clothes for a part. Just as in the *Fête vénitienne* Watteau's own sensitive features and beautifully articulated hands contrasted with his humble costume, so Gilles seems too dignified for the clown's white floppy tunic and abbreviated trousers. The moon-shaped hat encircles a vividly painted but solemn face, its lack of animation the more marked when compared with the boisterous lively faces behind. There is a complete separation between the group and the individual; they are active while he is idle, having fun while he remains unsmiling, welded into a self-contained group while he gazes out directly at the spectator. It is difficult not to feel that Watteau intends his to be the real awareness. He stands there a little dumbly, himself with a smack of the *berger* but dependent, like all entertainers, on his audience. The picture's mood is complex and inexplicably moving; it seems to record not a prologue but an epilogue (as so often in Watteau), a silencing of laughter and the sort of hush that pricks the eyes with unshed tears. It is like the moment at the end of *Twelfth Night* when the plots have all been disentangled, the lovers paired off, and only the clown is left, singing to comfort himself and justify a player's existence: 'And we'll strive to please you every day.'

By itself, this picture reveals how far Watteau had cut his style off from the rococo decorators. He continued in pursuit not so much of natural appearances

as of human nature. Of course, he understood that the two can go together; and he was to bring them together in one final, supreme, and large-scale treatment, self-commissioned: *L'Enseigne de Gersaint* (*Ills. 47* and *48*). Although nothing so marvellous could have been foreseen, the creation of this picture is logical. It is Watteau's testimony, made solemn by the circumstances, to his passionate attachment to visible things and people. In his own way he had always been a painter of genre. Beneath the airiest of his pictures there lies the scaffolding of his superb drawings, themselves a body of evidence testifying to his vigorous grasp on the hard shell of facts. Ourselves, our place in ordinary life – and in the scheme of things: these were the subjects of interest to the eighteenth century. Watteau, reluctant to make any moral judgment, any metaphysical statement, created instead this view of people in a recognizable environment, in Paris, in the shop of his friend Gersaint. Their aims are still the same as they always were in Watteau's pictures; only this time it is love in a shop instead of a garden, and buying and selling now take the place of music in society.

Because quite early (around 1744) it left France for Frederick the Great's collection at Berlin, the picture was not there to help Diderot, for instance, to comprehend Watteau's art. But it may well have influenced the young Chardin, very different though it is from anything he produced. It is a key document, as well as a masterpiece, in which almost every eighteenth-century artistic interest is contained – except the moral one. It is decoration, and *trompe-l'œil* decoration, intended for the front of Gersaint's shop – probably for that reason composed, as well as cut, in two halves; not only does it give the illusion of dissolving the shop wall, so that one steps directly in from the street, but the illusion is itself witty: expanding the poky reality of a shop on the Pont Notre-Dame to this grandiose room, with its glimpse of a tall-windowed salon beyond, papered with pictures that Gersaint probably never owned. Thus, though it is genre, it is enchanted genre, animated not only by wit but by a ubiquitous eroticism no longer conveyed through the presence of cupids. It is the paint itself which communicates an almost feverish excitement, a hectic vitality, to the society assembled here in autumn colours, chrysanthemum tones of bronze and yellow and pink, set off by black and silver-grey.

These figures are no longer in fancy dress but in fashionable costume, painted with ravishing response not only to lace and silken textures but to plain linen too – like the pierrot-style shirt of the man handling the portrait of Louis XIV. There are no subsidiary groups on a small scale; all the figures have equal

77

45 JEAN-ANTOINE WATTEAU *Le Mezzetin*

46 Jean-Antoine Watteau *Gilles*

importance in the dance-like rhythm which undulates in and out across the composition, with a convenient pause at the centre. The spectator is invited into the picture by the girl who steps from the street into the shops; her ankle breaks the long horizontal where the two meet and her stocking is revealed as a

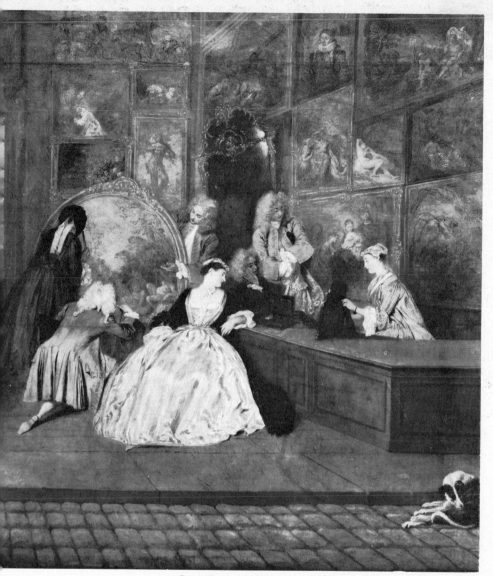

47 Jean-Antoine Watteau *L'Enseigne de Gersaint*

surprising sage green. As she advances, her partner gallantly steps forward as if in a minuet. They are the last of Watteau's couples, brushed by an invisible amorous genius present in Gersaint's shop – more obviously present in some of the pictures on the walls and quite patently in the large *Baignade* being examined

so closely by the kneeling man who has got down to thigh level. In the group who examine a mirror held by the pretty serving-girl there is more ambiguity: the men examine her as well as the mirror, and the mirror reflects back the image of the beautifully-dressed woman customer who gazes somewhat sadly at it. There is nothing so concrete as a story, but all these people – themselves objects of *grand luxe* – seem looking for more than works of art; and the picture becomes concerned with the shop of the human heart.

The tantalizing sense of psychological realism, perhaps present from the first in Watteau's work, is seen here on quite a new scale. There could be no advance beyond it, because Watteau was to die the year after it was painted, dying in the arms of Gersaint. The intensity behind the *Enseigne de Gersaint* comes from life looked at in a way it can be looked at perhaps only by the artist and the dying; and Watteau was both. The world of Rubens, which had allured him so much, is rivalled here, in scale and handling, and paid too a last homage in the curled-up dog which comes from the *Coronation of Marie de Médicis (Ill. 8)*. This is the real triumph of *Rubénisme*; out of homage and emulation has come a quite new art.

Its originality could be copied in turn but not kept alive once Watteau himself was dead. He had created a vogue, and this perhaps damaged his own art in the eyes of the next generation. Without Watteau the *fête galante* was soon to dwindle to triviality, but his example gave further impetus to the unco-ordinated desire for freedom. The difficult balance between decoration and genre was to be held best in France by Nicolas Lancret (1690–1743), immensely successful during his lifetime but who has perhaps suffered too much in reputation for his proximity to Watteau. Frederick the Great felt none of this, and collected both painters in quantity. Lancret did not attempt any psychological insight, but his eternal charm and his keen eye for contemporary manners led to pictures which occasionally are minor masterpieces. *Fastening the Skate* (*Ill. 49*) is more overt than Watteau, from whom the subject derives, but less obvious than many pictures by Boucher. It contains a neat mixture of truth and sentimental fiction, seizing on the decorative aspects of winter and winter clothes as the setting for one more flirtatious exchange between man and woman.

All over Europe Watteau stood as symbol of a new gracefulness and ease: the proof that the painter can tackle apparently flippant subject-matter and yet be a great artist. Watteau's own attitude was soon to matter no longer; he represented something which he might not always have wished to be. With the publication of his work in the corpus of the *Œuvre gravé*, his compositions exercised

48 Jean-Antoine Watteau *L'Enseigne de Gersaint (detail)*

49 Nicolas Lancret *Fastening the Skate*

50 THOMAS GAINSBOROUGH *Mr Plampin*

an influence which was perhaps sometimes hardly conscious. A Frenchified grace
in genre subjects was attempted everywhere, even in England. Pictures like *The
See-saw* (*Ill. 51*) by Francis Hayman (1708–76) are really closer to Lancret than
Watteau, but they exemplify a European movement, of which the last echoes
are detectable in Goya's tapestry cartoons. The most personal response to Wat-
teau is in Gainsborough, a great painter who yet seldom painted anything re-
sembling a Watteau subject. Several of Gainsborough's early portraits show him
utilizing Watteau's compositions for his sitters, through his knowledge of the
Œuvre gravé. The feathery countryside and nymphs that appeared in Watteau's
portrait of his friend Antoine de La Roque have been replaced by solid Suffolk
countryside in Gainsborough's *Mr Plampin* (*Ill. 50*), who yet poses similarly.

85

51 FRANCIS HAYMAN *The See-saw*

But Gainsborough borrows more than a pose, as his later pictures confirm. It is freedom that exhales from his portraits: the freedom of nature and natural settings is allied to free handling, and the whole expresses the idiosyncratic character of his sitters, so relaxed and yet lively, just like Gainsborough's own nature. The painter who described himself in a letter to a patron as 'but a wild goose at best' was clearly Watteau's cousin, taking the same freedom for the artist as he expressed in his art, and conscious of being the odd man out in ordinary society. Gainsborough, if anyone, was the heir to Watteau's art, but he was not to turn to the 'fancy picture' (*Ill. 52*) until late in life; and there would have been little patronage for an English painter producing *fêtes galantes* in preference to portraits.

In the rest of Europe, there continued to be a demand also for large-scale decorative painting, continuing the rococo wave at the opening of the century. But this style of painting was no longer connected with libertarian artistic ideas; associated with the courts that fostered it, it increasingly seemed to enshrine, even glorify, reactionary concepts. The splendid confidence of Boucher and Tiepolo flagged before their deaths – they both painted until the end – and was replaced by the last twist of the rococo, a flying calligraphic twist, that disappeared with Fragonard.

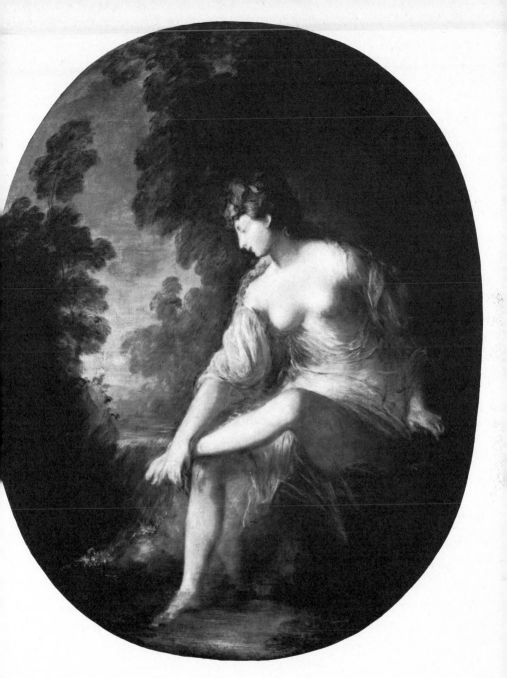

52 THOMAS GAINSBOROUGH *Musidora Bathing*

53 GIOVANNI BATTISTA TIEPOLO *Page with crown (fresco detail)*

High Rococo

The kingdom of the great decorative painters of the mid-eighteenth century is one largely created by Boucher and Tiepolo. Indeed, in 1750 they stood like two still-vigorous rulers with great achievements behind them and, at least in Tiepolo's case, greater ones before them in the twenty years further activity they both had. A style of decorative painting, varied for the two countries as markedly as Ricci and Pellegrini vary from Le Moyne and Detroy, had already been created by the artists who preceded them. Boucher and Tiepolo were to make something quite new from the style, heightening its imaginative possibilities, enjoying the sense of being virtuoso craftsmen, dazzling enough to make their predecessors seem clumsy and dull. In their particular, highly personal, way they actually put back a tang of realism into the increasingly diluted rococo style; they created their own individual types of people, two galleries together more varied and more vivid than anything the rococo decorators had created before.

It was a peak of achievement that, wisely, was not to be attempted by the apparent continuators of the style: the Guardi brothers and Fragonard. Their contribution is towards a dissolution of the rococo grand manner in which solidity is replaced by airy shapes almost of tinted steam and people once again dwindle to become so many curves and arabesques. What Boucher and Tiepolo achieve is a firmly extravagant baroque in connection with which some words of Reynolds' are apt; he was thinking of Michelangelo but they apply equally to the 'great style' of the eighteenth century: 'It must be remembered, that as this great style itself is artificial in the highest degree, it presupposes in the spectator, a cultivated and prepared artificial state of mind.'

The differences between Boucher and Tiepolo are understandable and perhaps more obvious at first than any similarities. But they share some things too,

not least the ability to please their patrons, themselves monarchs, nobility, people with ideas of aristocracy if not actual aristocrats. Both chose to paint pictures which disseminate myths, which willingly accept the structure of society and which minister to its wildest dreams of glamour or pleasure. Neither artist was in any danger of mistaking fiction for truth – being utterly of their century in their commonsense – and both have left plenty of evidence in drawings and occasional paintings to prove how sharply aware they were of ordinary existence. Their contemporaries Chardin and Piazzetta confirm that there was no necessity for the successful painter to take the path Boucher and Tiepolo took. If their imaginations wandered in a vaguely classical and historical sphere of consciously impossible dimensions and splendour, this was by choice and by the nature of their genius. Both of them embodied the principles not only of *Rubénisme* but of Rubens himself. Boucher continued the tradition represented by such pictures, and subjects, as the *Judgment of Paris*. Tiepolo extended the epic world of the Marie de Médicis series, in which history and allegory cheerfully blend to make great events seem greater, and where every act is a public one involving heaven and earth. It is no accident that both aspects concern women: the whole purpose of Boucher's art and prime movers in much of Tiepolo's most splendid work.

Whereas in Watteau's pictures, where their role was equally dominant, they were natural beings, they have become goddesses to the high rococo – supernaturally beautiful and powerful, sweeping through the heavens as the Madonna or lounging among cushions, impossibly, incandescently, blonde. The cultivated spectator is meant to enjoy the tall-story aspect of such women and to appreciate the skill of the painter in creating around them a completely unnatural structure, whether it is water as blue and hard as glass or a white marble palace of cloud-like insubstantiality. The imagination is there to be exercised; art is there to create; and the triumph of Boucher and Tiepolo is that nothing hindered the exercise of their great gifts simply as creators. And it was perhaps the very sureness of their grasp on reality that allowed them to go off into such firmly-controlled and fully-realized fantasies, spiced with wit: perfect rococo structures of shell-like clarity far removed from the moody, self-doubting, megalomaniac fantasy of Romanticism. In their art it is always daylight: darkness creeps on only with the close of the century.

As the older painter, Tiepolo had to make a journey towards the light for himself, and it is perhaps symptomatic of his basic artistic realism that as a very young man he was more attracted to the style of Piazzetta than to that of

Sebastiano Ricci. Boucher was to have the example of Tiepolo to help him, if one accepts the traditional statement that he admired Tiepolo's work when in Italy (sometime before 1730), and it is true that, like other French people, he owned a few Tiepolo drawings. Tiepolo himself was certainly to seek in earlier Italian painters examples of affinity, culminating in Veronese – the painter with whom he was so often to be compared at the period. In many ways the intended compliment had its disadvantages, for they were very different artists.

Tiepolo emerges, erupts rather, into public fame in 1716, when the rococo movement was itself in glittering activity, and Rosalba, Watteau, Le Moyne, Pellegrini, were all demonstrating new possibilities. But Tiepolo was never to become part of Franco-Venetian culture; the Académie showed no wish to enrol him among its members, and the audacity of his compositions was to strike most French connoisseurs as *maniéré*. Thus it is unlikely that he would ever have been welcome in Paris, and in his own country Rome remained equally unreceptive. Even in Venice currents of appreciation for the 'new' realism were to display some reserve about Tiepolo and, though he was famous, he was perhaps less warmly appreciated than in the courtly atmosphere of petty German kingdoms. The places where he was urgently sought are revelatory of his art. Milan under the Austrians (and hence his fame in Vienna already by 1736), Stockholm, Madrid. It was particularly fitting that his last years should be passed in Spain and that his late work should be concerned with the Divine Right of kings and visions of the saints – both beliefs which were increasingly under scrutiny, and then positive attack, during the century. Stylistically, he might pass on some hints to the young Goya, but his own art was much more deeply *ancien régime*, anachronistic in its century and to drop out of favour in the nineteenth century. Only painters, and collectors interested in colour and decoration, were by then likely to be interested in Tiepolo: Delacroix, who never reached Italy, shows some awareness of him, and Renoir discovered and admired him when he visited Venice.

What Tiepolo was trying to do was, perhaps, against the real grain of his period: keeping out the tide of reason, very much as Venice was politically trying to do. He postulated a world in which there is still room for the grand gesture and the heroic action. Much more than Watteau's, his art is that of the theatre, with a stage that is deliberately elevated above us, and actors who keep their distance. Although this allows very splendid effects, it restricts Tiepolo to rather simplified pageant emotions in which psychology is swamped or barely attempted. At the centre of it all, the chief characters retain an almost discon-

certing imperturbability and *hauteur*. The artist himself sometimes aids this by a touch of irony or wit, as if pricking the balloon of pretension. He reminds the spectator that the whole panorama is feigned and should never be mistaken for the truth. It is difficult to be moved by such art to any very definite emotion and Tiepolo is possibly at his least convincing when his subject requires tragic emotion, especially in religious subjects. Artistically, he rejects death and blood and terror, even when he has to depict them. There is always a solution, usually a positively happy ending, and his personages are seldom shown stripped of the trappings of allegory; they come before us the more confidently because of the machinery of heaven which is always at hand with an angel or a genius. Their very *désinvolture* is the product of the consciousness of servants behind the scenes. One is reminded of the epigram made when Garrick and Spranger Barry played King Lear and divided London audiences into two camps of praise:

> *To Barry they give loud huzzas;*
> *To Garrick – only tears.*

For the major part of his career, Tiepolo is like Barry, communicating a sense of excitement and exhilaration that first unites us and then makes us want to cheer.

In nothing did he more clearly reveal the traditional, national, basis of his art than in his superb ability to decorate – though the pejorative sense of the word unfairly suggests superficiality – and to do so not merely on a large scale but in harmony with varying architectural settings. Yet what ultimately separates him from Giordano and Pellegrini is the combination of this ability with an intensity of imagination. Tiepolo constructs a spacious, artistically actual, cosmos. He is not true to history or mythology but true to his own genius. The confidence exhaled by his persons, and echoed on the very clouds on which they often recline, is the artist's confidence in his own powers; it is typical that one of his ceilings should include an elephant among the clouds. There is a change in Tiepolo's style in his late years, a lessening of high rococo bravado and an increase in emotionalism, which may be connected with a feeling of age and a loss of confidence. It is possibly more than sentimentalism to see him as finally a Prospero-figure who had become a little weary of his own magic, whose dazzling feats cost him increasingly hard labour, and who was not altogether sorry to break his wand.

The Tiepolo of the middle years of the century, coinciding with the years of his own maturity, seemed inexhaustible in vitality and variety. Whether his

54 Giovanni Battista Tiepolo *Madonna del Carmelo*

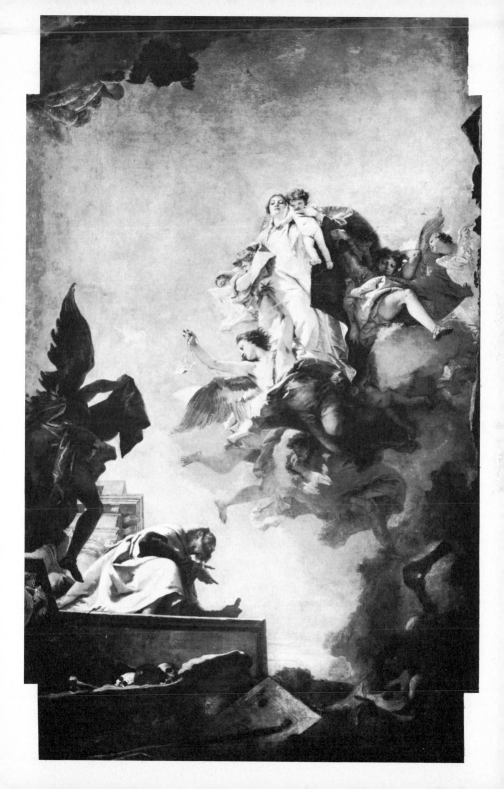

work was for church or palace or villa, he responded with fresh solutions, new visions, which are at the same time always recognizably within his own conventions. At their best, they have been produced to fill, and to create, space. Although he also produced some cabinet pictures, perhaps in emulation of French painting, such reduced dimensions seem to have cramped his imagination. At times one may even feel that to produce straightforward compositions at ordinary eye level was – if not cramping, at least uninteresting, to Tiepolo. They offered none of the challenge of surprising the spectator, which is so essential to the rococo, and seldom allowed those confusions of art and reality which are part of the surprise.

Religious subjects offered the ideal opportunity for Tiepolo to achieve such effects. He is an outstanding artist of the century for many reasons, but unique in being able to accept extravagant religious themes without sophisticated embarrassment and without reducing them to excuses for decoration. Unlike any other painter of the period, he *needed* such commissions on which to exercise his imagination; the more miraculous and visionary the subject the more ardently he responded. The ceiling picture of the *Madonna del Carmelo* (*Ill. 54*) is one of the most brilliant of his visions, of almost oppressively hallucinatory power as the spectator gazes up at it in the Scuola dei Carmini at Venice. The ceiling has become sky – a great expanse of sky which Tiepolo does not hesitate to leave empty except for the knot of flying angels who come with a sweep of dark cloud, bearing in their centre the imperious white-clad Virgin. The foreground of the composition tilts up as if to meet this vision: the crouched figure of St Simon Stock, a jut of Palladian cornice, a grim pile of skulls, these give a necessary but minimal location, making a right-angled frame towards which the air-borne fabric rushes with such impetus as if it would sweep out of the composition altogether. But it is in the actual assembly of the vision that Tiepolo most wonderfully combines intensity of imagination with brilliant draughtsmanship; nothing is blurred or confused, in fact all is carefully composed and executed, but the effect remains spontaneous and visionary. It does not derive from Giordano, and still less is it related to Veronese.

It is a culmination of all rococo religious visions, the final conjuring out of paint of creatures plastically real and yet divinely insubstantial. A miracle of Catholic doctrine becomes a miracle of art. Just as the Virgin comes to assuage St Simon Stock, transfiguring the grim reality around him, so Tiepolo comes to transfigure the simple room of the Scuola. He does not mirror ordinary experience, but dissolves reality, and instead expands our awareness into a new

55 GIOVANNI BATTISTA TIEPOLO
Beatrice of Burgundy (detail)

world unguessed at before. Even now it remains hard to analyse how he obtains his effects, but this vision of the Virgin contains a rich sequence of typical motifs. Dazzling draughtsmanship allowed the creation of the structure of flying angels, all foreshortened legs and fluttering folds of drapery, which serves literally to support the Virgin who, with almost insolent grace, places one hand on an angel's head as if steadying herself on the rapid flight – to which greater urgency is lent by the speeding, winged, cherub's head, pressing forward at the extreme right. Borne aloft, tall and calm in the heart of the agitation, the Virgin effortlessly holds high in her disengaged hand the Child – weightless, equally aerial – his head level with her own. There is nothing humble in this vision; it is more splendid than comforting; and the Virgin herself is very much the Queen of Heaven: miracle-working goddess or magician, created to bring consolation but remaining remote, untouched by what she witnesses. It must be enough that she deigns to appear.

This concept of woman, which can be disconcerting in religious work, found perfect expression in Tiepolo's profane decorations, where every woman becomes a queen, and queens themselves acquire a new aura. It hardly matters whether it is a story from Pliny or from the Dark Ages that needs Tiepolo's illumination; he recreates Cleopatra (*Ill. 56*) and the twelfth-century Beatrice of Burgundy (*Ill. 55*) as almost the same woman, dressed in his interpretation

95

of sixteenth-century Venetian costume, *alla Paolesca*, with huge curve of ruff and loops of great pearls, more radiant and blonde even than the airy settings which surround without enclosing them. It is romantic rococo when compared with Boucher's more earthy visions; the flight from reality results in a dilution of the erotic, and so dignified is the world inhabited by Tiepolo's people that love is only a vague sentiment, while the overtly sexual would be shocking within that public context. Cleopatra preserves her distance; and though she is not a feat of prestidigitation, she is partly sleight of hand, a bundle of patterned materials and piled curls, barely animated simulacrum of a woman, one less courtesan than virgin queen, who might have been constructed out of fabric and glass. Her artificiality is, of course, intentional; and the story of her swallowing a pearl in wine at her banquet for Mark Antony may have seemed not only artificial but faintly ridiculous to Tiepolo. He includes his own face among the spectators, clad in bizarre costume but vividly shrewd, perhaps even sceptical.

The mood is more solemn in the *Marriage of Frederick Barbarossa and Beatrice of Burgundy*, itself only a part of Tiepolo's decoration of the Kaisersaal in the Würzburg Residenz. Here the genius of Balthasar Neumann provided him with the most sumptuous setting he ever had; and Tiepolo produced equally sumptuous scenes over which polychromed marble curtains are suspended by stucco *putti*. History is quite consciously re-created in a pageant that is not only impossibly gorgeous but with its references to the present – the blessing bishop being a portrait of Tiepolo's patron, the Prince-Bishop. Neumann's real architecture gives way to this huge, vaguely Palladian basilica in which a train of sword-bearers, women, and pages swirls up to the altar steps where the Emperor kneels beside, but slightly below, his bride. The banners, dwarfs, dogs, the crown on its cushion, the fringed gloves and golden armour, are all brilliant, excited details which seem checked where they begin to merge in the long swell of the Empress's blue cloak, itself topped by the icing-white ruff which sets off her pearl-adorned blonde hair and cool profile. This still figure (*Ill. 58*), a winter queen of cold blue and sheer white and a few touches of frosty yellow, is the effortless heroine of the scene, blown out to these magnificent proportions from the original fact of an obscure woman in German history. Frederick Barbarossa is eclipsed; he becomes merely the partner to accompany the *prima donna*, for whom this whole stage has been created and which she so completely dominates.

Never again did Tiepolo transform history into such glittering fairytale, spun out of sheer imagination, recklessly free in concept and yet scrupulously exact in execution. By Tiepolo's standards it is pure history. No allegorical personages

96

56 GIOVANNI BATTISTA TIEPOLO *The Banquet of Antony and Cleopatra*

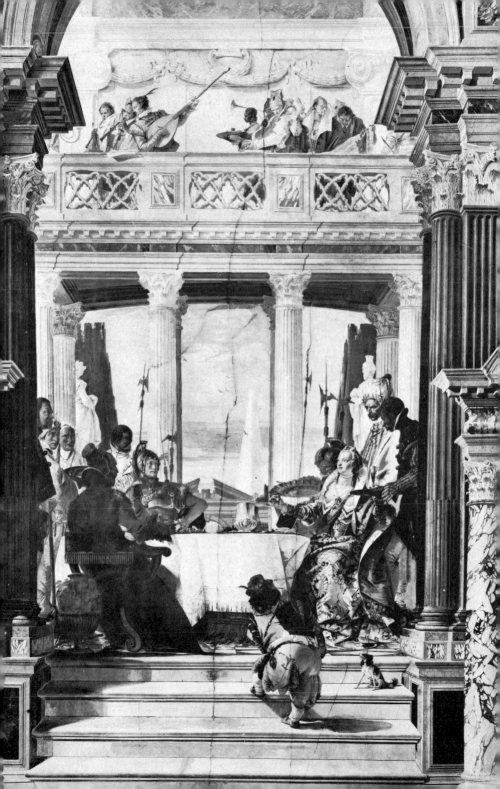

57 GIOVANNI BATTISTA TIEPOLO *The Sacrifice of Iphigenia (detail)*

intervene, as they do in Pellegrini's comparable work; there is no early rococo prettification, any more than there is accuracy of costume or setting. Instead, there are created people on a scale, and with the necessary magnificence, to inhabit Neumann's Kaisersaal, to play out their pageant in the atmosphere which begins above the cornice, raised far above the spectator in a brightly-coloured dream, not of what life is, but of what it could be.

Even for Tiepolo there was not to be another Würzburg. His own aims shifted, and he attempted more direct involvement of the spectator – never forgetting that presence – in the rather different drama of moments like the *Sacrifice of Iphigenia (Ill. 57)*, that popular subject for painting in the century. This was frescoed in 1757 and three years later Daniel Webb was to speak of the agitation the victim evoked: 'beautiful, innocent, and unhappy...' Tiepolo responds to that aspect, but he is concerned too with the arrested action, the

58 TIEPOLO *The Marriage of Frederick Barbarossa and Beatrice of Burgundy (detail)*

sacrifice not being a sacrifice in the end. It is a miraculous moment that he depicts, when the goddess appears to the woman before the knife plunges into the flesh. We are brought to the edge of tragedy and then, like Iphigenia herself, reprieved. But though Tiepolo's aims have slightly shifted, the elements of his art remain the same. There is still a delight in *trompe-l'œil*, concentration on a heroine, and – above all – the same imaginative atmosphere and characters which had served for his other decorative schemes. Like Egypt and Germany, the Aulis of antiquity has been transmuted to become a Palladian structure animated by oriental figures in striped clothes and with the very banners that had flapped at Würzburg (one even bears the German eagle).

Whereas, however, fantasy might play around Cleopatra, and make what it would of the Teutonic Dark Ages, serious subjects from classical antiquity were increasingly to be treated seriously in art. As the eighteenth century progressed it became necessary to harness painting to serve the new régime of the intellect; and Tiepolo continued to practise *Rubénisme* in a Europe where enlightened circles had returned to the standards of *Poussinisme*. His *Sacrifice of Iphigenia* is an offence against the rising tide of neo-classicism – or, rather, a brave blow of defiance by the retreating style which by 1757 had lost the battle. Only in Italy had it been possible to foster the full-blown tradition of the grand manner that Tiepolo represents; it lived as long as he lived, and was extinguished with him. His last gesture on Italian territory was an anthology of all his finest motifs, in the finest of all his Italian palace ceilings, that of Villa Pisani at Strà (*Ill. 59*), completed in 1762. The theme of this is that we are all going to heaven – at least the Pisani family are. Their apotheosis is not expressed merely in allegorical-triumphal terms but in literal portrayal of the individual members of the family astride the clouds, mingling in Olympian air with the Virtues and Arts, while at the centre Fame blows a trumpet blast – the final rococo note, rallying one last effort of belief in what is now, almost literally, the height of absurdity.

Boucher had never been such a committed artistic believer. Although he had worked in Italy, the Italian tradition did not tempt him into vast imaginative schemes. Tiepolo's art goes back eventually to Raphael in the Stanza della Segnatura. Boucher never aimed at a heroic vision. He expressed no glorious promises about heaven: either as an Olympian refuge for aristocratic families, or in ordinary Christian terms. Like most French eighteenth-century painters, he could not evolve a satisfactory idiom for religious pictures of any kind; and he was particularly unsuited to the task by the nature of his real abilities. '*Qu'était-ce que ses vierges?*' Diderot was to ask, at the Salon of 1765, and accurately

59 GIOVANNI BATTISTA TIEPOLO *Apotheosis of the Pisani Family (detail)*

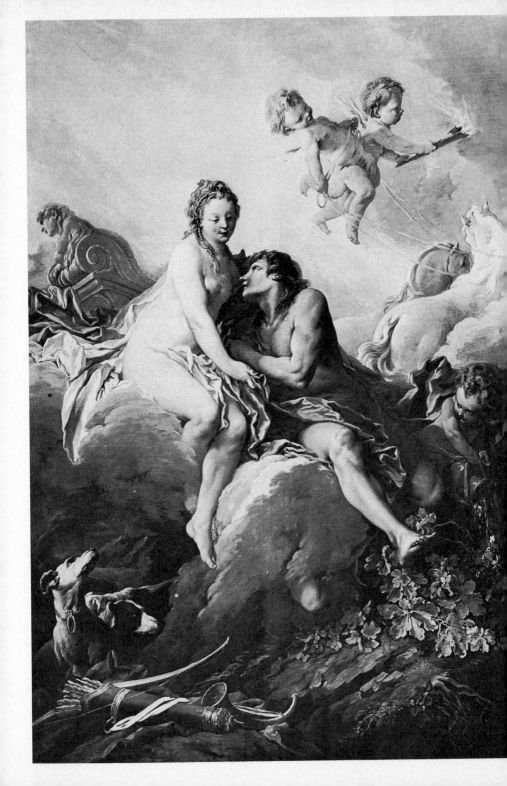

61 FRANÇOIS BOUCHER *Diana after the Hunt*

answer, '*de gentilles petites caillettes.*' Indeed, although Diderot bitterly attacked Boucher, he was remarkably perceptive of Boucher's real powers, and even allured a little by them: '*C'est un vice si agréable.*'

All Diderot's fury about falseness, lack of observation of nature, corruption of morals, loses its relevance before the finest products of Boucher's art. His mythological world was more frankly feminine, and more accessible, than Tiepolo's; it hardly tries to astonish the spectator, and its magic is no exciting spell but a slow beguilement of the senses, a lulling tempo by which it is always afternoon in the gardens of Armida. There is no clash of love and duty, no public audience, and with barely the presence of men (Boucher increasingly could hardly be bothered to delineate them at all). But this does not automatically mean frivolity. Especially in the years up to and about 1750, Boucher's own artistic and actual vigour combined to produce a whole range of mythological pictures which were decorative, superbly competent, and tinged with their own vein of poetry, sometimes muted and wistful as in *Aurora and Cephalus* (*Ill. 60*).

60 FRANÇOIS BOUCHER *Aurora and Cephalus*

This is more serious, as well as more competent, and much more beautiful, than anything painted by Boucher's master, Le Moyne, who committed suicide in 1737, the year it was painted. The female nude has not yet become the whole pretext for the picture. A mood, as well as tonality, gives its tender dawn light to the whole composition, in which the mortal man yearns for the pensive, even sad, goddess against a sky of pale rinsed yellow, only faintly warmed by the rose of the rising sun. The picture is full of the sense of imminent parting and change, of day replacing night, with the hounds eager for the chase and the immortal horses poised for flight. The solemn-faced, by no means merely playful, *putti*, the nervously creased draperies, and the evanescent mood are all reminders of Watteau's early mythological pictures. Perhaps Boucher could never have sustained this particular poetry – or only by dodging success and its demands. Like Tiepolo, he was the servant of his patrons, but bending his talents in an obsequious bow where Tiepolo preserved a sort of craftsman's independence.

Boucher's imagination was weaker than Tiepolo's. He remained much less sheerly inventive – though demand drove both painters to some duplication of effects and an increasing reliance on assistants. The atmosphere of France, so much more profoundly civilized and sceptical (largely the same thing), inhibited whatever wilder flights of fancy he might have liked to take. It was increasingly difficult for him to make the conventions in which he worked as serious as were Tiepolo's. It is almost a symbol of this lack of firm structure that his pictures attempt no architectural settings and seldom offer any composition beyond the relation of the foreground bodies. Trees like clouds, and clouds like birds, cluster and flutter to fill the spaces left over, with diminishing energy. Since Boucher could not have managed that instinctive rhetoric which was Tiepolo's birthright, he sensibly expressed himself in a less grandiloquent manner, one disarmingly playful and yet more disarmingly sensuous.

Tiepolo's chilly women are stripped by Boucher to complete nudity, warmed by love or lust, and made always girls before they are goddesses. The trappings of mythology are increasingly only different wrappings for the same offering, guaranteed not to interfere with contemplation of the woman even if she is supposed to be *Diana after the Hunt* (*Ill. 61*). Thus, while the stage is equipped with false trees or false doves, truth is present in the observation of naked bodies, draperies that set them off, and – most caressingly – in the texture of flesh conveyed by paint. It was in that context that Boucher produced his most sustained work, best when it is not too large, seldom again quite so perfect as in the *Birth of Venus* (*Ill. 62*). This is the quintessence of his aims, blending the natural and

62 FRANÇOIS BOUCHER *The Birth of Venus*

the artificial to make a completely enchanted scene, exuberant and yet relaxed, an aquatic frolic and yet also an air-borne, sea-borne, vision which has authentic pagan feeling. It is a glimpse to make anyone less forlorn as these creatures rise dripping from the waves. The green water itself becomes an exciting erotic element as it swells and falls, bearing up the pearl-pale bodies that abandon themselves to it and offer their limbs like branches of white coral as perches for Venus's doves. In place of Tiepolo's romantic nobility there is a human simplicity. Despite the snorting dolphins and heaving Tritons, the tumbling *putti* and the tremendous twist of silver and salmon-pink striped awning, the goddess remains a ravishingly pretty, demure girl, half-shy of the commotion of which she is the centre. She, like the nymphs around her, is reality idealized, divinely blonde and slender, touched with a voluptuous vacancy, a lack of animation, which perhaps only increase her charm. The insolent consciousness of Tiepolo's

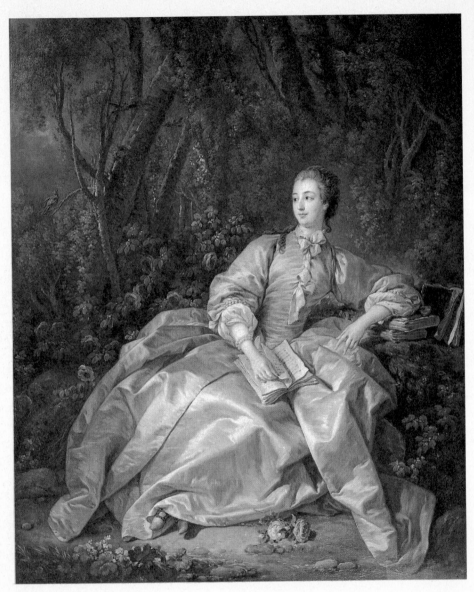

63 Fʀᴀɴᴄ̧ᴏɪs Bᴏᴜᴄʜᴇʀ *Madame de Pompadour*

people is replaced here by innocence bordering on stupidity; herself so desirable, the goddess seems without desires. Boucher keeps much closer than Tiepolo to the terms of ordinary experience; his idealizing touches are restricted to the refining of ankles and wrists, perfecting of the arc of the eyebrows, tinting a deeper red the lips and nipples. Both artists can be related to the sculpture of their period. Boucher belongs with the naturalistic nude statuettes of Falconet and Clodion; Tiepolo has much more in common with the extremes of gilded and rouged Bavarian rococo sculpture.

Although Boucher served the rococo movement well, it was essentially through the exercise of conscious fancy rather than by any profoundly imaginative impulse. He was capable of painting straightforward genre scenes and portraits as soberly realistic as that of the extremely youthful *Duc de Montpensier* (*Ill. 64*). All his portraits of Madame de Pompadour (*Ill. 63*) are characterized by

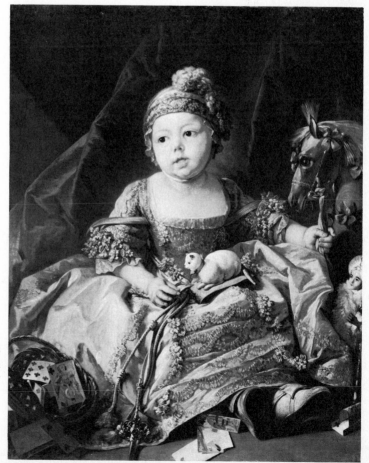

64 FRANÇOIS
BOUCHER
Duc de Montpensier

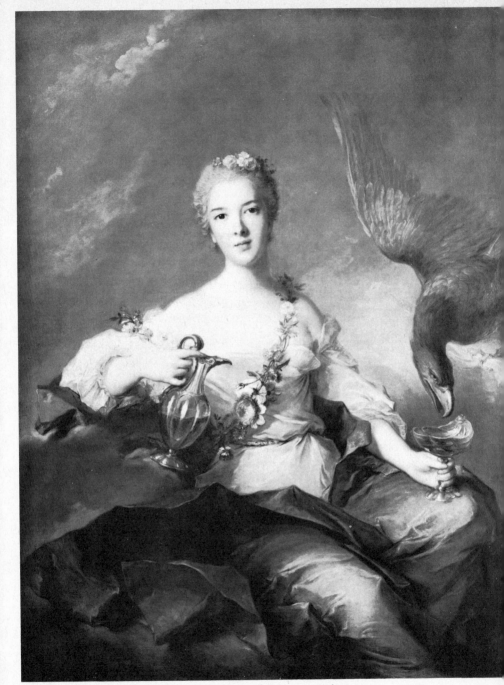

65 JEAN-MARC NATTIER *Duchesse d'Orléans as Hebe*

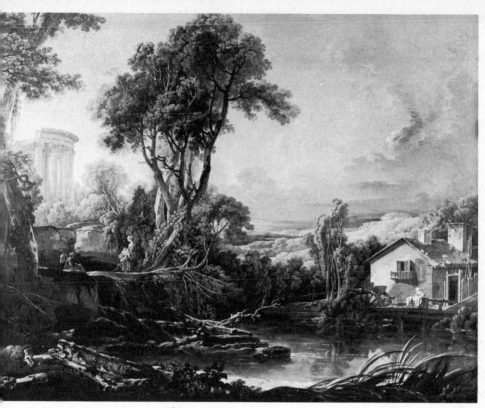

66 FRANÇOIS BOUCHER *Landscape with Watermill*

equal directness and emphasis upon spontaneity. He placed her reading, re-
clining, seizing a hat before going for a walk, and not only in natural poses
but in a natural, half-rural setting. Simply dressed and well equipped with books,
she pauses in her reading to listen to a bird singing, in a wonderful woodland
of velvet moss and silken foliage. This is a portrait artificial only in the way that
Watteau and Gainsborough were artificial. It is utterly simple in concept, even
anti-rococo, when compared with the high court portraiture of Nattier. His
Duchesse d'Orléans as Hebe (*Ill. 65*) shows a rather different encounter with a
bird, requiring the sitter to remain ludicrously unperturbed in trying to carry
off the charade. To Cochin, the friend of Boucher, it was Nattier's type of por-
trait that seemed unnatural; he was to make witty play with the idea of ladies
whose diversion consisted of taming eagles by offering them white wine in
gold cups.

67 Nicolaes Berchem *Ploughing*

Boucher's pastorals and landscape paintings, which are certainly part of his rococo achievement, are wilfully artificial on a basis of real observation. They create a new branch of rococo art in which the growing tendency to shake off dynastic and mythological duties has been completely developed; they are stage settings without characters, or with at most some actor-peasants, in which nature is dressed alluringly as Venus had been undressed. Occasionally Boucher had been anticipated by an almost accidental rococo in the work of Dutch seventeenth-century painters; and the fact that he actually owned Berchem's *Ploughing* (*Ill. 67*) is significant. This contains in nucleus the rolling, foaming cumulus-like foliage which drifts like soap bubbles across the landscapes of Boucher and spurts up more dramatically in Fragonard; and even Berchem's ploughman has something of the same half-elegant, rococo motion. Perhaps Boucher's most enchanted landscapes are those where the stage is set but the characters hardly appear: a rural dream of tranquil nature where man has added only picturesque

water wheels, some cottages and a few inevitable doves, and where the taffeta grass, the blue trees, and the pale stretched silk sky (*Ill. 66*) create an ingenious, impossible Arcadia more beautiful than any reality. By the mid-1750s Gainsborough in England was achieving similar effects, blending French elegance with native facts and producing idyllic landscapes, often with courting woodcutters and milkmaids. Perhaps better based in observation of nature than Boucher, Gainsborough has no hesitation in refining it into something movingly artificial, scenes of country love which are not recorded but created by the artist. Both painters realized that such pictures give pleasure because they are recognizably not true – any more than is the theatre or a mechanical singing bird. It is by an exercise of sheer reason (in contra-distinction to the emotionalism of Diderot) that Boucher accepts that all art is convention and that the actual countryside can never appear in a painting. What obligation is on the painter to depict a green tree if a blue one appeals to him more, and is in fact artistically more beautiful?

This is the real break in the eighteenth century's standards. The dilemma was expressed openly by Cochin when he spoke of artists like Tiepolo: '*Ces peintres sont fort agréables, c'est dommage que la nature qui est fort belle ne soit pas à beaucoup près aussi belle que leurs tableaux.*' Diderot said in effect much the same of Boucher: '*Cet homme a tout, excepté la vérité.*' There was no one to champion the rococo; it had only patrons or enemies, and the latter had increased markedly by the middle years of the century. In 1762 Tiepolo was summoned to Spain; when his first royal commission was completed, he asked to remain there, though he must have realized that he might well die there without returning to Venice. In fact, that happened; and the last eight years of his life are a sort of retreat. In 1764 Boucher's greatest patron Madame de Pompadour died. His own powers were failing and though he continued to exhibit at the Salon he was increasingly attacked by Diderot. Whether he or Tiepolo quite understood, their reign was over; they were virtually deposed before they died.

What further possibilities could be squeezed from the rococo were developed by the Guardi brothers and by Fragonard. Gian Antonio and Francesco Guardi represent the same phenomenon, probably active in the same studio and possibly in some sort of collaboration, until the death of Gian Antonio in 1760. Out of the art particularly, it seems, of Pellegrini they produced a more dazzlingly-coloured, more melting style – but one that had none of Pellegrini's international success, being restricted chiefly to serving a decorative function in obscure churches and villas of the Veneto. In many ways the closest affinities of this style

68
FRANCESCO GUARDI
SS. Peter and Paul

69 GIAN ANTONIO GUARDI *Erminia among the Shepherds*

are with Maulbertsch, and it remains more typical of the Tyrol than of Venice. Their compositions are quite often shamelessly borrowed; when not borrowed they are often shamelessly incoherent. In them objects are splintered by light in a sort of proto-, rainbow, impressionism. Perspective, organized aerial space, the Palladian solidity of Tiepolo, these are exchanged for a personal style of coloured handwriting – now brilliantly calligraphic, and now brilliantly cloudy, which uses reality as a sparking off point.

The most perfect expression of this style remains in the Tobias series for the organ loft of the church of Angelo Raffaele in Venice. In them (*Ills 70, 71*) it is as if the brush had barely touched the surface of the canvas, so rapidly does it move, obeying its own laws, and leaving the whole surface crackling with vitality. Everything shares the same texture, given by the painter. The compositions, framed by trees, set within deliberately decorative fronds and branches, are as capricious as some fan-design by Watteau. Normal reality has been dissolved and replaced by a new luminous atmosphere in which everything exists only in so far as light defines it. Indeed, the lines run like electric wire broken here and there by flashes of fire which give a glowing softness even to wood or metal or stone. Similarly, the large-scale *Erminia among the Shepherds* (*Ill. 69*), one of a

whole decorative series illustrating Tasso's *Gerusalemme Liberata*, is an essay in transmutation. Where Tiepolo crisply delineated and defined, exposing planes, the Guardi cover everything with the enchanted tar and feathers of their style, dripping paint to run its own personal way, wavering along the hard edge of objects, burning in a mist of bright colour on some folds of drapery, and in a few rapid strokes creating the mirage-like landscape seen in the background.

This almost extravagantly coloured explosive technique is less obvious in pictures established as by Francesco Guardi, such as the altarpiece of *SS. Peter and Paul* (Ill. *68*), which dates from the 1770s, the decade after Tiepolo's death. Yet even here the dissolution of the rococo goes on, though with less pyrotechnic display. The setting is reduced to vapour which drifts across the slight suggestions of solitary pillar at the left. The saints seem scarcely more substantial than the vision they witness, and all the forms are delineated with a ragged, windy outline. Francesco was by that date hardly any longer concerned with the paint-

70 GIAN ANTONIO GUARDI *Tobias and the Angel (detail)*

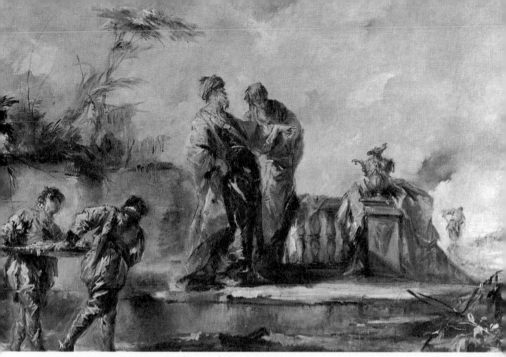

71 GIAN ANTONIO GUARDI *Tobias and the Angel (detail)*

ing of such subjects; he had created a personal style in which to interpret the topography of Venice, making it an insubstantial city washed by light and water, with its inhabitants reduced to tiny points of brilliance. What the Guardi had done to the imaginative world of Tiepolo, Francesco later did to the factual world built up by Canaletto. Living on until 1793, almost to the extinction of the Venetian Republic under Napoleon, he asserts a rococo freedom which is perhaps at its most daring in his very latest paintings and drawings.

It is the same point of no return which is marked in France by Fragonard's style. Like the Guardi, he used light and atmosphere to absorb people and objects until one is left with an airy, empty but still vibrating, surface; it is as if a conjuring trick had been played over some painting by Boucher, from which so much 'reality' has been abstracted. For both Fragonard and the Guardi, this is an escape from the discipline represented by Boucher and Tiepolo, but it is given an additional twist by Fragonard's knowledge and admiration of Tiepolo – the wilder genius anyway, but one become wilder and more romantic in Fragonard's interpretations of his compositions. Just as Veronese had provided Tiepolo

with material out of which to build his own fantasy, so Tiepolo stimulated Fragonard: to caprice interpretations of scenes like the *Banquet of Cleopatra* in which Venice is remembered as if in a dream.

Fragonard is a romantic rococo painter, inspired more perhaps by the picturesque aspects of nature than by people, who are usually dwarfed into insignificance beside the foaming trees which shoot up like great jets in his landscapes. When this Francesco Guardi-like diminution does not take place, Fragonard seems to produce a version of Gian Antonio's style, in which figures become mere arabesques of paint, animated but often faceless, tight balls of energy that shoot about the canvas under the impulse of his brush. In both styles they remain the painter's puppets, and one is always conscious of manipulation. Although capable of doing so, he is really too eager to stop and record natural appearances, actual textures, or facial expressions.

Titles like *The Washerwomen* (*Ill.73*) hardly prepare one for the steamy, sketchy composition where the eye has to search to find the washerwomen. In fact, Fragonard's subjects hardly matter, because he has a perennial subject in sheer erotic energy. Where Boucher restricted his to suitable themes for it, and otherwise painted with conscious sobriety, Fragonard is harnessed to this dynamo on all occasions. His landscapes are so many erotic curves where clouds mingle with the trees, foliage becomes frilly underwear, and fountains spurt uncontrollably. When he tackled the history picture – a rare occasion – it too was animated by love. The large *Corésus sacrificing himself to save Callirhoé* (*Ill. 72*), shown at the Salon of 1765, is Fragonard's effort to combine his own tendencies with academic requirements. It is not surprising that he exhibited there only once afterwards; this sort of machine was replaced by brilliant, witty decorations, positive riots of cupids and bathers, kissing lips and torn clothes, which always express love in action. The *Corésus* is negative love, sublime self-sacrifice, and in effect useless passion. Fragonard does his best to excite the composition, sending waves of smoky clouds and excited winged figures to fill the space between the two pillars not occupied by the strangely feminine priest and the swooning heroine – herself almost as if ravished by love. Perhaps hints from Boucher and Tiepolo (the *Sacrifice of Iphigenia, Ill. 57,* offers interesting comparison) worked on Fragonard to emulate the high style for which he was not suited. His genius lay in aiming lower, from an academic standpoint, in being more rational and natural – that is, by being more witty, mischievous, and relaxed.

But in 1765 this was not yet apparent, though perhaps suspected. The whole, high, rococo fabric was toppling. For a moment the painter of the *Corésus*

72 JEAN-HONORÉ FRAGONARD *Corésus sacrificing himself to save Callirhoé*

seemed the man who might keep it still upright. The picture itself was thought by Diderot to have attracted attention less by its own merits than by the need in France to find a successor to the established Carle van Loo and the supposedly promising Deshays, both of whom died that year. Boucher's talent had patently declined. Great painters, Diderot wrote in the same context, *'sont aujourd'hui fort rares en Italie'*, and the only person he could think of comparing with Fragonard was Mengs. At Venice, Gian Antonio Guardi was dead; Tiepolo was self-exiled in Spain; Pittoni, last of the generation of talented practitioners still in the city, was to die in 1768.

And, of course, Fragonard was not to develop into a buttress of the style represented by these artists. He was to go his own individual way, supporting neither the old grandiose world of myths nor the chaster, more 'modern', classicism of Vien. As a result, he almost disappears from history, much as he quickly

disappeared from the Salon exhibitions. Like his art, his life was free from restraints. He seems to have been indifferent about patronage, readily serving the dealers, private boudoirs, the Crown. Clearly he could have no attitude to, or use for, the historical subject. His mythology is flippantly unlearned – or learnt rather at the Opéra-Comique, where his nymphs have served their amorous apprenticeships. In many ways Fragonard is much closer to Watteau than to Boucher. His amused response to natural behaviour, and his piquant combination of topical genre with decoration, make him at the same time anticipatory of the Goya of the tapestry cartoons.

The real Fragonard is revealed not by the *Corésus* but by a masterpiece of some ten years later, the large *Fête at Saint-Cloud* (*Ill. 74*) where nature dominates the figures, and the huge trees are dominated by the spacious expanse of cloudy sky. Mankind may gesticulate and lounge, watching the theatre of

73 JEAN-HONORÉ FRAGONARD *The Washerwomen*

74 Jean-Honoré Fragonard *Fête at Saint-Cloud (detail)*

marionettes; but nature is growing all the while, assuming the giant proportions of these beautiful green and lemon-yellow trees, beside which mankind shrinks to marionette proportions. What set out to be a topical scene (as topical as some charlatan's booth in Piazza San Marco painted by Francesco Guardi) has become a wild poem about the strength of natural forces and puny man which is ready to take its place in the Romantic Movement. The same could be said of Guardi's late ruin pieces, with their Shelleyan-like response to the poetry of the lapsed wall or fragment of palace archway which 'Topples o'er the abandoned sea'.

That might serve as a metaphor for the rococo style itself: a palace of art which rising natural forces destroyed, and which was long to remain neglected and unvisited. It took more than a hundred years to reinstate Tiepolo and Boucher in the face of the reaction against them which their own century had produced. Like other monarchs of the period, they were overthrown by revolution.

119

75 Jean–Baptiste–Siméon Chardin *Vase of Flowers*

Natural Reactions

So far, the art of the eighteenth century has appeared as quite frankly eager to please. The rococo movement and Watteau equally seem concerned to carry out the dictum of Madame du Châtelet: 'We must begin by saying to ourselves that we have nothing else to do in the world but seek pleasant sensations and feelings.' Yet, from its earliest years, the century had other aims for art, whereby it could be harnessed to moral and educational purposes. Though some manifestations of this are apparent only in mid-century – in France with Diderot and Greuze, for example – the strong tendency had already shown itself long before in England, the country least sympathetic to rococo concepts, the least autocratic in its government but probably the most puritan, as well as protestant, in its attitude to art. As early as 1713 Shaftesbury, the pupil of Locke, had condemned, in painting and the other arts 'this *false Relish* which is govern'd rather by what immediately strikes the sense, than by what consequently and by reflection pleases the Mind, and satisfies the Thought and Reason'. The visual puritan streak in Shaftesbury was not content with expressing condemnation in those terms but seems to anticipate the feminine bias of the rococo as he goes on in reproof: 'So that whilst we look on Paintings with the same eye, as we view commonly the rich Stuffs and colour'd Silks worn by our Ladys, and admir'd in Dress, Equipage, or Furniture, we must of necessity be effeminate in our Taste, and utterly set wrong as to all Judgment and Knowledge in the kind.'

For Shaftesbury, the right type of painting was of an elevated masculine kind in subject as well as treatment. It was based on nature and true to human passions, but it observed truths of art, propriety and morality, and in its highest manifestations was historical rather than 'merely natural'. Just while the rococo is getting under way, Shaftesbury seems to call for, in effect, neo-classical art. That is the dignified alternative to the rococo. At the same time there existed an

76 WILLIAM HOGARTH
Marriage à la Mode:
The Countess's Morning Levée

art that is content with being natural and which, whether sentimental or satiric, is patently less aristocratic. Perhaps inevitably this art was fostered in England, the country which had had its political revolution before the eighteenth century began. It was connected with the rising middle classes who provided a new reading public, one that looked for literature and art to deal with the world it

knew. It produced the journalism of *The Tatler* and *The Spectator*, and it conditioned Hogarth. Not necessarily consciously anti-rococo, it was certainly opposed to the fictions of the high rococo painters. It is an art that is not easily summed up by a generalization but it was concerned with reflecting modern life, sometimes commenting upon it and always relating what is depicted to

what is known – ultimately as scientifically as in the work of Stubbs and Wright of Derby. Whether the truths it depicts are physical facts or the psychological facts of the human heart, it concentrates upon truth. The artist takes his place in society therefore not as ministering to its dreams of pleasure but as an educator. Art recovers a definite purpose, attaching itself to morality and science as it had earlier served religion.

Hogarth remains the most familiar painter in what became virtually a new category of picture. He was quite explicit about his aims and was tinged with a literary quality that strongly anticipates Greuze. Unlike Greuze, he did not attempt to write a novel but the narrative urge is quite clear in his concept of series of compositions; and in his friend Fielding he might be said to have vicarious existence as a novelist. Hogarth stated that he wanted to depict 'modern moral subjects' which were, he believed, writing about 1730, 'a field not broken up in any country or any age'. And even when every precedent in narrative series of engravings about the dangers of courtesans, or whatever, has been examined, Hogarth has a just claim to priority in his elaborate and often bitter topicality and the moral preoccupations of his drama. Just as much as any rococo painter, he thought of his picture as a miniature stage – but one on which should appear the ridiculousness of real men and women. In the actual theatre this revolution is associated with Gay's *Beggar's Opera* (first produced in 1729) which set out to satirize the conventions and high-flown heroics of that musical version of the rococo style, Italian opera. It was exactly by the standards of natural behaviour that the *castrati* and *prime donne* who so beautifully stormed and wept, and loved in vain, seemed increasingly ludicrous to a hard-headed age. The apology in the Prologue to Gay's opera is significant in its satire: 'I hope I may be forgiven that I have not made my Opera throughout unnatural.' It is convenient that Hogarth should have painted Macheath confronted by his two wives in a scene from *The Beggar's Opera* (*Ill. 77*) which includes the audience as well as the actors. Between them, Hogarth and Gay – with the addition of the utterly sober Richardson – created a climate which gradually extended all over literate Europe, touching the France of Diderot and Rousseau, Goldoni (and possibly Pietro Longhi) at Venice, Lessing and the whole *bürgerliche* movement of literature and art in Germany. Just at the mid-century comes Goldoni's *Pamela*; in 1755 Greuze first appeared at the Salon and Lessing published *Miss Sara Sampson*.

Well before this, Hogarth had moved from the contemporary theatrical life of *The Beggar's Opera* scene – among the first of his topical pictures in a career

77 WILLIAM HOGARTH *The Beggar's Opera*

that had begun with portraits and conversation pieces – to complete series of pictures of his own devising in subject, with an earnestness foreign to Gay. At least, it is presumably in earnest that he painted his famous series like *The Rake's Progress* and *Marriage à la mode* which have a cruel power of observation and a perhaps rather simple belief in humour as a method of reforming abuses. It is the optimistic programme of Fielding ('to laugh mankind out of their favourite follies and vices') but it remains resolutely unpsychological, inevitably confusing folly with foibles and seeming to discover the root of all evil in money. Even though the Rake ends in insanity and the married couple end prematurely dead, their lives have been shown as possessing an awful glamour. Object lessons in the dangers of hedonism, they have actually supplied Hogarth with the material he most enjoys.

(Above) 79 GIOVANNI BATTISTA PIAZZETTA *Boy holding a Banner*

(Left) 78 JEAN-JACQUES DURAMEAU *The Saltpetre Factory*

There is more gusto than disgust in Hogarth's depiction of the absurdities, vanities and toadyings of society (*Ills 76* and *80*); and his delight in elaborating detail, until each picture is a treasure-trove of minute allusions, reveals a Dickens-like fascination with what he set out to condemn.

Despite the modern dress of his stories, the moral they contain is both bourgeois and old-fashioned. Hogarth is against all extremes, those of riches and poverty, those of refinement and grossness; and it is not always easy to see which in his eyes is the more serious crime. The lessons he teaches are strangely negative; he was not even as successful as Greuze when he appealed to virtue. Effortlessly lively in depicting abuses, he became positively dull when showing good behaviour. He produced the companion series of the *Industrious Apprentice* to rival the *Idle Apprentice*, but neither his own age nor posterity has paid much attention to the platitudes of the former. Hogarth remains, perhaps too consciously, the spectator-cum-creator of a theatre of puppets. Destined for dreadful ends, to serve as moral examples, his people have none of that free play of irrationality – the licence just to *be* – which Goya gives to people. Hogarth is with those conservatives, of every period, who really believe that people can be better if they try, that it is only a matter of will-power.

Indeed, satire like his supposes a state of full rationality: on seeing how absurd our behaviour is, we will check it. In that sense Goya is not only liberal but pessimistic.

Hogarth's difficulty in devising anything attractively good to replace the abuses of society was the century's difficulty. Thus, far from being blind to the impending storm, pre-Revolutionary France was constantly applying and rejecting solutions to what was seen to be a dangerous situation. Hogarth proposes ridicule as the method of bringing people to their senses, but his own sense of the ridiculous extends far beyond any moral preoccupation. In his art foreigners are funny, and so are fashionable ladies and dancing-masters: and such targets have remained butts of middle-class English wit on the stage down to our own day. Ultimately, it is nature that Hogarth finds funny. To some extent, his moral purpose is a pinch of salt put into an art that claims the right to depict and comment on ordinary life.

It is the morality that is revolutionary, for the depiction of ordinary life had occupied sufficient painters during the previous century. And the tradition of such straightforward genre painting continued in the eighteenth century, sometimes tinged with a faint humour or pathos, but at its best when it held a completely dignified mirror up to nature as in the work of Piazzetta (*Ill. 79*) and

80 WILLIAM HOGARTH *The Rake's Progress: The Heir*

Chardin (*Ill. 89*). In them ordinary life is treated with all the seriousness previously reserved for history pictures, but it is significant that an artist like Piazzetta continued to paint altarpieces. There is no clear-cut opposition. Hogarth, Traversi, Pietro Longhi, all found themselves commissioned to execute the traditional type of religious picture, though it is hardly by such pictures that they are remembered. Greuze notoriously aspired to be a history painter, and it was a snub that the Académie inflicted in accepting him only as a painter of genre. Official hierarchies, and even unofficial ones, continued to rank the genre painter, like the topographical painter, on a low plane. The brilliant genre of Domenico Tiepolo seems to have brought him no fame at the time; and it is noticeable that his most inspired fresco decorations were reserved for the guest house, rather

81 GASPARE TRAVERSI *The Wounded Man*

than the villa, at Valmarana, and for the privacy of the Tiepolo family's own villa.

As a result of the 'official' attitude, which was prevalent throughout Europe, there remain subterranean aspects of the natural artistic reaction. It sometimes pushed up mysteriously, leaving little trace of who patronized it, and without anybody appearing to comment on it. This is particularly true of the Italian manifestations. Hogarth would probably have been surprised to learn that even there, in a country he doubtless thought of as the home of baroque history pictures, lurked an undercurrent of realistic painting – concerned not so much with our equals as with our inferiors. This tendency found little encouragement in Rome, but was present and partly traditional in Naples and in North Italy. Working in Naples and also in Rome, was Gaspare Traversi (*c.* 1732–69) whose

painting of *The Wounded Man (Ill. 81)* subordinates anecdote to a forceful actuality enhanced by the scale of the figures. As usual with him, they fill the composition to the exclusion of any setting; space not utilized for the central incident is occupied by other heads, set against a dark background, sometimes with the ironic disconcerting effect of the man's head at the extreme left here – so ostentatiously indifferent to what is happening centrally. Traversi points the whole picture with a flavour of irony: the incident is faintly absurd and undignified, the expressions on the faces hover on the caricatured, and there remains some ambiguity about the total effect.

The solid handling of the paint, which very carefully records not only details of costumes but also textures, and which has its own sense of weight, is typical too of genre in Northern Italy, where soberness of attitude replaces, however, Traversi's ironic attitude. The realism of Giacomo Ceruti (active 1720–50) is

82 GIACOMO CERUTI *The Peasant Family*

sometimes pungent to a displeasing extent: muddily coloured pictures of dwarfs and grotesques being a peculiar aspect of taste in Italy, resulting at its lowest in the horrible pictures of another Brescian artist, Bocchi, in which all the figures are rioting, diseased, amorous dwarfs. Ceruti is quite free from any tendency to make humorous capital out of the very humble subjects he depicts – as free as he is from sentimentality. The *Peasant Family* (*Ill. 82*) simply exist, barely composed into making a picture or a family unit. There is no suggestion of peasant life being anything but toil – toil that has imprinted itself in permanent fatigue upon these people so that they are hardly any longer personalities. They have become as lustreless as their clothes, with minds as empty as the interior they inhabit, dull with the dullness of exhaustion. Society has placed them in this environment and nothing hints that it will ever change. Ceruti depicts them without pleading for them, but the steadiness of eye which records this aspect of *la condition humaine* could not fail to make the owners of such pictures think – even if only of the dubious picturesqueness of being poor and tired.

Ceruti, though still inexplicable in many ways, was certainly not working against one current of the period, as becomes obvious in considering a much greater and always more famous painter, Giuseppe Maria Crespi (1665–1747). It was probably only at the beginning of the new century that Crespi broke away from the more dignified aspects of the Bolognese tradition and turned to painting the genre subjects which are his finest achievement. He was encouraged in his tacit rejection of the history picture by the patronage of the Grand Prince Ferdinand de' Medici at Florence, to whom his genre pictures apparently seemed amusing. Often they were indeed lively and unconventional enough, an effect increased by the fluent and lively handling of paint, but their sympathy for the humble lives they depict makes them in retrospect profoundly moving.

Crespi painted an interesting-sounding (but lost) narrative series concerning an opera-singer – perhaps significantly, for an English patron; and also a series of the Seven Sacraments, conceived not as part of Christ's ministry but as scenes of contemporary life, with the emphasis upon the humble condition of ministers and those ministered to. Though the pictures were destined for a Cardinal, their religious feeling seems much slighter than their humanity. None of the figures is splendid or awe-inspiring: there is the same simplicity of character, and as far as possible of vestments, in the bishop as in the plain priest. It is as if a sacrament were part of man's natural charity to man. The cycle of the human pilgrimage which Crespi traces has its inherent solemnity: from the proffered naked baby of *Baptism* (*Ill. 83*) to the expiring man of *Extreme Unction* (*Ill. 84*). No further

83 GIUSEPPE MARIA CRESPI *The Baptism*

84 GIUSEPPE MARIA CRESPI *Extreme Unction*

moral lesson is preached and no satiric point is made. Crespi's people are honest clay, clay-coloured, dressed in browns or black and cream, with the instinctive dignity of being involved in an important rite; there is no distraction from the main incident, no ogling of the spectator – instead, a tremendous sense simply of existence, and a tenderness in the painter's response to it. The result has a rare poetry. Far more concerned with catching the essence of life than with recording trivial details of costume, or setting or manners, and apparently indifferent to social rank, Crespi is constantly transcending genre to create a soberly enchanted world.

At its most picaresque it is seen in his group of *Musicians* (*Ill. 85*) which has a mysterious cloudy beauty that is found again only in his greatest pupil, Piazzetta. The musicians are like gipsies, exotic in their simplicity, having paused only temporarily, with a vague background of roaming and an uncertain future. In such a picture Crespi is much closer to Watteau than to Hogarth; it has a delicacy of mood which borders on the melancholy, suggesting a private climate far removed from ordinary life and a personal vision beyond influences and trends. It is not ultimately typical of anything except the nature that created it.

The same subdued nonconformism is apparent in Piazzetta – as unexpected a contemporary of Tiepolo's in some ways as Chardin is of Boucher. Just as much as Crespi, perhaps more, Piazzetta became an established figure; he was virtually the leading painter of Venice while he lived, respected, widely-commissioned but known to be a slow worker. His powerfully sculptural art is a rebuke to rococo characteristics, as is the restraint of his colour schemes. All the individualizing tendency of his altarpieces and religious pictures emerges quite openly in his genre paintings. They continue where Crespi left off, increasing the sense of mystery and detachment and effortlessly transcending the everyday aspect of things.

The *Boy holding a Banner* (*Ill. 79*) remains locked in a private dream, half dressed up, only playing at being a standard-bearer with a sheet wrapped round a pole, but absorbed in the pretence. Far from presenting an easily-recognized aspect of reality, Piazzetta has woven a romantic atmosphere, and a memorable one, about the quite simple subject; it is as if he had taken some acolyte from Crespi's *Seven Sacraments*, or even some peasant boy out of a Ceruti, and concentrated on portraying his mood in isolation. The picture is lonely but self-contained; it seems to require no spectator; it tells no story; and it may even claim, under the guise of genre, new freedom for the artist to indulge his own mood, oblivious of any client or patron.

85 GIUSEPPE
MARIA CRESPI
Musicians

86 GIOVANNI BATTISTA PIAZZETTA *Idyll on the Seashore*

Several mysteries surround Piazzetta's so-called *Idyll on the Seashore* (*Ill. 86*) where the subject is even more elusive. Perhaps there is some story, even satire, in it; yet it probably appeared merely naturalistic to its original owner, Marshal Schulenburg, who also owned several paintings by Ceruti. Piazzetta *is* naturalistic in his preference for people over types, and in his sympathy with plain,

countrified people – themselves somewhat uncouth, *'un peu berger'*. His people retain their feet on the ground; reserved, sullen almost, bovine – a point made apt by the unexpected cow's head poking into the picture – they are intensely real. But they do not correspond to any recognizable section of society; they are patently not at work, and far from being circumscribed by their environment, they exist in a bizarre, private realm of the imagination. All is timeless and un-topical, because of their vaguely fancy-dress clothes and the deliberate obscurity of their surroundings.

Much more comprehensible to his contemporaries, and truly typical of the century's interests, was Crespi's other Venetian pupil, Pietro Longhi. Without Lancret's charm or Hogarth's satiric bite, Longhi was closer to a tattling jour-nalist, observing life in Venice with mild, rather respectful, humour. Local patricians commissioned his little pictures which hold up to nature no more than a small handmirror, none too steadily, in which the more amiable surfaces of life are prettily reflected back. So many pages from an almanach, Longhi's pic-tures dutifully report the daily round of visits and coffee-drinking in patrician circles, and sewing and serving food in humbler milieux, and move out of doors to record carnival novelties – like the presence of a rhinoceros in Venice (*Ill. 87*). Manners are painted with a decorousness that becomes insipid; in most of the pictures nothing is happening and the figures are sometimes barely composed into any coherent relationship. Longhi's justification is not really by any artistic standard but through a comparatively new claim: that what he depicts is true. His pictures were not collected internationally as souvenirs of Venice, but must have hung on the walls of actual rooms similar to those he depicts: reassuring in their reflection and yet something of a revolution, at least in that city, by their simple realism. Goldoni was to hail him politely as a man 'looking for the truth', and Gasparo Gozzi, writing in the nearest equivalent of a newspaper in Venice, seems to have preferred Longhi to Tiepolo since the former painted 'what he sees with his own eyes'.

Yet this was welcome from advanced, somewhat isolated figures, more 'en-gaged' than Longhi himself. Goldoni left Venice for France and never returned. Neither Venice nor the rest of Italy was generally in sympathy with the revolu-tionary naturalism that was bound up in part with social revolution. England had successfully absorbed a revolution in the seventeenth century; Italy was to wait until the *Risorgimento* for its entry into the modern world, from which it was rapidly retreating during the eighteenth century. Goldoni's departure is a symbol. And it is symbolic that he chose Paris as his goal, though he was not

87 PIETRO LONGHI *The Rhinoceros*

to be particularly contented there. Here was a society in more ferment even than it seemed, but highly literate, sophisticated, and increasingly *bourgeois*. It was a climate that encouraged a public response to all the arts, and with the new phenomenon of Salon exhibitions, painting found itself confronted not only by an audience but by critics. One says critics but means Diderot. For in him there was fully expressed all the pent-up obsession with nature in art which others had only stumblingly formulated; and he had two artists to make his heroes in Chardin and Greuze.

Diderot could have no higher praise of a Chardin still-life than to say: '*C'est la nature même*.' And for him Chardin remained the great magician-painter whose canvases deceived the eye by their tremendous realism, down to the very textures of the objects painted. Such pictures kept the spectator completely within his own experience, and to some extent that is true of all the pictures painted by Chardin – including those genre scenes which were executed chiefly in the years before Diderot wrote of the Salons, but which are also in their way still-lives. Neither category of picture was novel, and Chardin might seem merely to be practising what had been among the most typical products of Dutch seventeenth-century painting. And yet there is an ideal aspect of Chardin's art, so selective and elevated is it, and by no means as preoccupied by natural appearances as Diderot believed. Compared with Hogarth and Longhi, Chardin is less anecdotal and more dignified, and utterly free from any wish to be satiric about the scenes he depicts. Indeed, his view of society is perhaps the most seriously optimistic produced by eighteenth-century art; he is typical in putting emphasis on the powers of education, but he has done this so discreetly that the point is sometimes missed. It was not missed, however, at the period. We should temporarily forget Diderot, and turn instead to the verses which the engraver, Lépicié, put under his engraving of *La Mère laborieuse* in 1740 and which the *Mercure de France* found expressive of the whole picture. They address themselves to the girl being trained by her mother:

> *Et goûtés cette vérité*
> *Que le travail et la sagesse*
> *Valent les biens et la beauté.*

Chardin's work contains, in every sense of the word, a moral: the importance of truth, the necessity for strict guidance of children, the dignity of labour. He never weakens his art by explicit statement of such things; they are the essential fibre out of which it grows, and everything we know suggests that they were

88 JEAN-BAPTISTE-SIMÉON CHARDIN *La Fontaine*

his own beliefs. The public understood him instinctively and probably always preferred his genre scenes to his still-lives. His Salon appearances were – especially in the years before Greuze arrived – outstandingly successful. Mariette, a little sour from the realization that Italy and the high style of art were dropping from favour, might speak of the appeal to '*le gros public*' with its preference for pictures of daily life as it could be in their own homes; but Chardin cut across any class. The actual purchasers of his pictures were bankers or great foreign ambassadors like the Prince of Liechtenstein, and two of his finest genre scenes were owned by Louis XV. At the same time, through the medium of engraving,

his work could pass into the hands of '*le gros public*' itself. In apparently mirroring the simplest aspects of the most ordinary lives, Chardin appealed to everybody. The emphasis was not on humour, nor on anything even faintly erotic. For all the bandying about of comparisons with Teniers, there were no inn scenes, nor feasts, nor drunken peasants. Absolute decorum, an almost intellectual as well as emotional decorum, controls the subjects. The emphasis is on humanity – yet despite the realism, it is less humanity as it is and more as it would like to be.

Chardin's career started with a large and untypical, dramatic, genre scene – known to the Goncourt brothers but destroyed at the Commune – which showed a barber-surgeon aiding a man wounded in a duel. It had been painted for a barber-surgeon, to serve as a signboard outside his premises, and it is thus comparable to the *enseigne* which Watteau had painted for Gersaint. There Watteau had at last brought his people in from countryfied open-air settings and collected them in an urban environment. Chardin began with a Parisian street scene, but his later genre pictures carry us indoors into much more intimate, and less animated, scenes. Already in *La Fontaine* (*Ill. 88*), exhibited in one version or another at Chardin's first Salon of 1733, all the recognizable aspects of his world are present. The moment depicted is utterly commonplace: a woman drawing water from a copper cistern. Although other figures are visible in the background, the first impression is of a single figure, on which the eye concentrates even while she concentrates on her task. Such concentration is typical of Chardin; even when the subject is a boy idly building a card house, or blowing bubbles, there is an intentness that lifts the trivial pastime into an occupation. Unlike Greuze, Chardin never allows his people to ogle the spectator, to *act* the housemaid or village girl; they are absorbed, absorbed almost literally in the wonderful paint surface which seems to express integrity by the very oil medium.

There never was such a perfect world as Chardin's; and in its way it is as enchanted, and as delimited, as Piazzetta's. It is a puritan, perhaps almost more truly Quaker, life that is depicted in simple, windowless rooms, dark and sheltered domestic interiors in which nothing more is happening than the preparing or serving of frugal meals, the education or amusement of children. The appeal is in the restriction: an emphasis on plain living and clean linen – linen, not silk. There is humbleness without poverty. Above all, everything indicates industry. The few possessions are polished and harmoniously arranged; the plain-coloured clothes are cared for, neatly worn. Gravity is present not only in the mood, but in the sense of each object finding its own place in the scheme of things. And

89 JEAN-BAPTISTE-SIMÉON CHARDIN *La Toilette du Matin*

objects are as important as people: they coexist, so that the copper cistern is no mere prop but is as fully realized, as measured and plotted, as the girl who bends at it.

In all this there is rebuke, if no more than a tacit one, to rococo sensations. A cold bath of purity replaces the heady hot-house languor of Boucher. Those tendencies for everything to shimmer, melt, dissolve – for art to hover on the point of orgasm – are counteracted by chastity: chaste draughtsmanship and chaste activity. Women remain the chief subject, but treated as household managers and mothers; girls are firmly put back into a domestic environment, often shown assuming maternal responsibilities. Chardin's technique is equally in opposition to rococo fluidity. Like Piazzetta again, he was a slow worker. His father had been a carpenter and there is something almost of joinery in Chardin's tiny slabs and slices of saturated paint which are, as it were, assembled and slotted into place in the composition.

All Chardin's achievement as a genre painter is concentrated in *La Toilette du Matin* (*Ill. 89*), of which the title taken in isolation would suggest some gallant if not erotic treatment of a popular boudoir theme. But Chardin's is maternal once more, the preparation for attendance at church, with the faintest hint of coquetry (seized on by contemporary critics) in the child's glance into the mirror while her mother adjusts her cap. It may be charming, but it is also much more than charming. There is austerity in the air: from the cold early morning light to the austerely plotted design with its firm triangle of the two figures giving a sense of permanence which the clotted, viscous, paint enhances. The mother's striped skirt might be marquetry work, so inlaid do its colours seem; in the original a small area, perhaps no more than half an inch, is occupied by the muff lying on the chair – and Chardin has found a quite unexpected, elusive tone for it, pigeon-blue, slate-blue, set off by a minute edging of grey fur. This picture was bought by the Swedish courtier, Tessin, who also owned, with no sense of discrepancy, Boucher's marvellous *Birth of Venus* (*Ill. 62*). The two pictures perhaps symbolize less different tastes than different aims. Chardin refers us back to ordinary experience, concentrating it with almost microscopic intensity, tingeing it with the hint of the moral and educative, yet still not telling any specific story. There is almost nothing left to say of the picture than that significant praise addressed to its creator after it had been exhibited in 1741 at the Salon: '*ta main en fait une réalité*'.

Chardin's still-lives, perhaps nowadays more in vogue than his genre pictures, are equally a part of natural reactions. They themselves moved from the early

90 JEAN-BAPTISTE-SIMÉON CHARDIN *The Skate*

Skate (*Ill. 90*), a drama and an anecdote (as well as shockingly raw reality, which is almost the equivalent of the lost barber-surgeon's sign) towards a much more austere and less littered type of composition. Absolute timelessness is achieved in the *Vase of Flowers* (*Ill. 75*), with a simplicity of arrangement, combined with intensity, that makes Van Huysum quite rococo in his elaborations. Indeed, it is natural enough to make Fantin-Latour seem artificial. Beautiful though it is, it remains a unique picture even for Chardin; his still-lives preferred to suggest, though no more than suggest, the not distant presence of humanity. Perhaps it could be claimed that the flowers adumbrate their arranger, but much more strongly and consciously evocative of people is a still-life like the *Pipe*

145

91 JEAN-BAPTISTE-SIMÉON CHARDIN *Pipe and Jug*

and Jug (Ill. 91). Here it is the very essence of the objects that matters. For all Diderot's praise, Chardin is not obsessed with surface appearances but with what lies beneath. Yet the objects themselves are deliberately homely; they are possible possessions for anyone and, like Chardin's people, they suggest use. At their richest they are comparatively poor; the utensils are more often those of kitchen than dining-room; and they form in fact a logical extension of the lives that Chardin's genre pictures depict.

Diderot seems never to have made any specific comment on those Parisian domestic interiors that should, one might suppose, have embodied for him art at its finest. Perhaps they were too austere, too elevated, too self-contained, to appeal to him. They resolutely refuse to appeal. It was in Greuze that Diderot

92 JEAN-BAPTISTE GREUZE *The Morning Prayer*

93 JEAN-BAPTISTE GREUZE *L'Accordée de Village*

found the appealing painter of genre, one who increased his popularity by taking his scenes out into villages and emphasizing the humble rank of his actors. The rustic fallacy was only one chord of falseness played on by Greuze. Anything that might have been a hint in Chardin – such as the church-going of *La Toilette* – becomes in Greuze an over-stated illustration: we must now witness *The Morning Prayer* (*Ill. 92*), and those countless anecdotes with doves and broken mirrors in all of which there is a confused appeal to sentimentality and a lack of confidence in art that is unsupported by narrative. Greuze made the naïve mistake, from which no amount of special pleading will excuse him, of supposing that a moving anecdote will make a moving work of art. He begot a fearful progeny of nineteenth-century academic work throughout Europe from which came nothing except the problem picture. That he was quite capable of appre-

148

hending and conveying reality is shown by his often excellent portraits, but he wished to make some more striking contribution to art. He did indeed succeed in expressing something of the spirit of his age; he spoke the new language, as foreign to Chardin as to Boucher, of the heart.

Greuze is a perfectly convenient phenomenon, with his own life as a lesson in moral retribution. Arrived on the artistic scene in 1755, he perhaps reached his greatest popularity with *L'Accordée de Village* (Ill. *93*), shown at the Salon of 1761, the year that Rousseau published *La Nouvelle Héloïse*. He went on to make, instinctively, the connection between *la peinture morale* in genre scenes and in history pictures, producing an essential fusion of the two in 1769 with *Septimius Severus and Caracalla* (Ill. *94*) – a picture whose chief fault was its prematureness. Had d'Angiviller been at the head of the Bâtiments in 1769, he would probably have made the Académie accept Greuze as a history painter. Though the Revolution ruined Greuze, he lived through it. Perhaps the last person to record seeing

94 JEAN-BAPTISTE GREUZE *Septimius Severus and Caracalla*

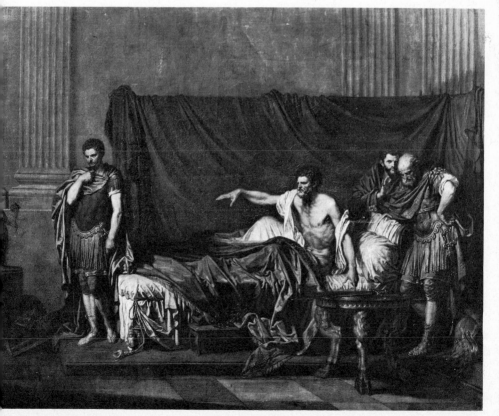

him was Farington in 1802, confronted by an old man who seemed no more than a piece of *ancien régime* flotsam: '... saw Gréuze [*sic*], formerly an Artist of very great reputation'.

The importance of Greuze is historical rather than artistic. He is one of those painters whose impetus seems public, not private; he can almost be compared with a best-selling novelist, so literary were his interests and so conscious his angling for an audience, even to the point, for instance, of paying written tribute to the parish priests of France for having inspired his composition of *La Veuve et son curé*. Such activity is tribute to the revolution Greuze represented: the urge for painting to affect people, to tell a psychological story in a deliberately narrative way (Greuze conceived a series which should number more than twenty pictures with a Balzacian plot of two entwined lives). It had long been apparent that the painting of falsehoods must be destroyed; pictures which simply depicted truth might not be sufficiently affecting and elevating. Boucher was doomed; Teniers was inclined to be coarse. There remained nature as seen by Greuze: seen and re-arranged, preserving women as the central theme, not omitting to titillate even while posing as virtuous. When Diderot compared Teniers with Greuze, it was inevitably in the latter that he found '*plus d'élégance, plus de grâce, une nature plus agréable...*'

This is some way towards admitting that the truths of Greuze have been softened and sweetened. The resulting art might have been defended, should it even have needed defence, because it mixed sentiment with virtue, flattered the spectator by depicting scenes like *L'Accordée de Village*, where emotion runs riot through the composition – leaving no one untouched. If Greuze had been asked why he concentrated on rustic life, he could have answered in the words of the Preface to *Lyrical Ballads*: 'because in that condition the essential passions of the heart find a better soil in which they can attain their maturity'. The picture is sensibility's revenge upon so much sense in the first fifty years of the century. It sobs of the natural goodness of peasants, no longer needing to have virtue inculcated because they enshrine it; it not only assembles a whole family to make its emotional point but also enlists the natural illustration of a hen and her chicks. There is deliberate flight from reason and intellect; it is now sufficient that we should *feel*. And Greuze was soon aware of further ways to set the emotions stirring. Rousseau had made splendid use of the deathbed in *La Nouvelle Héloïse*; Greuze's *Piété filiale* (*Ill. 95*) ingeniously adds a last twist by the addition of paralysis to death, and at the Salon of 1763 managed to reduce spectators to tears. Diderot remarked, with admiration, the varying nuances of grief on

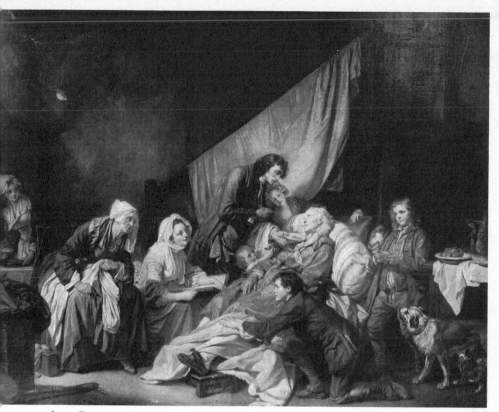

95 JEAN-BAPTISTE GREUZE *La Piété filiale*

each face in the picture, worked out the various relationships of the characters to the stricken man, and was so enthusiastic that it is not very surprising that a reaction followed. Something of the grey monotony of Greuze's technique had perhaps secretly always worried him. Greuze's adept acceptance of all morality, the Church's as well as natural man's, probably offended him – and he, like others of their contemporaries, came to detect some licentiousness even in the midst of Greuze's most virtuous-seeming subjects. There is a wide application to the remark of Rousseau's Julie on her deathbed: '*On m'a fait boire jusqu'à la lie la coupe amère et douce de la sensibilité.*'

Greuze's pictures offered a comforting solution to some of the century's problems. They assured everyone that cottages contained the cleanest of peasants, untroubled by toil or poverty, transparent vessels for the most tender of emotions, and with no thought of revolution, being occupied weeping at deathbeds,

explaining the Bible to their children, or tearfully becoming engaged. *L'Accordée de Village* could perhaps hardly have appealed to Louis XV, who was to reject Cochin's scheme for surrounding him with instructive examples of antique morality, but it was to be acquired for the Crown under Louis XVI. Life too almost caught up with Greuze when, the year before coming to the throne, Marie-Antoinette performed her 'generous deed' of comforting the family of a peasant wounded by a royal stag – and artists hurried to record the unusual moment of condescension and sensibility.

It was perhaps a miscalculation by the normally shrewd Greuze to take for his antique historical essay such an obscure subject as Septimius Severus rebuking his son Caracalla for an attempt in Scotland on his life. The appeal to the heart was less obvious than usual; certainly the subject is moral and the picture might well have been entitled *La Malédiction paternelle,* but it is almost violently severe, masculine and unyielding after Greuze's sweetened, rural genre. Few people, even in an age of strong emotional outbursts, could have been moved by the incident. The public were not yet prepared for such high dramas of imperial Roman history and could make no application of it to their own lives. Although often enough criticized since its first poor reception, the picture is certainly as good as many other more applauded paintings by Greuze and probably better than many neo-classical canvases that were soon to follow it. Greuze recognized the importance of the history picture, but he painted his within Boucher's lifetime and before David had emerged. Had he taken as subject some distressed classical heroine, he might have succeeded in pleasing the world pleased by the women of Vien. It is significant that when he was attacked – and replied – it was the standards of Poussin that were evoked. To the criticism that Poussin would have produced a sublime picture of Septimius Severus, Greuze humbly replied that he had made careful study of Poussin's style. *Poussinisme* was returning. Five years later, with Louis XVI on the throne and d'Angiviller Directeur des Bâtiments, official commissions were to concentrate on ancient and modern history pictures, 'suitable', in d'Angiviller's own words, 'to re-awake virtue and patriotic sentiment'. What Cochin had vainly urged on the ageing Louis XV thus became royal policy.

This was only one expression of the now quite patent determination to make art connect with life. While ambitious projects were everywhere being conceived to reproduce the truths of especially classical antiquity, there still remained the truths of the period itself – and not merely in the peasant genre aspect exemplified by Greuze. The century's achievements deserved their place in art: the

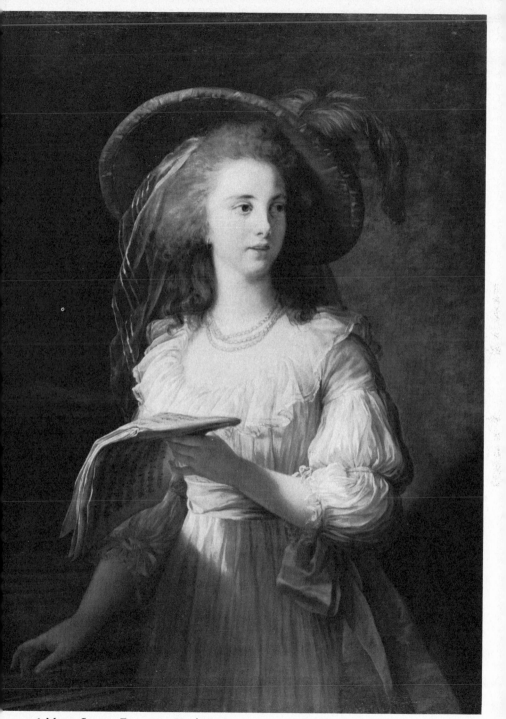

96 MARIE-LOUISE-ELIZABETH VIGÉE-LEBRUN *Princesse de Polignac*

philosophical, scientific, industrial advances which had been made through fresh study of nature. Naturalness, which was not at all a discovery of Rousseau's but which he had made into a doctrine, was really the century's last burst of optimism. At the emotional extreme it found Madame Vigée-Lebrun, who gave it *chic*, and confused simplicity in dress with goodness of heart. Ravished by the charm of her own appearance, and hardly able to paint a male sitter, Vigée-Lebrun continued the century's cult of women. By removing any suggestions of intelligence (naturally) as if it had been rouge, she created the limpid, fashionably artless portrait, of which the *Princesse de Polignac* (*Ill. 96*) is a brilliant example. The Princess, close friend of Marie-Antoinette, naïvely rehearses a song, in contrast to Nattier's women who were already competent – themselves sometimes Muses – before they were portrayed, and Boucher's *Madame de Pompadour* (*Ill. 63*) who had left singing to the bird. The Princesse de Polignac claims to be just like us – an amiable but unconvincing claim. In Vigée-Lebrun we have the last view of eighteenth-century woman – who had begun as a goddess, became a courtesan, and now ended all heart – before Napoleon and War banish her from the centre of events.

More interesting is the intellectual extreme, represented by several painters for whom Erasmus Darwin spoke to some extent when he claimed to '*inlist the Imagination under the banner of Science*' (his italics). This was the intention of his *Botanic Garden* as proclaimed in the preface of 1791. Nature by itself was not sufficient for him, because he aimed at artistic novelty. He might have applauded, had he ever known, the allegorical expression by Januarius Zick (1730–97) of the century's indebtedness to Newton (*Ill. 97*). Though the means whereby this is conveyed are traditional pictorial rhetoric, the person celebrated is one of the eighteenth century's most cherished lawgivers, who had replaced fantasy by new and exciting facts. Newton's theories were true and relevant, especially to painters. And Zick, trained first in Paris and then under Mengs, pays his faintly confused tribute to intellectual and scientific truth. In a more direct way, tribute was to be paid to the revolution achieved by science when applied to industry, and for the first time industry – in contradistinction to rural labour – provided the subject-matter for painters all over Europe.

Long before Ford Madox Brown devised *Work*, and with much less contrivance, painters like the Swedish Pehr Hilleström (1732–1816) and the Belgian Léonard Défrance (1735–1805) had seized on the industrial, working, aspects of modern society. The *Saltpetre Factory* (*Ill. 78*) by Jean-Jacques Durameau (1733–96) was exhibited as early as 1767 at the Salon, where unsurprisingly it

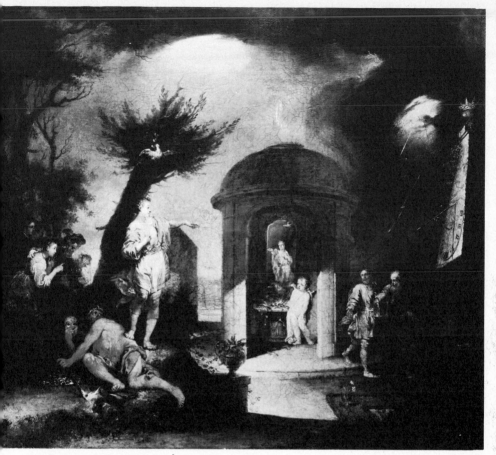

97 JANUARIUS ZICK *Newton's Service to Optics (?)*

appealed to Diderot. Here man is dwarfed by the machinery he has made; and it is in a great smoky cauldron of atmosphere that small figures stir and heave the tubs of burning, nitrous substance. The romantic tendency to reduce the role of mankind can be detected here, just as in the very different work of Guardi and Fragonard.

Nature is more than man and his environment; there is a universe unshaped by him but all the more attractive to him for this reason – not only its appearance but its creatures. It was not the animal piece as such which was new, but the conviction and scientific passion given to it by Stubbs. The views of Stubbs are exactly what we might deduce from his pictures. He travelled to Italy in 1754, not with any Winckelmann-like anxiety to experience the marvels of antiquity,

98 GEORGE STUBBS *Green Monkey*

99 JEAN-BAPTISTE OUDRY *Terrace with Dogs and Dead Game*

but instead to convince himself that 'nature was and always is superior to Art, whether Greek or Roman…'. Nor did he mean by nature the decorative animal pictures of Oudry (*Ill. 99*) which are almost Nattier-style interpretations, never forgetting the court and the menagerie, usually with echoes of the chase. Oudry's rococo foliage, guns and dead game, hints of cage bars, give way to suggestions of natural environment which make all the more marvellous Stubbs' *Green Monkey* (*Ill. 98*), painted only just within the century, in 1798.

Oudry continues a tradition of the hunting picture, tailoring his effects with one eye on a royal sportsman, Louis XV, for whom so much of his work was painted. Stubbs is impelled by more scientific interests; when he has a patron at all it is someone like Dr Hunter (not accidentally, the owner of some Chardin genre scenes). The *Green Monkey* is yet more personal, probably painted for himself and certainly remaining on his hands. It sets the monkey before us with

100 GEORGE STUBBS *Leopards*

dispassionate observation and innate dignity – no frolicking pet with collar and chain but alone in a strange, dark wood lit by nothing more than the orange globes of fruit. Though inevitably one thinks of horses in connection with Stubbs, he was equally attracted to the exotic animal, shown not merely untamed but often positively, ferociously, wild. Wordsworth and Coleridge may be content with simple passions in ordinary rustic surroundings, but Stubbs responds to an animal kingdom which exults in a wider freedom, adumbrating

life without mankind. If the feeling is romantic, the vision yet remains utterly truthful and natural (*Ill. 100*), and the actual paint is applied with Chardinesque sobriety. Leopards and monkeys are more relevant than anything produced by Greece or Rome: they are real, and thus worthy subjects for art as much as for scientific study. In Stubbs the two are blended – most obviously in his work on the anatomy of the horse – and art has come back to its Renaissance purpose of instructing us about the world in which we live.

101 JOSEPH WRIGHT *Arkwright's Mill*

Like Stubbs, Joseph Wright went to Italy; and like him, he was more interested in its natural effects than its art. It is apt that he should be known as Wright of Derby, for it was there that he was to find pioneers of science and industry – men like Priestley and Wedgwood – who provided him with subject-matter and with patrons. His is a provincial milieu, with serious rather than sophisticated interests, more doggedly *bourgeois* than the capital, and still optimistic about the benefits of progress. As Hogarth had been the initiator of *la peinture morale*, so Wright was the initiator, and the finest exponent, of the century's final contribution to genre: the industrial picture, where the mills are not yet dark and satanic but blaze out hopefully in the night (*Ill. 101*). Magic effects of light – artificial and natural – and darkness, combined with a sense of nature rustling, never

still, increase the powerful effect of the *Earth-stopper* (*Ill. 102*), eerie countrified genre which is more pungent than Rousseau and anticipates some sinister nineteenth-century story. The lonely digging figure in the moonlight, with a gaunt tree near by, might well be engaged on a nastier job, even, than stopping a fox's earth.

In one picture Wright united science and sensibility: the *Experiment with an Air-pump* (*Ill. 103*), painted in 1768. This picture was exhibited in London at the time, but could have been exhibited anywhere in Europe, representing what advanced opinion looked for in art. Voltaire and Diderot and Goethe would have found much to praise in this dramatic night scene of a family watching – with a variety of reactions – an experiment perhaps necessary but cruel. The litter of scientific apparatus is carefully recorded; an air-pump itself was to

102 JOSEPH WRIGHT *The Earth-stopper*

103 JOSEPH WRIGHT *The Experiment with an Air-pump*

remain a piece of amateur equipment which any curious student might own and, typically, Shelley had one in his Oxford rooms. At the centre is the glass globe containing the dove that must die as the air is sucked out and a vacuum formed; and this knowledge makes the two girls cling sadly together, with un-exaggerated sensibility that is yet in contrast to the boy's cheerful indifference. Extremes of youth and age are collected about the shadowy table. The picture is a *tableau* of life and, perhaps also, education. It is a hard picture, hard in its paint surface and in its moral. Only the pensive seated man at the right, who has taken off his glasses and has his eyes turned from the experiment, seems to reflect on the whole incident. Though some ambiguity is present, the picture ultimately subsumes a rich number of the century's favourite themes. It is 'modern' and scientific, even while grouping people around an anecdote; it shows us neither rococo superiors nor rustic inferiors but prosperous *bourgeois* in a handsome

room – the very mirror of Wright's friends and patrons. It is fully natural, touching the emotions as well as the intellect. Not only is it scientific in its central incident, but light is painted scientifically in it – and the picture is a virtuoso display of glass and brass, polished wood, and cloudy moonlit sky through the window, which makes a palpitatingly real atmosphere within which the figures express each a different, psychologically subtle, response.

The work of Wright and Stubbs was not known out of England. It contributed directly to no new movement, but it expresses the triumphant breakthrough of nature into art which had so long been the century's aim. Perhaps it points also to a less social aim than had been Hogarth's, or Chardin's – or even Greuze's; it hints at the artist fleeing from society into moonlit landscapes and dark jungles. But its chief obsession is with truth and knowledge. These standards could also guide the history picture. Not many painters went to Italy in the cavalier spirit of Stubbs and Wright. Truth and knowledge seemed overpoweringly present in Rome, and there an international movement, comparable to the artistic events of the seventeenth century, created a 'natural' view of antiquity which became neo-classicism.

Nature and the Antique

It might be thought that the painters discussed in the previous chapter had, in their different ways, all obeyed the century's dictum and followed nature. The truths so patently lacking in rococo art were present in their work: they spoke to the heart or to the mind, mirrored society and made some comment on it. But their truth was soon seen to be not true enough. It was local rather than universal: it was what Shaftesbury had called '*the merely natural*'; it led back to the shallows of Dutch art. Thus it became necessary to ask what is the 'true imitation of nature'? The answer was given most publicly in 1755 when there appeared Winckelmann's *Gedanken über die Nachahmung der griechischen Werke in der Malerei und Bildhauerkunst*. It does not matter that the views expressed there were not altogether novel; and much of what Winckelmann said had been practised by artists long before. But he codified in effect the aspirations of the century to produce great art, and encouraged its lingering tendency to rely on tradition. It is in the Greeks that we find great art, and by imitating them the 'true imitation of nature' will be reached. The quarrel of *Rubénistes* and *Poussinistes* seemed to be fought again, and lost by the *Rubénistes*, when Winckelmann remarked simply that Rubens never approached Greek proportions; it was sufficient condemnation.

Although Winckelmann's book was published at Dresden, its spiritual place of publication was – not Athens, but Rome. Throughout the century travellers had been hurrying there, bringing nature with them and then modifying it in the environment of the greatest surviving city of the past. The most dramatic of all conversions is also the one most relevant here. More fascinating than Napoleon's crossing of the Alps is that by the young Jacques-Louis David, brought in the baggage of the painter Vien, coming down to what might almost be called his birthright. The century had been waiting a long time for a truly moral artist,

165

104 ANTON RAPHAEL MENGS *Cleopatra before Octavius*

a regenerator, a patriot, a great painter who was also an admirer of the antique. That David's revolutionary qualities should not be only artistic but also political is part of the price that the century had to pay; it was the opposite extreme from the uncommitted yet *serviable* nature of the rococo. So much eighteenth-century art lacked a cutting edge? David answered with the guillotine.

David had set out for Rome determined not to be seduced by the antique. It was in a very different spirit that most people went there, and the synthesis which was so much desired is conveniently expressed in the portrait, carefully devised by Tischbein, of *Goethe in the Campagna* (*Ill. 105*). This key picture enshrines the optimistic late-eighteenth-century world where nature and antiquity harmonize into a new creed, fused from the teachings of Rousseau and Winckelmann. Goethe is seen relaxed, almost negligently posed, at the centre of an open-air, natural world which also belongs to antiquity. The mood is more profound than that in Batoni's portraits, where Grand Tour sitters jostle an antique urn or gaze at a bronze bust – very much tourists sightseeing. Tischbein takes Goethe out of the city, and tinges his portrait with romantic response to the lapsed and grass-grown monuments of the Campagna, suggesting informality and communication at the same time. It expresses the successful outcome of a long hoped-for pilgrimage. Goethe becomes almost a natural growth, rooted to the stone he reclines on, absorbing atmosphere. The calm of the ancients becomes his calm, while he yet remains a modern man, whose interests are symbolized by the accurately delineated plants as much as by the bas-relief. He seems a new-style hero, priest almost of a new cult, with the wisdom of Sarastro and the experience of Tamino. Tischbein finished the picture in 1787; two years later came the French Revolution.

The Revolution was the drastic moral regeneration in real life represented in art by the neo-classical movement. What distinguishes the neo-classic from other eighteenth-century artistic currents is the earnestness of its adherents. An ethic rather than a religion, it tacitly or openly challenged Christianity and replaced its sluggish observances with a fiery inspiration which swept like a last Crusade through Europe. And underneath its most ridiculous manifestations and claims, there was the solid structure of fact: the fact of Rome and the exciting facts newly unearthed at Herculaneum and Pompeii, the marbles and terracottas, temples and houses, which all had the primary value of existing, of being true, and the secondary one of being beautiful. That wonderful world had set up its own standards, without the aid of Christ or the Virgin, and there was sufficient harshness in them to appeal to an age consciously anxious to reform. Where the

105 JOHANN HEINRICH WILHELM TISCHBEIN *Goethe in the Campagna*

rococo had implied a life of leisure, the neo-classic promised hard work, discipline, and sacrifices at which even human blood might excitingly flow. The neo-classic represents the triumph of the corpse in art; and what begins as past history culminates in the actuality of *Marat assassinated* (*Ill. 125*).

It is a sign of the basic reformist principle of the neo-classic that even Vien should claim – in an extraordinary letter-*cum*-petition written during the Revolution – to have been the great regenerator of the French School. When he returned to Paris from Rome in 1750, so he claimed, he set out to stem the tide of '*mauvais goût qui menaçait l'industrie nationale*'. To his pupils he offered the proper guide of nature, and this saved French art. It is of course true that both David and Vincent studied under him; and it is probably also true that he may have had some effect on the minor decorative arts – more significantly perhaps than on painting. What Vien really shows is how fashionable the neo-classic was

106 JOSEPH VIEN
Greek Girl at the Bath

becoming by 1750. In artistic stature less a forerunner than a footman, Vien made a successful career by stripping off the rococo apparatus and substituting the gauzy decencies of neo-classicism, while all the time preserving an erotic element beneath. He might claim to be a revolution in himself; for it, however, he was equipped not with a gun but a scent-spray.

Not in fact by him but by his younger contemporary, Jean-Simon Berthélemy, is the *Apollo with the body of Sarpedon* (*Ill. 107*), a semi-baroque, neoclassic picture more typical and more vigorous than the work by Vien. Advised by the Comte de Caylus and praised by Diderot (two men with no love for each other), Vien was hardly more antique or severe than had been François Le Moyne. The latter's *Baigneuse* (*Ill. 24*) is a unlearned anticipation of what Vien was to conceive but spice with fashionable classical accessories: Vien's *Greek Girl at the Bath* (*Ill. 106*) is in fact a good deal more insipid than Le Moyne's girl, and yet it was a famous picture in late-eighteenth-century

107 JEAN-SIMON BERTHÉLEMY *Apollo with the body of Sarpedon*

Paris. The cruel truth is that it is neither natural nor antique; it is *chic* and pretty and no more robust than most of Vien's over-refined art. Simplified compositions suited him and kept him within the limits of his talent. He could hardly excite the patriotic virtues or preach elevated moral lessons, but that did not make his work less welcome. Besides, he said that he constantly talked of nature and antiquity, electrifying his pupils. The electricity which passed to David had certainly deserted Vien, who kept going on a watery diet of sentimentalized love: love in the hearts of young girls, or love for sale in the Pompeiian pastiche – both in subject and style – of *The Merchant of Loves* (*Ill. 108*). This is closer to Josephine at Malmaison than to anything Greek; it is a suitably muted, genteelly decorous appeal to what Vien probably called the softer passions, and thus keeps alive the French tradition which runs from Le Moyne to Prud'hon.

Nevertheless, Vien had changed his style drastically to achieve the emasculated charm and too simple bas-relief composition of this picture. His early pictures show him as thoroughly baroque (a tendency apparent again in the *Apotheosis*). The influence of Caylus was even stronger than had been his Roman experiences in revealing to him the new direction art was taking. Yet it is to Rome that one must constantly return, for it had largely remained aloof from the rococo and continued its eternal function of forming, but seldom producing, painters. It did not in itself make an artist neo-classical (and the contemporary careers of the sculptors Bouchardon and Adam neatly reveal its two facets); it had successfully housed Bernini as well as Poussin. But once the standard of truth is set up – truth related to antiquity – then Rome belongs to Poussin; and before him to Raphael. Severity, chastity of draughtsmanship (preference for line over colour), elevated sentiment, Rome stands for all such reforming discipline: literally a school where the artist will be educated and improved, a public school of manly attitudes, with hints of the cold bath and the cane.

It is possible to show that stylistically there is no single initiator of the eighteenth-century antique movement in painting because at Rome the tradition of classicism had never died out. A style of somewhat insipid classicism was carried on by Carlo Maratti who lived until 1713. His fame and popularity extended far beyond Rome. He is rather typically neo-classic in being more gifted as a portrait painter than as painter of subject pictures. His late work is virtually neo-classic in everything except subject. Winckelmann, who rarely mentioned any painter other than Mengs, could praise Maratti's draperies; and Maratti's *Apollo and Marchese Pallavicini* (*Ill. 109*) was to be hung with a pendant painted most suitably by Mengs himself – the *Cleopatra before Octavius* (*Ill. 104*).

108 JOSEPH VIEN *The Merchant of Loves*

The sources of Maratti's style lie in Raphael, who was so often to serve instead
of any direct use of antique monuments, or antique painting, as part of the
general return to classicism. Many so-called neo-classic pictures betray borrow-
ings from several non-antique sources and even utilize the odd baroque motif in
composition. The general effect of Roman painting at the mid-century is cer-
tainly tending towards a diluted classicism, well represented by Sebastiano
Conca's *Vestal Virgin Tuccia* (Ill. *110*), painted in 1751. In some ways, this picture
is a complete anthology, a blend of France and Italy, of the baroque and classi-
cism, which ends by having hardly any individual flavour. Probably most trav-
ellers to Rome would yet have felt it was satisfactorily Roman and classical –
and not just in its subject-matter. It is dignified and serious: a clear composition

171

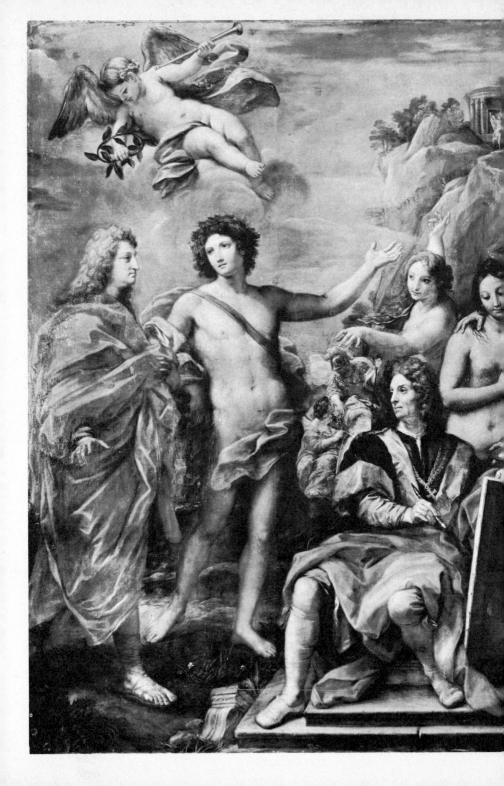

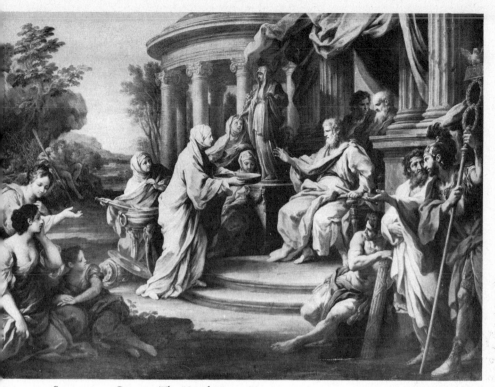

110 SEBASTIANO CONCA *The Vestal Virgin Tuccia*

with an absence of violent movement and hence with decorous, carefully-painted, draperies. A satisfactory suspicion of learning can be detected throughout, and if it is not truly antique at least it is neither novel nor *outré*. It calms rather than excites the imagination, and ends by being rather dull.

Conca's style prompts a doubt as to whether any Italian painter could be fully neo-classical. At least it is remarkable that what became the style was most rigorously practised by German and English painters (forerunners of the Nazarenes and the Pre-Raphaelites) until the dramatic revelation of David's *Oath of the Horatii*. It is usual to make Pompeo Batoni the Italian representative of this international movement. He has his place, if only because of his recognition when an old man of the young David, but it may be wondered if he was ever truly a neo-classical painter. He seems to have had little serious interest in depicting antiquity, and was really more at ease in a graceful allegorical climate, sweeter than Maratti's and with much more attractive – indeed brilliant – tonality. Not only

173

109 CARLO MARATTI *Apollo and Marchese Pallavicini*

111 POMPEO BATONI *Innocence*

112 POMPEO BATONI *Benedict XIV presenting the Encyclical Ex Omnibus to the Duc de Choiseul*

was he a gifted portrait painter, though never a very profound one, but he had the ability to make a decorative composition out of almost any English sitter. He could not help being decorative, though in a Roman way that is in permanent opposition to Venetian bravura. The simple personification of *Innocence* (*Ill. 111*), anticipatory of Greuze but less sentimental, is a *tour de force* of clarity, beautifully drawn, with so many tones and textures of white set against a plain red curtain. Calm without being chilly, accomplished in its paint handling and yet not dull in surface, the picture represents Batoni's style at its finest; almost nothing is said, but the means of expression are exquisitely competent.

Faced with the problem of a modern historical subject, Batoni could only continue to offer competence, and to marry – not very happily – actuality with allegory. The painting of the *Concordat* (*Ill. 112*), where the Duc de Choiseul kneels before Pope Benedict XIV, shows that they ordered this sort of thing much better under the rococo. Batoni's grasp of reality is unremitting to the

point of making the composition absurd; his lack of bravura effects becomes timidity, and even his decorative gifts desert him here. The sort of antique subject which suited him best was not stern or stirring, but closer in mood to Vien. Batoni's *Allegory of Love* (*Ill. 113*), painted only four years after *Innocence*, is a perfectly charming, perfumed vision. Essentially decorative and unlearned, it is really Roman rococo in style rather than neo-classic – how rococo would be apparent if it were juxtaposed to a Poussin, for example.

Such reserves about Batoni seem justified. Although his pupils called him the 'regenerator of the school' that was not the view taken by Winckelmann and other neo-classic theorists. Admittedly, the *Dizionario delle Belle Arti* of Milizia, published in 1797, is violent in its prejudices, but it is interesting to find Milizia almost as bitter in his criticisms of Batoni as he was of Boucher and Tiepolo. He wrote of Batoni that 'he always lived in Rome, ignorant of the lovely things of Rome and Greece, and the ignorant lauded him to the stars, enchanted by the falseness of his colouring'. Thus, by the twin standards of the antique and the natural, Batoni had erred. It might be said that the most truly neo-classic thing about him was his first name.

If Vien and Batoni are to some extent false prophets, shaped more by fashion than conviction, one may reasonably ask where was the true preacher of the gospel. For Winckelmann, and a lot of other people, the answer lay in Anton Raphael Mengs. Attempts have been made to show that he was not originally orientated to neo-classicism, that he owes his place to Winckelmann's influence, and that in sheer priority some British (viz. Scottish) artists led the whole movement. Yet many people pąid willing tribute to Mengs at the period. And his revolution consisted not so much in what he produced as in his attitude to art. Dismissed, explained away, disliked, he yet remains central to the whole movement. Inevitably perhaps with his first name, he set his art on a study of Raphael, and laid emphasis with his pupils on design rather than colour. Those who came into contact with him sensed his seriousness of purpose. Already in 1753, without any propaganda from the still unknown Winckelmann, the reactions to Mengs at Rome are reported by a Scotsman there: 'He is thought superior to any of the Romans. His works are, indeed, surprising…' His drawings appeared 'most beautiful'. And Mengs himself, who had visited Rome once before as a child, intended to execute all his work there: 'Sensible that Rome is the best place for a painter to improve his taste…'

This figure, with these ambitions, was bound to crystallize currents of taste around him. He was set on a path patently anti-rococo even if not yet fully neo-

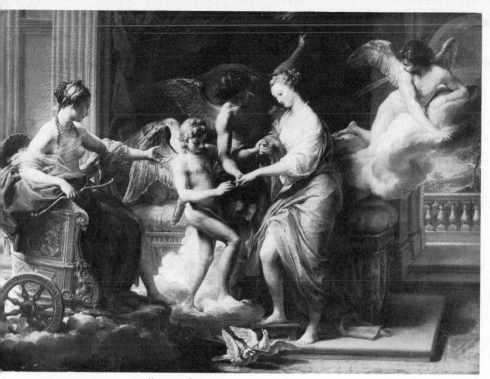

113 POMPEO BATONI *Allegory of Love*

classical. Raphael stood not just for nature, but nature elevated as the ancients had elevated it to produce ideal beauty. Mengs was never to achieve greatness as a painter, but he must command some respect. His health had been ruined by the excessive work forced on him when a boy by his horrible father (an artist *manqué*). Isolated, reserved, literate, sensitive in his response to not always the expected old masters (Correggio he brilliantly analysed, and he pioneered re-appreciation of Velazquez), fanatical in his painstaking application of paint, Mengs produced works which have every merit except that of being art. There the bird-brained Batoni had the advantage of him. Their rivalry was to be expected; their natures were quite dissimilar, as different as were their origins.

Mengs was twenty years younger than Batoni, a slow and uncertain worker, attacked by self-doubt as well as illness. He did not, and could not, undertake the wide series of portrait commissions that Batoni successfully did. But his best work was probably in portraiture; and, significantly, he comes nearest to creat-

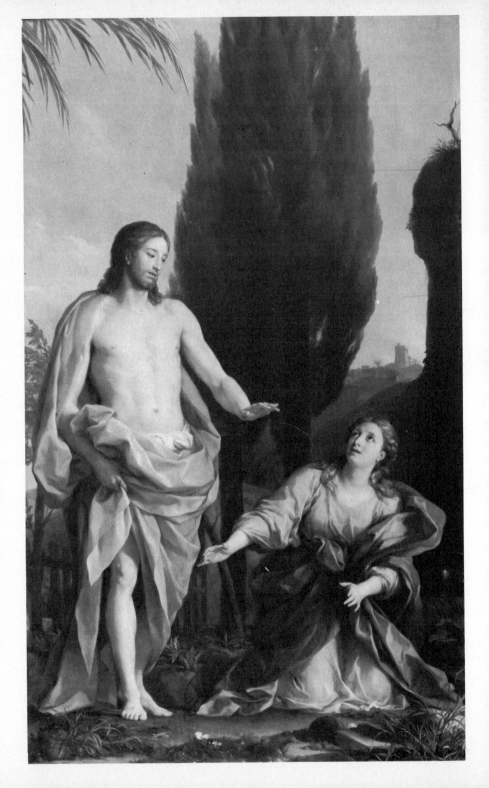

ing a work of art when the sitter is himself. It was inevitable that he should become a friend of Winckelmann's: they are merely the first of serious German students living in Rome, never able to relax and take for granted the monuments with which they were surrounded. Winckelmann forced into the open the stylistic opposition of Mengs to Tiepolo. It was right that where Tiepolo had thought up so much high fantasy around the reckless lavishness of Cleopatra's banquet, Mengs should paint instead Cleopatra's humiliation at the feet of Octavius (*Ill. 104*). This was executed about 1760 for Henry Hoare, the creator of Stourhead and owner of Maratti's late allegory (*Ill. 109*), for which it strangely served as pendant. Not only is Cleopatra stripped of glory, shrivelled to a tiny supplicating figure before the tall, unbending man, but the whole composition is stripped of fantasy in the concern for historical truth and simplicity. The appeal is less to the eye than to the emotions. East confronts West with no panoply, but in a plain Egyptian room: restricted as deliberately as are the gestures. All is firmly delineated, plainly coloured, as un-exotic as possible – but as accurate as Mengs can make it.

It is very much more successful than Mengs' treatment of a Christian version of almost the same theme, where another woman kneels in intercession: the *Noli me tangere* (*Ill. 114*). This altarpiece at All Souls', Oxford, executed in 1771, is no less carefully painted. There is the same suppression of personality in handling the brush, so that the final effect is of glossy, glassy, enamel smoothness: sheets of translucent paint that preserve the bodies in waxen perfection, making a *tableau vivant* rather than a painting. But despite all his care, the truth of nature has eluded Mengs. The problem of the religious picture in an age of reason is presented more vividly than anything else; nor can it be felt that, even historically, Mengs has done more than perfunctorily project himself into the situation. Like a true neo-classical artist, he is much more at home in Cleopatra's palace at Alexandria than in the garden at Jerusalem.

It was obvious that in choosing his subject from history the painter had already achieved part of a moral aim: he was illustrating what was true. The incidents which were chosen tended to serve, like the whole neo-classical movement, the cause of a new secular religion; emotional and instructive scenes from lives of the saints were replaced by comparable antique examples, where virtue was tested more sharply than in, say, the *Continence of Scipio*. There are hints of the motif of public good, sometimes illustrated by abstruse examples, sometimes by stories like that of Regulus. The death of Socrates is especially the martyrdom that touches this religion; but deaths of all heroes have their part – rather like

179

the school war memorial – in vaguely stirring associations of glory, pity, and patriotism. Women must be heroic too, or else weep. Their role as enchantresses is over; adultresses face artistic ostracism.

In a quite remarkable way, unparalleled before, art thus prepared for political events. Even the relative subjugation of women was to be part of Napoleon's code; 'the angel told Eve to obey her husband', he is recorded to have remarked. If republics, senates, consuls, were to become political actualities inspired by ancient Rome, it is hardly surprising that artists working in the city should feel the urgent need to capture something of the classical spirit. The effects ranged from capriciously assembled views of ancient Rome by Panini, and the more romantically charged response of Piranesi, to the history pictures of Gavin Hamilton, with subject-matter more often Greek than Roman.

Hamilton's *Achilles mourning over Patroclus* (*Ill. 115*), finished in 1763, is only one of several pictures in which the Iliad was his literary inspiration and Poussin his artistic prototype. Hamilton was painting pictures like this in Rome by 1758, and he is perhaps the earliest strictly neo-classic painter there. Through the medium of Cunego's engravings his compositions were widely disseminated and the novelty of his achievement was certainly remarked at the time. There is a combination of learned subject and pathetic anecdote, not new in itself but developing a new emphasis which will culminate in David. The choice of subjects from the Iliad is novel enough; yet symptomatic of a turning back to the epic, martial, world of legendary heroes. Soon the painter will not have to conjure up battles of the distant past but will have subject-matter enough in a Europe at war. Meanwhile, Hamilton's art seemed not only novel but important. Indeed, it would be hard to overlook the sheer size of the *Achilles mourning*; and then, for all the rather Rosa-style figures at the right, the central group suggests direct study of classical sarcophagi. It contrasts the violent access of Achilles' grief with the terrible calmness of Patroclus dead, a beautiful, lifeless corpse. Of a comparable Iliad picture by Hamilton, information was to be sent from Rome to the *Gazette de France*, testifying to the effect of this art which '*excite également de mouvements d'horreur et de compassion*'.

Hamilton himself did not feel restricted to antiquity for his subject-matter. As a Scotsman, working usually for Scottish patrons, he not surprisingly considered the possibility of painting *Mary resigning the Crown* – and though one must not force the pattern, it is noteworthy that the subject once more enshrines woman's yielding: as it were, a modern Cleopatra shown stripped of power. Already, the ancient and modern history picture were linked; and the neo-

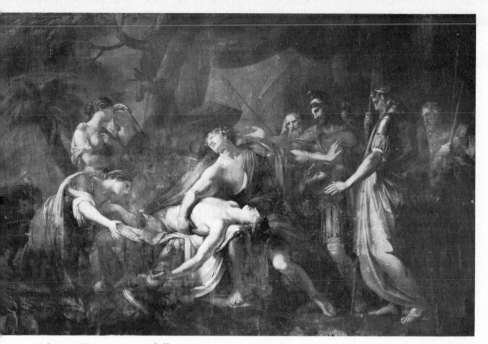

115 GAVIN HAMILTON *Achilles mourning over Patroclus*

classic brought with it renewed interest in national history. That was to merge into romantic art, when neo-classicism fell away, and several pictures actually painted fully in the eighteenth century have an overblown, even Victorian, melodramatic appearance (*Ill. 119*).

Rome and Mengs still represented the ideal location and master. The young Benjamin West was drawn there and into that circle in the key years of the early 1760s, to produce much more tranquil, and insipid, pictures than Hamilton's. A natural lack of artistic energy helped him early to achieve the ideally neo-classic manner: Poussin-style exercises, often on a vast scale, which may be tolerably faultless but are terribly null. More clearly than anything painted by Mengs, West's *Departure of Regulus* (*Ill. 116*) obeys the canons established by Winckelmann. It is, too, far removed from any romantic absurdity or excess; its merits are largely such negative ones. Perhaps West was most successful when least pretentious; his illustrations of English historical events are simply illustrations, simply composed, unaffectedly direct. Neo-classicism had trained West to give full value to the facts of the scene depicted, removing anything merely decorative or liable to spoil the sense of witnessing an actual event. The utter

sobriety of *Charles II greeted by General Monk* (*Ill. 117*) disarms criticism; it hardly aims at being a work of art but rests its claim on documentary grounds. Except to a limited royal circle, the anecdote is not particularly stirring. Wisely, West does not make it a moment of high drama; but he does manage to convey a suggestion of history happening before our eyes, exerting himself to achieve something very like the truth.

The more ambitious *Regulus* contains the much more typical neo-classic recipe of affecting and inspiring the present by depicting the past. Some artists had to choose which they would attempt. A painter like Angelica Kauffmann, though working in Rome, could not achieve much Roman gravity. A tendency to prettify pervaded even her portraiture (Goethe found her portrait of him charming but quite unlike) and she was perhaps more successful in touching the heart. History is seen as a series of sentimental anecdotes, unurged by any very definite intention, located in a vaguely classical past and acted out by quite sexless people with straight profiles, wearing sandals and plain tunics. When she tackles the

116 BENJAMIN WEST *The Departure of Regulus*

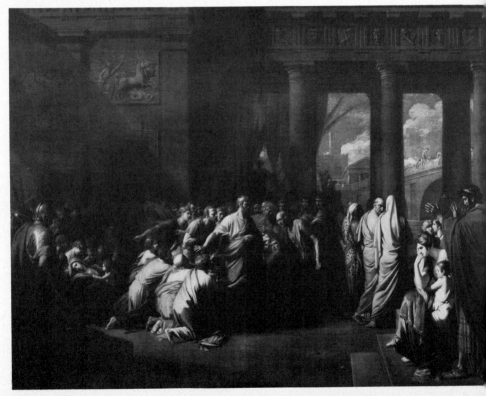

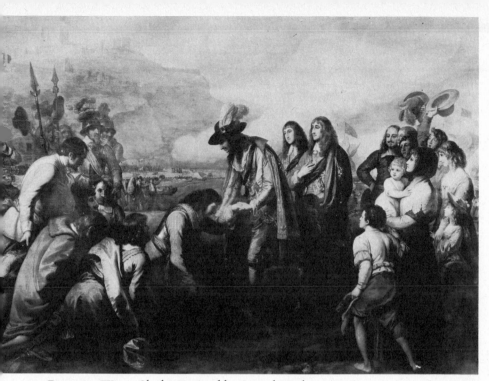

117 BENJAMIN WEST *Charles II greeted by General Monk*

story of Antony and Cleopatra, it is suitably muted into an elegiac mood. Cleopatra mourns the hero (*Ill. 118*) who is conveniently out of the way, and already in the tomb. This blameless, passionless, type of picture represents the danger inherent in neo-classicism: that it would fall into a formula just as shallow as the extremes of rococo but without any saving vitality of brushwork or colour. Even in the hands of David the convention could not be saved; his *Rape of the Sabines* marks the style's ultimate sterility.

While the quite illogical idea developed that a classical subject must be painted as a bas relief, with movement frozen and the paint applied in chilly smoothness, the artist remained – as West showed – less constricted by modern history subjects. No formula for these existed; they naturally carried none of the tremendous prestige of antiquity, and the painter could oscillate back from the pole of Poussin to snatch some vibrations from Rubens. Indeed, David's failure ever to establish an equilibrium is perhaps due to such oscillation – fatally destructive to any decisive, committed style – which was part of his inner lack of certainty.

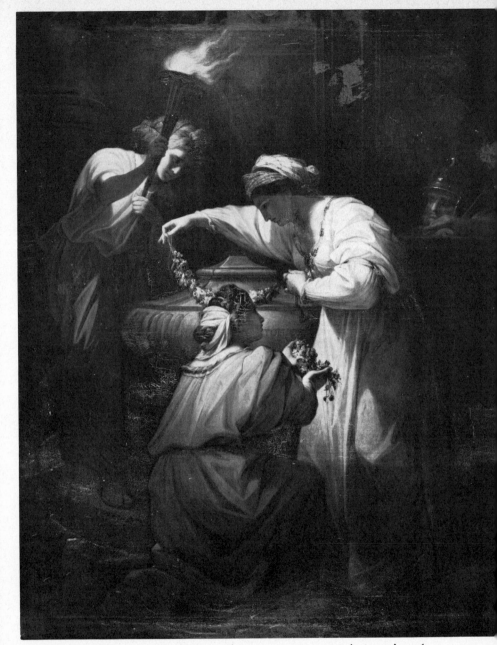

118 Angelica Kauffmann *Cleopatra mourning at Mark Antony's tomb*

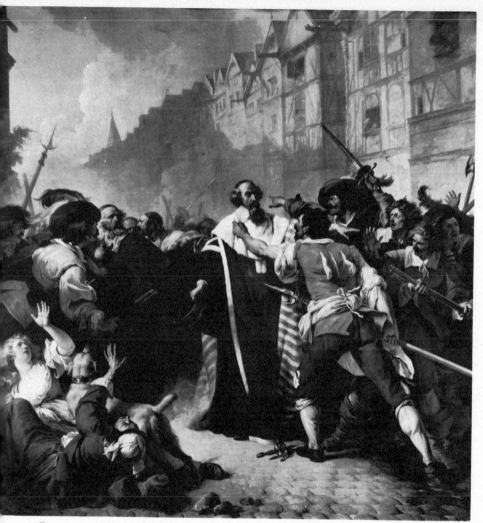

119 FRANÇOIS-ANDRÉ VINCENT *President Molé halted by rebels*

Whatever the failings of the *President Molé halted by rebels* (*Ill. 119*), by David's
co-pupil under Vien, Vincent, it is at least a bid for striking effects. Compared
with Angelica Kauffmann's picture, painted ten years earlier in 1769, it is full-
blooded. It returns to the world of action and heroism – significantly, taking a
dramatic, literally arresting, moment from the history of the Fronde, and set-
ting up associations of patriotism, heroism and humanity. Far from lifting the
scene into a tranquil sphere where even death comes with dignity, it involves

the spectator in the President's shock, creating a seventeenth-century Parisian street which may smell of the theatre but which seems preferable to the insipid surroundings chosen for most neo-classic pictures. It represents the new attitude of historical realism which is to overtake the neo-classic movement, out of which it came, and it prepares the way for Delacroix.

But the specific eighteenth-century recipe was to fuse nature and antiquity to produce a type of art which should compel attention by its moral force. To achieve anything of value, it was necessary that artistic force should also be present: taking us beyond the mere prose statement such as West uttered to the poetic achievement of something created. There is something profoundly unpsychological – and unurgent – about most neo-classical pictures. They remain illustrations, dependent on a Greek or Roman text, doubtless more accurate than the Renaissance vision of the classical past – but lacking that imaginative energy which so often animates a quite minor Renaissance painter's picture of antiquity.

It was perhaps inevitable that a sophisticated and rational age, *au fond* sceptical of art's power, should rely on the painter instructing where he could not inspire. At least, he should not corrupt by telling lies. But behind the pictures of Vien, Mengs, Hamilton, and more obviously behind those of the Wests and Kauffmanns, there was really no moral-*cum*-artistic force. The whole neo-classic movement in painting might seem merely a curiosity of taste, were it not that the recipe suddenly produced results in the work of Jacques-Louis David.

All along there had existed the possibility of a painter coming with a fervent belief not so much in antique virtue as in the need for modern virtue: for reform and for revolution. Then, this painter's Brutus, Regulus, Hector, would do more than stir vague associations of glory; his heroes would point not back but forward. David was the torch that fired a pyre of long-assembled aspirations. He seemed the painter so long promised. Thus when he exhibited the *Oath of the Horatii (Ill. 122)* in Rome, it was an immediate success; everyone appreciated it and believed he understood it. But in fact, of course, David fired more than an artistic bonfire. To return it was necessary also to destroy. We find Reynolds, who had applauded David, apparently withdrawing his praise when he grasped the real revolutionary principles of the art. In Rome the aged Batoni might, with unpardonable vanity, see David as his artistic heir, but others early paid the *Horatii* its real tribute; the picture was said to have 'inflamed more souls for liberty than the best books'.

In David, almost as much as in Goya, the whole century seems represented. He was not a neo-classical painter by temperament, nor because of fashion. His

120 JACQUES-LOUIS DAVID *Count Potocki*

early portraits show him competent in a vein of straightforward naturalism, and his first subject-pictures are still rococo, betraying an artistic relationship with Boucher which reinforces their family one. His pictures are full at that period of confused hints of clashing tendencies: ludicrous pink and blue pseudo-balletic mythological persons with fiery horses that prelude Gros and seem ready to gallop into Delacroix's *Massacre of Chios*. David himself as a young man was constantly in need of being calmed; he was already threatening the romantic act of suicide which Gros eventually had to commit.

Despair did not immediately cease with his arrival at Rome. He did not seek out the city with the yearning of Goethe or Gibbon (who actually recorded that he passed his first night there sleepless) but had arrived after expressly stating that the antique would not seduce him. The achievements of neo-classicism did not facilitate his conversion; he was to fight his own battle, welding nature and antiquity under the direct stimulus of seeing Herculaneum and Pompeii, encouraged by the enthusiasm of Vivant Denon and Quatremère de Quincy – beside both of whom Winckelmann was an amateur. Yet Naples was also the modern world, to which David was never blind. It had its own graceful heroism, impetuous, private, undidactic. While one aspect of David's nature pondered on, and produced, an antique subject-picture with modern application – the *Belisarius* – another produced the *Rubénisme* and realistic panache of *Count Potocki (Ill. 120)*: a portrait in which the sitter is treated naturally and yet heroically. It may be merely legend that David had witnessed at Naples Potocki's mastery over a supposedly untamable horse; yet the picture rings with triumph and with a witness's vivacity, still electric and charged by the painter's response to human endeavour and animal spirits. Reason may guide David to the example of Poussin, but the passion in him finds kinship with Rubens, from whom the horse in *Potocki* is borrowed. David's dilemma is not in fusing nature and antiquity as such, but in fusing reason and passion, spontaneity and thought. Perhaps in no single picture did he achieve complete integration; his career is made up of splendid and disconcerting fragments, as erratic artistically as it was politically, and leaving him with a strong sense of double failure.

Had he continued along the path indicated by *Potocki*, he might well have had Delacroix as his pupil. But David could not rest as just painter; he shared the century's uncertainty about art. His must be allied to the age, must not only reflect it but positively guide it. To some extent, antiquity remained for him the wrappings inside which his message could be conveyed. Napoleon sensed it very quickly, and saw the possible propaganda dangers when he told David, then

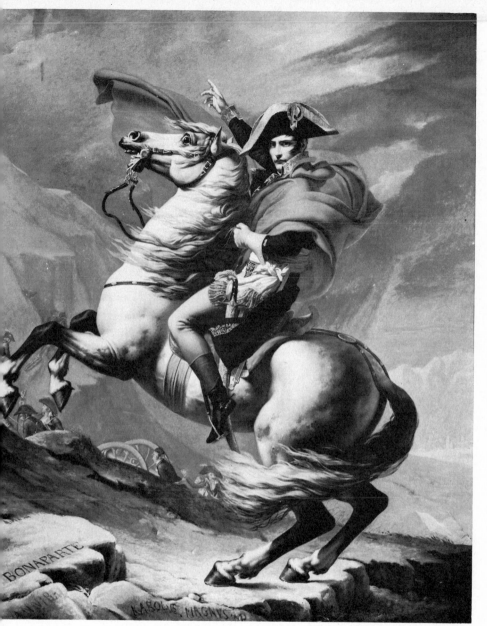

121 Jacques-Louis David *Napoleon crossing the Alps*

engaged on *Léonidas*, that he was wrong to paint conquered men. Indeed, it may be said that Napoleon cruelly but perceptively seized the root of David: he wanted a hero and should have one from the present; modern history would replace antique subjects. And in place of the trivial domestic issue of a Polish count mastering a restive horse, there should be Bonaparte himself in the saddle, '*calme sur un cheval fougueux*' (*Ill. 121*).

The success of *Potocki* and *Belisarius* led to a royal commission which resulted in David's republican-seeming *Oath of the Horatii* (*Ill. 122*): the quintessential, neo-classic picture, whose impact was immediate when it was exhibited in Rome in 1785. It united the generations and the nations, and was admired by those whom by implication it attacked. During the long period of brooding on the subject, David was brooding too on the influence a painting can exercise on the public. It was not an accident that he showed it at Rome before it appeared at the Paris Salon. It is not only a public picture, but is closely linked to the public interest, the *res publica*. Far from the stoicism and increasingly allusive, abstruse, philosophizing of Poussin, David tells a simple story in a simple way, illuminated with hallucinatory clarity, and shot through with frightening, dramatic intensity. The picture shrieks of the sword; nowhere does the light glitter more threateningly than on the cluster of blades – unless on those sword-like arms thrust out so greedily towards them. Though there is poignancy in the group of grieving women, it is subordinated to stern patriotism. Men toe the line at the moment of exultation and self-sacrifice. In this proto-republican world there is no place for anything else: nothing to break the unrelenting claustrophobic courtyard of bare brick which completely fills the background.

Although nobody appears to have said so at the time, the picture perhaps partly owed its tremendous success to the fright it gave the spectators. For so long the century had asked to be affected, had half pretended to be touched by appeals to domesticity, dropped a tear for Greuze's girls in trouble, felt morally better for seeing Scipio exercising continence. David clears all that away. Even depictions of Homer's epic world are reduced in emotional importance beside the new issue of the state. The *Iliad* tells of obscure wranglings by petty chieftains, with justice administered by petty gods. But the Horatii, presented with powerful realism, are fighting for Rome, putting the state before all personal considerations; they are men in a world without gods, trusting in their swords to preserve the city from tyranny. It is an exciting prospect, a call to arms in a just cause by ordinary citizens: themselves brothers, amid their family, equals

122 Jacques-Louis David *Oath of the Horatii*

and about to die for liberty. Only four years later, the National Assembly at Versailles was to list the rights of man: 'Liberty, Property, Security, and Resistance of Oppression'. Soon it would not be in mere painted rhetoric that men swore oaths and seized their swords.

Painting is about to affect people, with a vengeance. David himself was the most affected of all. Perhaps the deepest conviction behind his picture is that violence will provide a solution; and tension comes from violence suppressed in the actual paint-surface, as if there was an almost hysterical determination to appear calm. The whole Horatii story is one of exaggerated *pietas*, involving a series of deaths through duty which culminate in the high Roman virtue of a brother killing his sister for loving the Republic's enemy. And originally David had thought his composition might be of the moment when Horatius is absolved from murder because of his services to the Republic; a hero must be judged by special standards.

123 JACQUES-LOUIS DAVID *The Lictors bringing Brutus the Bodies of his Sons*

David never again achieved the intense impact of the *Oath of the Horatii* in its unity of antique *exemplum* and modern application, its combination of moral and artistic force. It succeeded in being an international picture, whereas his later work inevitably addressed itself morally to France and seldom recovered the intensity. He was to become aware, too, of increasing revolution – revulsion – against the neo-classic and this affected his own art. But in 1785 the *Oath of the Horatii* summed up three-quarters of a century's striving: tragic, classical, as resolute in draughtsmanship and design as in sentiment, it was really a culminating rather than a seminal work of art. So perfectly did it express what had been required that it was hard to see what development there could be beyond it – except by revolting against its standards. Even David could not eclipse it.

Its mood is reproduced in harsher terms, but without the full impact, in *The Lictors bringing Brutus the Bodies of his Sons* (*Ill. 123*), a clear attempt to re-do the *Horatii* but which could be said to show less classicism and definite hints of

romanticism. The pitiless illumination of the courtyard has been exchanged for a chiaroscuro interior, patterned with deep shadow and shrilly-glittering patches of dramatic light. What in the Horatii was only an irrelevance – emotion dividing a family, with women the sufferers – is here the theme. The Roman code had demanded that Brutus condemn his own sons for fighting against the Republic, and their bodies now enter the house: greeted by the hysterical, writhing, group of mother and daughters – and ignored by the immobile figure of the father. The picture has gone to extremes avoided in the Horatii. The fainting girl, an emotional zigzag of dissolving limbs, is Gothic in the sense that Ingres is Gothic. (David spoke of something Florentine in the pose of Brutus.) Equally extreme is the device of the corpse, as it were for ever on the point of entering the room, ironically blotted out by the dark statue of Rome, seen by the women but not by us – and made the more effectively frightening by the dreadfully dead, sticking-up feet that recall Caravaggio and seem to anticipate Géricault.

The picture is more disturbing, as well as more disturbed, than the Horatii. Roman virtue's stern requirement has brought nothing but death and grief to a household; even a deathbed is no edifying moral spectacle à la Greuze but a shocking sight. Finished in 1789, the Brutus reveals the almost feverish state of David's mind in the year of the Revolution. The Académie sensed some disturbing element in it, and not wholly artistic reasons prompted the attempt to exclude it from the Salon that year; when it was finally admitted it was guarded by students in the uniform of the newly-constituted National Guard. Artistic and political revolution are merged in the incident. Modern republicans parade in front of this depiction of ancient republicanism. All that remained was for life to present David with events comparable to the dramas of antiquity. Four years after the Brutus was painted, and in the full tide of Revolution, Marat was assassinated by Charlotte Corday (Ill. 124).

Well before that, David's search for a hero had led him to demand, and make, memorials to the dead heroes of the Revolution; but the greatest consecration of this aim is in the Marat assassinated – enshrining the most famous person to die a martyr to the cause. David's type of devotion usually led to emotional identification with his hero (he was to cry at the crisis of Robespierre's downfall: 'If you drink hemlock, I shall drink it with you') and he was already an ardent defender of Marat. He was the Revolution's servant, thinking of himself perhaps less as politician and more as the people's painter. It could be said that the Marat assassinated was commissioned work. The Convention looked to David when news of the murder broke; and David responded with a painting that combines

124 JACQUES-LOUIS DAVID *Marat assassinated*

the emotional and the factual. It shows a modern martyrdom: bringing violent death out of the past and thrusting it ruthlessly before us, with brutal effect. It does not merely stir the spectator, it accuses him. For our sake Marat suffered. He trusted humanity – and it stabbed him.

The detailed realism is almost too forceful to be faced. There is a sense of shocking actuality not only in the blood-stained bath water but in the roughened wood of the packingcase-like table and the patched sheet. All exercises an atrocious fascination, so that one hardly likes – and yet cannot avoid – examining the whole composition to discover what other unpleasant details lurk in it. Standing where Charlotte Corday stood, we are close to the waxen, lolling head that slumps towards us; and the knife is dropped virtually at our feet.

The shock of *Marat assassinated* is the century's shock. The Revolution stood for liberty and the release of all mankind's finest feelings; it was meant to end, not inaugurate, bloodshed. Yet liberty has led to this. It was a pointed rebuttal made by a friend of Madame de Staël's when he said that he could not admit 'any necessary connexion between abstract ideas and murder'. For David's picture tells us that you cannot trust mankind. Instead of confident enlightenment brought about by reason, we have a reign of terror and the apparent anarchy of Marat's assassination. The sense of betrayal is increased by David's careful recording of Charlotte Corday's deceitful message: '*Il suffit que je sois bien malheureuse pour avoir droit à votre bienveillance.*' Yet, in fact, Charlotte Corday, the descendant of Corneille, had seen herself as a patriot, ridding her country of an evil man; David had no monopoly of high ideals. In the subsequent confusion he clung to the rock abruptly arisen from the waves, pledging his faith once again, and this time never faltering, in devotion to Napoleon.

But that inevitably meant leaving the harbour of antiquity. Events had precipitated David into a modern world which he did not perhaps completely understand; as chronicler, he could paint the events of Napoleon's reign, but he never produced the thrilling actuality of Gros's interpretations. And what had happened to the recipe which as late as the Salon of 1799 was publicly proclaimed by the Minister of the Interior: the artistic advance of the French School being credited to its return '*à l'étude de la nature et de l'antique*'? The ideal was collapsing and being replaced by Napoleonic realism. In 1808 David prophesied that 'in ten years the study of the antique will be forgotten'. In England only Haydon continued to mix nature and Raphael and the essence of the Elgin marbles – producing huge pictures which nobody wanted. Among all his pathetic questions Haydon never asked England one more revelatory than when

he enquired: 'Do you really expect to raise Art by encouraging pictures two feet long and three feet wide?' That size was adequate enough, one is forced to reply, for the genius of Turner and Constable.

The Royal Academy exhibition of 1799 contained 681 pictures, apart from miniatures; the vast majority were portraits and landscapes, but there was a sprinkling of fancy and religious pictures (the latter chiefly for Fonthill). Amid the whole range there was only a single picture based on a classical-historical source. The last eighteenth-century Salon was not such a frank victory for nature over antiquity, but the doom of neo-classicism was apparent in the work of David's own pupils. The moral content – which had seemed so essential to the eighteenth century – was not to be found in the chaste nullity of Ingres any more than in the reckless vigour of Gros. If we wonder which proved the more vital stock, both sprung from the divided plant that was David, the answer is the natural one. There was to be a solitary convoluted flower of classicism in the hot-house bloom of Ingres, a waxen camelia about whom it is hard to decide whether it is real or artificial. But from Gros there came a dazzling profusion – Géricault, Delacroix, and through them the Impressionists, then Van Gogh and Cézanne.

Almost a return to rococo standards is apparent in the charming, carefree, classical world of Prud'hon. In a twilit glade that Corot too will evoke, Venus and Adonis playfully flirt with each other (Ill. 125), bodies built out of warm light and tender shade, caressed by paint as by the last rays of sun. Modern lovers in the gardens of Malmaison, they have never been touched by the chill of a bas-relief, nor could ever be mistaken for antique statuary. Hotter still, and much more vigorous, is the modern world of Gros where Napoleon becomes a miracle-worker in the Plague at Jaffa (Ill. 126): the more effective for the pungent realism of the plague-stricken around him. Marat was only a dead hero, but Napoleon has come among his men, the youthful saviour, whose small stature merely adds to his poignancy. At last, the century has found its hero, not in antiquity but in real life. And it was to Gros that David finally confessed, writing from exile in Belgium under the re-awakened influence of Flemish art: 'It's too late...' He might have been the champion of neo-Rubénisme, but he had bent to the century's wish and lived to see his style outdated.

Yet if nature and the antique would not properly fuse to provide the answer to the century's demand for its own great painter, and nature by itself seemed not profound enough, the century had failed to produce a truly modern painter who would express its deepest fears as well as its aspirations. England, Italy,

125 PIERRE-PAUL PRUD'HON · Venus and Adonis

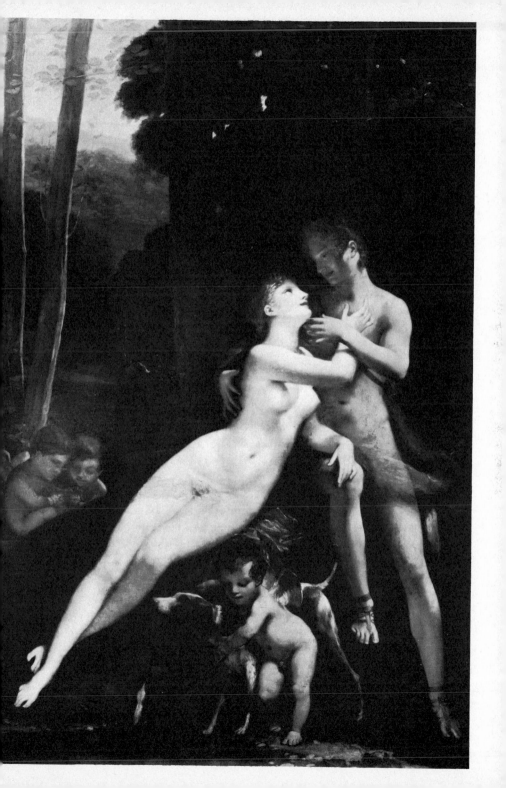

126 ANTOINE-JEAN GROS *The Plague at Jaffa*

France and Germany had made their bids, perhaps too consciously. It was in Spain – a country not associated with reason, enlightenment, liberalism, or equality – that such a painter was unexpectedly to be found: in Goya. He is the one figure the century had not foreseen – in that as in so much he is the reverse of his close contemporary, David. He is only half an eighteenth-century man, but it is an important half. He stands like Goethe, and Stendhal, facing both ways. He dragged the old century with him as deaf, aged, banished, lonely, he battered his way into the nineteenth century with tremendous courage. That he should die in France is an accident symbolically correct: laying down his life in the country that would do most to foster modern art.

In the chain of painters named by Baudelaire in *Les Phares* – those beacons across the centuries – Goya is perfectly placed: between Watteau and Delacroix. And Baudelaire apostrophizes him with beautiful suggestions of the nightmare surprise-packet he is: '*Goya, cauchemar plein de choses inconnues*'. It is the unknown quality in Goya that makes him at once artist, jack-in-the-box, and bomb.

27 DAVID *The Lictors bringing Brutus the Bodies of his Sons (detail)*

Goya

At the beginning of this book a verse of Pope's posed a question which is central to the preoccupations of the eighteenth century: 'With Terrors round, can Reason hold her throne?' The question was to be asked with increasing urgency as the century advanced; and the answer seemed increasingly in doubt. Though it might be said that the tremors of forthcoming earthquake were felt chiefly in France, what followed involved all Europe; it was not to remain solely the 'French' Revolution. To a remarkable extent, eighteenth-century art had gone a long way with reason – ignoring the 'Terrors round' and also those 'witches, devils, dreams and fire' which Pope singled out as threats to the dominance of reason. All the talk of man and nature – those major concerns of eighteenth-century society – had resulted in generalizations which concealed the harsh truths beneath. A more probing enlightenment would have told the century that it is not enough to *want* to follow reason, *want* to be good and social. Nature really includes the witches and devils and dreams; and the system that builds without allowing for them is bound to be toppled by them.

Most of the art so far illustrated in this book ignores psychology – with the outstanding exception of Watteau. It is ignored in the interests of pleasing or instructing, and the effect is to give much of it a faintly filleted quality. The extremes of rococo and neo-classicism are equally lifeless. Even when art tried to link itself to daily life, perhaps because it wished to borrow some vitality, it was easily reduced to depicting it as a spectacle or satirizing – as Hogarth did – its more obvious social abuses. Against this aridity had arisen the damp cult of sensibility: the 'religion of the heart' which had Greuze as its high priest. But none of these approaches touched on the region of the mind or attempted to suggest the true complexity of human nature. The vices of society cannot be explained as due just to gin and poverty; nor can we all be as sure as Greuze

128 FRANCISCO DE GOYA *The Harvest*

pretended to be that a father's deathbed will fill the spectators with straightforward grief and remorse.

To dig deeper requires courage, and the eighteenth-century painter risked losing his supposed social role if he produced too personal a vision. Since the century was suspicious and utilitarian in its whole attitude to art, the pressure remained strong on the painter to serve society – even if in so doing he might be tempted to be false to art and his own nature. Inevitably, to Blake Reynolds seemed a leading example of such villainy: a man 'Hired to Depress Art'. Conversely, to Horace Walpole Fuseli seemed mad: his highly personal fantasies refused to be related to the ordinary known world. He suggested there were more things in heaven and earth than Walpole wanted to dream of. And to the Davidian ideal of the artist consecrating his talents to the service of the nation, Fuseli returns an almost obscene answer. Fuseli is certainly interested in man's nature, but it is the private nature of man that attracts him: dreams, above all, and the devil (who had, he claimed, sat for him). Although the *Nightmare* (*Ill. 2*) may now seem ludicrously conscious, still it pays tribute, fascinated tribute, to the derangement of reason, emphasizing the strength of horrid fantasy and the weakness of mankind. In that world it is irrationality that reigns, with licence to distort reality in the interests of obsession (*Ill. 129*), reminding us of Sade.

The individual's sensations are what matter; and in opting out of the social framework, Fuseli is already romantic. He provides no answer to Pope's question because he is on the opposite side. As a young man he had defended Rousseau and attacked Voltaire; he was naturally attracted to confusion – of which his writings are an admirable example – and perhaps there is some truth in Walpole's diagnosis of insanity in him. Fuseli can serve as a prologue to Goya, partly to show the interest in fantasy and mental states which they share and also to show clearly how different was Goya's attitude to irrationality. Though younger than Fuseli, he was much more deeply part of the eighteenth century; the social basis of his art is very real. His attitude to reason is significantly different too: '*Et Voltaire est immortel*', he wrote. The power of Goya comes from the double awareness: of man's duty to be rational, and of the irrational elements in his nature which make this task so hard. The purpose of the *Caprichos* is didactic and Goya wrote quite plainly that the work was intended 'to banish harmful vulgar beliefs, and to perpetuate... the solid testimony of truth'. Thus Goya sees the fantasy world as false; he believes that there is such a thing as truth and that the artist can play his part in leading us towards it. Far from supposing that reason

129 HENRY FUSELI *The Débutante*

cramps the imagination (a fallacy invented by romanticism and still with us today in most people's attitude to the eighteenth century), Goya felt that without reason imagination was sick. One of the *Caprichos* showing rat-like creatures with padlocked ears being spoonfed was given the draft caption 'The illness of Reason'.

Goya's art is seriously concerned with the fate of mankind. And he is typically eighteenth century in seeing mankind within the social framework – for Goya it is always *modern* man. The artist wants to comment on not only what he sees but what he knows. Reality is there not merely to be reproduced but to be pondered on and mocked if necessary. How much the individual matters is revealed by Goya's portraits, but they are only one aspect of his ubiquitous pictorial suggestion that 'the proper study of mankind is man'. Art is directed to man, and with Goya words often sharpen his graphic message. Both have a witty brevity which stings by its aptness after the moment of amusement.

Almost as much as David, Goya was involved in the political storms which brought in the nineteenth century. Unlike David, he remained committed not to a national cause but to the cause of humanity. Where David glorifies war when waged by Napoleon, Goya indicts the folly of all war, the senselessness of battle between human beings. In the dark night of stupidity and bloodshed he managed to keep alight a candleflame of sanity – by an act of willpower the more moving for the sense he gives of reason threatened. Even if the so-called 'black paintings' represent the temporary collapse of his optimism, it remains a courageous act to have depicted that collapse so vividly – and a creative one to have made art out of it. Such acts are typical of Goya; among his last pictures is one of himself being tended by his doctor in a portrayal direct, unsentimental, and moving. At Bordeaux in 1824 a friend found him 'deaf, old, awkward, and feeble... and so happy and eager to see the world'.

Goya had marvellously preserved the mood in which all his early work was executed: beginning with a delight in people and their antics which is as innocently gay as Domenico Tiepolo's, but deepening into greater awareness as the sky of optimism clouded over. And all the time he was following nature – following it, indeed, down darker tunnels and past more dreadful sights than the average eighteenth-century person ever conceived of. That lay in the future when Goya began painting his tapestry cartoons which represent an enchanted, only half-real rustic world, brightly-coloured, cheerful: very much peasant life seen from a palace window.

At first these cartoons are rococo in their decorative landscape settings but with a piquancy – a positive pinch of earthy actuality – lacking in most rococo

130 FRANCISCO DE GOYA *The Swing*

132 FRANCISCO DE GOYA *The Parasol*

art. The people are always real, amusingly so, and already by 1777 Goya had achieved the perfect blend of reality and decoration that is the *Parasol* (*Ill. 132*). Perhaps it is less ironic than is usually supposed that it should be Mengs who turned the Spanish royal tapestry factory to the task of producing compositions of ordinary country life. For that shift was part of the century's whole movement towards the truth of things, and its delight in our equals, or our inferiors. Goya's lady and parasol-holder give a sense of being dressed-up, posed with a faint tinge of irony in an airy setting of graceful arc of feathery tree against sunny sky which is no less solid than they. There is some affinity with Piazzetta's *Idyll* (*Ill. 86*). Both pictures make one smile, not in condescension but in amused enjoyment just of people: in both cases the male attitude is hinted at as itself amused by the ladies, a sort of 'we're their servants but we know their pretensions' sentiment which Goya was to develop. Observation makes the *Parasol* more than just a brilliantly-coloured, ravishingly painted, piece of rainbow decoration. There is nothing sentimental, nor anything particularly Wordsworthian or worthy, about being in the open air in the countryside. It is rather as a piece of innocent fun that Goya shows upper-class people amusing themselves

131 GOYA *Queen Maria Luisa.* Detail of *The Family of Charles IV*

in the *Swing* (*Ill. 130*) – so far removed in feeling from the erotic excitement engendered by Fragonard's famous treatment of the theme.

Yet, as Goya worked on at tapestry cartoons (producing finally a total of sixty-three over a period of nearly sixteen years) he must have become aware of harsher realities in the lives of the peasants usually depicted. Autumn might seem a season of charming idleness when families sit about, playfully grabbing at a bunch of grapes (*Ill. 128*), though behind them people toil among the vines. The mood, however, remains rose-coloured: the sky a sunset glow and the foreground figures softly bright in tones of peach and grape-green and purple. A deliberate shock is administered by the scene of *Winter* (*Ill. 133*): ease and plenty replaced by this snow-covered terrain with a few huddled men in drab-coloured clothes, their dog with its tail between its legs. Nor is this change to be explained as merely seasonal. Goya's early enchanted world, which held reality at some removes, is breaking up and being replaced by harsher facts. Other cartoons show poor children at a fountain, while perhaps the most serious of all depicts a wounded mason fallen from some scaffolding (*Ill. 135*). There is no longer any emphasis on the decorative. The two helpers seem well aware of a tragic situation, while the utter abandonment of the injured man – conveyed particularly in the slackly-hanging arm – suggests that he is fatally hurt. It is curious that Goya should have executed the preliminary sketch with a hint of the mason being drunk, and the helpers amused, for the whole incident brings to mind the moment in *L'Assommoir* where the drunken workman falls from the roof. Zola's social-moral point is not made by Goya; but it is probably right to see in these later cartoons an increasing concern with the human condition. The rococo balloon is abruptly filled with poignant emotion. Life has ceased to be a series of enchanted moments acted out by puppet figures. Goya's own life in these years underwent its first drastic changes and he was suddenly conscious of age. 'I have become old', he wrote in a letter to a friend in 1787, when in fact he was no more than forty-one.

What is so effective in Goya's tapestry cartoons, culminating in the *Wounded Mason*, is the power of observation which retains its power by an apparent *naïveté*. Goya goes on gazing when everyone else has lowered their eyes, seeing everything as if for the first time. It is a candour of vision that was to prove more devastating than any amount of emotional fervour. And it is the same candour that we meet in Goya's portraits – not satire, but a quality that is akin to the grave scrutiny to which Velazquez subjected his sitters. It is not they in particular who seem ridiculous to Goya, but to some extent the spectacle of all

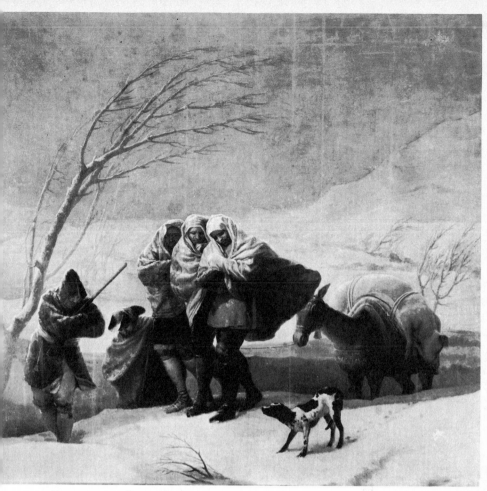

133 FRANCISCO DE GOYA *Winter*

human life. They are people plucked, as it were, out of the *Caprichos*' social framework and placed vividly before us with their foibles, their rather sad attempts at grandeur, and also with a moving sense of loneliness.

Queen Maria Luisa, so obtusely supposed by some critics to be caricatured by Goya, is treated with almost tender gravity. She inspired a whole row of masterpieces: it would be easy to persuade the uninitiated that it was she, rather than the Duchess of Alba, whom Goya loved. A false use of history has suggested that Goya is savagely indicting where in fact he is recording – with ravishing delicacy – a woman with attractive arms and tiny feet, a cloudy dream of crocus-yellow muslin (*Ill. 138*). It is not a crime in art to be ugly; and at least Maria

134 FRANCISCO DE GOYA
The Family of Charles IV

Luisa has welcome vivacity in comparison with some of the doll-like women Goya had to paint. What is remarkable is the direct honesty of vision which makes Maria Luisa no more regal than she is – and no less. While Madame Vigée-Lebrun is softening the pride of Marie-Antoinette, applying the principles of the heart to the old French image of the sovereign, Goya attempts no such propaganda. His heart speaks his mind, but it is one never indifferent to the graces of costume, never negligent of the decorative possibilities of a cordon or an order – or a pair of curved Turkish slippers. Compared with the portraits of Spanish queens by Velazquez, Goya's suggests a much more relaxed relationship to the sitter, symbolized by the exchange of stiff, distance-making farthingale for the straight, graceful, tunics usually worn by Maria Luisa (whose concern with fashionable clothes is shared by the painter).

Even in reactionary, monarchist Spain the century has brought kings and queens to earth. It is part of Goya's achievement to make his sitters human and accessible, regardless of their rank. The large-scale official commission of the group portrait of the whole royal family (*Ill. 134*), assembled to face a new century in 1800, is a masterpiece of intimacy, casual despite the jewels and uniforms, lacking in any sense of etiquette and touched with hints of affections and dissensions – no accident, probably, that the future Ferdinand VII is in the shadows, well removed from his parents. All the average person's preconceptions of Spanish court decorum must give way before what is really the most sheerly familiar depiction of royalty produced by the eighteenth century: children, aunts and uncles, and the king and queen at the centre holding hands with their youngest child, the Infante Francisco, himself depicted tenderly and yet without sentimentality as nervously conscious of the ordeal of being painted. A European tendency to dispense with ermine-draped portraiture had already produced the bourgeois intimacy of Zoffany's portrayal of George III's children with their mother, and some rather self-conscious depictions of Marie-Antoinette and her children – all pictures from which the father was banished. Goya manages to combine the monarch and the father in the unpretending Charles IV, a dull man whose sole glitter is provided by his scintillating stars.

There is hardly any need for the painter to have included himself in the composition, for it bears throughout a witness-quality equivalent to '*Goya fuit hic*'. The eye that watched these people knew them in a way that virtually revolutionizes the art of portraiture: paying every tribute to face values, decorative qualities, yet penetrating beneath these to show us – should we need the reminder, and Goya knows we do – the pathetic fragility of all human beings. In

135 Francisco de Goya
The Wounded Mason

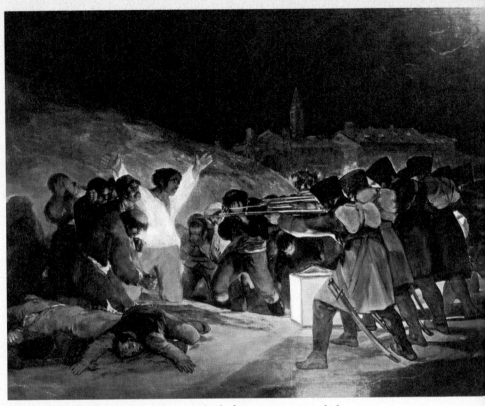

136 Francisco de Goya *Third of May 1808 at Madrid*

some sense, this family might be assembled to face not an artist but a firing squad; and thus, far from accusing them, Goya may be said to be pleading for them. We are on the point of condemning the whole family as royal boobies and cretins, when Goya hints that we, without being royal, may share their other characteristics. To such questions as whether Maria Luisa was a cruel ambitious woman and faithless wife, or whether she was merely someone passionate and intelligent who had the bad luck of being sent to Spain and married to Charles IV, Goya returns no answer at all. He paints history, and historical persons, without any final conclusions. Their point for him is simply that they live – and must be kept alive by his art. And so they are, we may exclaim, looking at the almost rapturous freedom of the brushwork that makes this large canvas an airy sketch, with runs and trills of liquid paint, now shimmering in evocation of sequined muslin, now building up faces and hair of muslin delicacy with eyes that gleam like sequins.

137 Francisco de Goya *Conde de Fernán-Nuñez*

139 FRANCISCO DE GOYA *Equestrian Portrait of the Duke of Wellington*

138 FRANCISCO DE GOYA *Queen Maria Luisa*

Against this nature most eighteenth-century naturalism is too trivial or too stiff, while the century's other extreme was towards the inflated heroism finally enshrined in David's *Napoleon crossing the Alps* (*Ill. 121*). To that Goya might be said to reply with his equestrian *Wellington* (*Ill. 139*), a casual conqueror, an eccentric private gentleman rather than a victorious general. For Goya there are no heroes and no villains. Even the utterly detestable Ferdinand VII was to be served by the artist who had served Joseph Bonaparte – and it is impossible to think that Goya produced several large-scale official portraits of the king (*Ill. 141*) in a spirit of undetected mockery. Life and the painter were a good deal more subtle. Ferdinand was Spain's ruler – at the date of this portrait just returned triumphantly from exile – and he may at this moment have seemed to offer some possibility of stability after chaos. If Goya had any hopes left, they were to prove illusory. All that can be said is that Ferdinand VII's appearance was no deceptive mask of his real nature, and that Goya mitigated nothing of its grotesqueness.

The artist becomes the receptive wax on which the sitter may imprint himself. It is the sitter who takes the risk that Goya will serve him only too well, transmitting an image which has in it almost over-awareness, affectionate, ironic, or both, of his real nature. All Goya's sitters are like the royal family group in being defenceless. It is no cliché to speak of them being captured in paint; simply, they do not realize that it is happening, and it is their unawareness that is touching. It is hard to find any of Goya's mature portraits unsympathetic: either as works of art or for the sitters' personalities which now exist only in art. The mood changes in other ways, but this empathy remains. The *Condesa de Chinchon* (*Ill. 140*) sits like a shy grey mouse, the ghostly figure of Godoy's neglected wife, no match for the gipsy-bold Maria Luisa, and seeming content with a shadowy half-life, withdrawn, uncertain, peaky through pregnancy. She is perhaps the most elusive of the women portrayed by Goya, a nocturne beside the brash open air daylight of the *Conde de Fernán-Nuñez* (*Ill. 137*) where the painter revels in the sitter's self-contented air and consciousness of his own glamorous elegance. This portrait, rather than those of Maria Luisa or Ferdinand VII, is subtly satirical. Fernán-Nuñez assumes a proto-Byronic pose and faces the world as if it was his to dispose of; history should have picked him out to be a great figure, yet he had to be content with an embassy to London and a reputation as a fop rather than a hero. But in one dimension, of course, he remains a hero – the memorable one of Goya's portrayal, with its sweep of cloak, cocked hat, buff tights and pointed black boots, all somehow so personal that the clothes *are* the man: making a portrait that could afford to dispense with the actual face.

140 FRANCISCO DE GOYA *Condesa de Chinchon*

141 FRANCISCO DE GOYA *Ferdinand VII*

Goya's consciousness of his sitters is almost animal-like in its intensity and its absence of shame – as marked as is the absence of respect. He is always responsive to their sex, which the clothes of around 1800 seemed to emphasize: the men all faintly martial and swaggering, the women tending to be bundles of gauzy lace and yet capable of flashing glances and gipsy coquetry. It is personality that counts in this world rather than social position. Maria Luisa or the Duchess of Alba were not painted with the attributes of their rank but with the more effective apparatus of being feminine: rulers of hearts rather than lands. And Goya's attitude has something in common with Stendhal's, not merely in the more obvious ways of penetrating, affectionate irony, and exploration of the human heart, but perhaps in a certain envy of the health and passions of the people portrayed. In Goya's paintings it would probably be easy to find equivalents for the splendid Sanseverina, for Julien Sorel, Mosca, or Mathilde de la Mole. This is not just an accident of period, for David's *Madame Récamier* is quite foreign to the mood; she is completely posed, stiffened further by the rigid lack of any hint of humour. Goya's sitters are dolls that have been given a good shaking, the stuffing and the nonsense fallen out of them, so that they are left touchingly absurd, charmingly defenceless – naked, for all their elegant clothes. How well Goya seems to know his own son (*Ill. 142*), nonchalant, fashionable, with a man of the world air and with yet somehow a boyish uncertainty.

It is tempting to see Goya's technique, ever increasing in fluidity and impressionistic power, as mirroring his increasing sense that nothing is certain: '*todo es fingido*'. Each of us is an irrational creature; society is only an agglomeration of such creatures, perhaps the more irrational for the sinking of their individuality in the mass. We have Goya's own testimony to the restraint he felt in commissioned work 'where caprice and invention do not have free rein'; and it was probably inevitable that he should break away from such confinement to record his own unfettered reactions to society and the world. Well before the collapse of the Spanish monarchy and the irruption of Napoleon, Goya had opted out of one aspect of the system. Even while he remained court painter, he was tacitly claiming the freedom of a Blake to pursue his own imaginative interests. He chose a mass medium in which to disseminate his ideas, much more profoundly occupied than David had been with the problem of addressing a wide public. What he had to offer it was in effect an illustrated commentary (where words significantly played their part) which would censure common human errors and vices chiefly through ridicule: a formula worthy of Pope which resulted first in the *Caprichos* series of etchings, published in Madrid in 1799.

In a certain sense the *Caprichos* continue the tendency of the tapestry cartoons, but with the new element of fantasy in place of fun, and with a revolutionary examination of the springs of behaviour rather than merely country manners. The shift to what one feels is a predominantly urban setting (implied, however, rather than depicted) widens the range of society and sharpens Goya's vision. Typically for the eighteenth-century person that he basically was, Goya throughout contrasts enlightenment with darkness, literally and metaphorically. The world is a murky place inhabited by masked figures groping and huddled (*Ill. 143*), distorted into strange tall shapes which have authentic nightmare proportions. The animating factors of this dark dream universe are not those social ills that Hogarth had indicted so cheerfully. There is no comforting assurance that it is drink or poverty which shaped these sinister figures, with their suggestions of skulls and metamorphoses of sex. This is the masquerade of life, where even between man and woman rational dialogue is difficult. The light of sanity has been reduced to this greyish mist which is almost a symbol for the groping obscurity of the human mind.

The humour is as black as the sky in the intensely frightening *Tooth hunting* (*Ill. 144*), where a silly woman is led by her belief in sorcery into pulling a tooth from the mouth of a hanged man. Here we plunge into a night of irrationality much darker than anything encountered before in the century: the power of superstition shown is strong enough to overcome all feelings of horror and humanity. The woman has braved darkness, the precipitous wall, the suspended corpse, to take the tooth for a witch's brew – and yet cannot bear to look at her own action, holding up a handkerchief in a ridiculous gesture to shield her face. Against that active folly of the living is contrasted the ghastly quiescence of the dead, with broken neck, and bound hands and bare, dangling feet – a premonition of the *Horrors of War*. The incident combines the ridiculous with pathos; Goya moves us not only to laugh and cry, but to feel the sting of application to ourselves. It is from out of this shadowy irrationality – where death indeed lies – that he means to lead us into rational daylight. It is the same seriousness of purpose, and the same journey, that shape *Die Zauberflöte* and *Fidelio*; but Goya never managed to achieve the optimistic paean of '*Heil sei dem Tag!*'.

The *Caprichos* are no isolated tendency, either in Goya or in the artistic products of his period. They are part of a whole movement towards a new feeling of and for humanity which, when it finally rushed forward, was bound to do so violently. Goya lived to be the witness of what crimes liberty could commit, but he was witness also to the *douceur de vivre* of society just enjoying itself in the

144 FRANCISCO DE GOYA
Tooth hunting

open air: whether rioting in carnival gaiety (*Ill. 145*) or calmly seated on the banks of the Manzanares, with parasols and refreshments (*Ill. 146*), picnicking in the utter unconsciousness of anything wrong with the world. This marvellous *plein-air* piece of work is an enchanted view of society, where Madrid lies along the skyline, as undistinguished then as now, brushed on to the canvas with the economical felicity of early Corot. Yet Goya's view could not remain so tranquil. The *Burial of the Sardine*, when looked at again, has an almost sinister quality, something frenetic in its excitement. We are not far from that tragic animation of the *Madhouse* (*Ill. 148*) which presents the cruel, more usually concealed, aspect of society. Goya, and perhaps Goya alone among painters, was to bridge the gap between the naked wretches of that scene and the sunlit, well-dressed figures of the *Pradera de San Isidro*.

143 FRANCISCO DE GOYA *Nobody knows anybody*

145 Francisco de Goya *Burial of the Sardine*

Events were to prove Goya no unjustified pessimist. If he had set himself to be the eighteenth century's modern moralist – hoping to cure by ridicule – he was to see human behaviour exceed even his horrific visions of its irrational impulses. One among many extraordinary things about him is that his art was able to include this experience within it – to digest it and build art, not propaganda, from it. His concern had always been with humanity; the *Caprichos* may necessarily use Spanish customs and costumes, but their application is universal. What threatened in those compositions was anarchy; and the black anarchy of actual war between Spain and France inspired Goya to the series of the *Horrors of War* which are not a patriot's view of war, but the view simply of a human being. Too prophetically perhaps does he conceive of a world where humanity has nearly blasted itself out of existence (*Ill. 147*). It is not the French, nor Fate, nor events, that are blamed. In fact, Goya goes beyond blame. With what must have been a tremendous effort to achieve dispassionate depiction, he shows the factual result of man's cruelty to man. David, clinging to the concept of the hero, had shown Marat martyred in his bath. Goya can find no single hero, any more than villain. Human nature is too complex for such a simple solution. When reason sleeps, monsters invade the mind. And the next step is shown by the two pictures of the events of the 2nd and 3rd May 1808 (*Ills 136, 149*).

Goya painted them a few years later. He was then in his sixties, having survived illness and suffered permanent deafness. From his earliest pictures, even the apparently light-hearted tapestry cartoons, there had been hints of some awareness of the ambiguity in human nature. In these pictures there is perhaps even more irony than tragedy. Like other Spanish liberals, he had looked to France as a place of modern civilization. Himself intelligent, articulate, well-read (the possessor of a considerable library), he might have expected the arrival of Voltaire's countrymen to bring to Spain a solution rather than further problems. These two pictures together express the stalemate of the human condition: killing or being killed. There are no longer those fantasy elements which served to make the *Caprichos* palatable; these scenes are not figments of the sick imagination but actual events – both barbarous.

War is not seen as a matter of bounding horses, splendid uniforms, and victorious generals – still less a rococo parade of operatic heroes with padded cuirasses and plumed helmets. Its carnage is democratic, and its victims anonymous. On 2nd May 1808 Napoleon's mamelukes were attacked in the streets of Madrid: their surprise and their slaughter provide a theme which Goya treats with no chauvinistic pride. Death is undignified and terrible; it is to be dragged

146 Francisco de Goya
La Pradera de San Isidro

backwards, like the central corpse, over the slit-open body of a horse, with blood raining down on to ground already littered with the dead. There is no place here for reason or enlightenment. What is commemorated is a moment – the instantaneous effect of the picture is part of its shock – which shows that man's worst enemy remains himself.

The sequel is historical and psychological. Spanish slaughter of the French troops is countered by French slaughter of Spanish hostages. It is in a real night that the inevitable revenge is carried out, by men as ordinary as those they shoot but transformed by darkness and uniforms into a long, inexorable, grey line of executioners whose level rifles are not deflected by the central, wildly gesticulating, too well-lit victim. The *Caprichos* had shown Goya's interest in the physiognomy as mirror of the emotions; the *Second of May* shows a whole range of eager, half-crazed faces of attackers and attacked. But in the *Third of May* the soldiers are faceless; it is the victims who alone are allowed expression, culminating in this face of angry despair – like a last screech for life at the moment death strikes. He dies for the mameluke's murder of the day before. And nothing is solved.

Artistically, the two pictures answer the eighteenth century's requirements of the history picture, but pitched now by events out of calm contemplation of the

228

147 FRANCISCO DE GOYA *Horrors of War: Bury them and be silent*

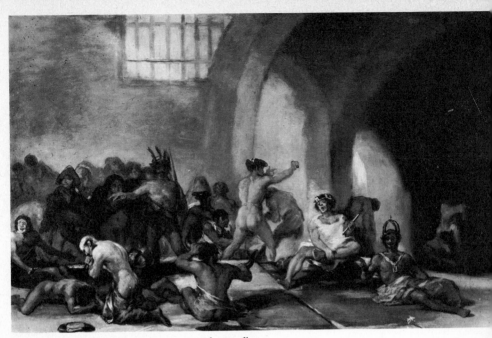

148 FRANCISCO DE GOYA *The Madhouse*

past into the bloodiest possible actuality. It is truth-telling art of a quite revolu-
tionary kind: 'engaged' in the cause of humanity as the century had thought art
should be, though it had hardly foreseen the result. Not only rococo nature but
even the domestic dignity of Chardin is upset by this depiction of natural man;
how faint and far away are both those climates when compared to a Madrid
street scene where the pavement is slippery with blood. And, one might add,
how hopeless seem the aspirations of enlightenment ('*Alle Menschen werden
Brüder*') amid such a noise of murder.

Goya himself perhaps retained some glimmer of hope, sufficient to keep him
alive but hardly to illuminate any ideals. His final artistic step was into the
obscurity of the nightmare visions painted for the 'Quinta del Sordo' – pictures
intended for the painter's own surroundings, as personal as Blake's prophetic
writings. They reject the public and social utility of art which had been the
eighteenth century's chief defence of artistic activity. That, rather than life itself,
is what Goya turns his back on. Almost aggressively, the results refuse to please,
decorate, or instruct. The artist who had filled so many rooms of Spanish royal
residences with topical vivid depictions of country manners chose for his own

230

house timeless scenes in the ugly countryside of the mind, where pleasing colour has been sucked away, to be replaced by greys and muddy browns, which infect the vast figures struggling in a miasma. The *Caprichos* had assumed mankind was capable of improvement. The 'Quinta del Sordo' paintings suppose nothing; they do not even bother to record the facts of mankind's brutality as had the *Second* and *Third of May*. The artist who had been such a sensitive observer of all the outward aspects of existence deliberately shuts his eyes – and paints what he then sees. His autonomy is complete. He has cut himself off from the social framework, patronage, all concepts of art as communication. Instead, these paintings are expression; they verge indeed on Expressionism. They express perhaps the only truths Goya could any longer recognize.

His earlier fantasies had played with the stock images of witchcraft and goblins, making witty and frightening use of supernatural machinery. There are still supernatural subjects, like the floating Fates (*Ill. 151*), sinister hags that seem to blast the vegetation they pass over. Yet they have ceased to have any comforting

149 FRANCISCO DE GOYA *Second of May 1808 at Madrid*

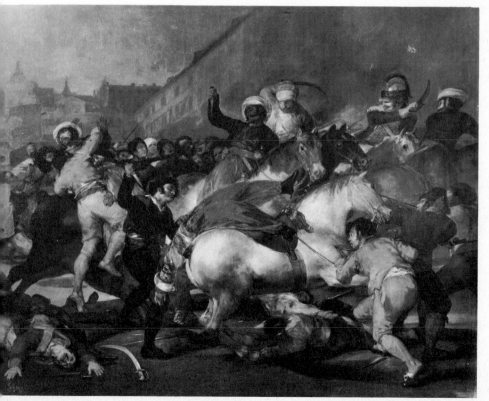

150 FRANCISCO DE GOYA *Fight with Clubs*

sense of being allegory; they are not even removed into the fictional region of the supernatural but are palpably real, horrifyingly natural, authentic creatures of the unconscious. They have come out of the painter's own mind where they had all along been waiting while he painted cheerful man, public man, even possibly rational man. And they bring a message of the deepest pessimism. For there is something that is not false in nature. The onion-layers of clothes and habit and environment, when stripped away, do not leave a vacuum but the seed of a blind, raging, clawing, vitality that lives only by trying to destroy. The cosmos is under one vast brooding shadow (*Ill. 152*) which Goya expressed in a powerful etching, close to the mood of these paintings. But that is not literal enough. The full horror lies in that scene which seems to vibrate with echoes of Cain and Abel, and also with the hopeless tone of Hesiod's Iron Age – always the present age – when might shall be right. Like the last survivors of a doomed world two men, already struggling knee-deep in apparent quicksands, spend their time in exchanging blows (*Ill. 150*). One head, one final memorable mask, is a mere black fuzz, with blackened eye-sockets, blood-stained, agonized, yet still intent on reducing the other head to the same condition.

Just as Goya imposed on himself withdrawal from the whole politico-social apparatus of art – retreating while in fact advancing into the freedom of modern art – so he imposed exile on himself, withdrawing from the insane autocracy of Ferdinand VII's Spain to Bordeaux. To his deafness was added failing sight and stiffening hands. He had nothing, as he himself wrote in these last years, but

151 FRANCISCO DE GOYA *The Fates*

the will to write – and paint, we may add. He had brought art out of the wonderful rococo past of his youth, not in reaction but through positive evolution. Born the heir of those Italian rococo figures who had all worked in Spain – Giordano, Amigoni, Giaquinto, Tiepolo – Goya had also been indebted indirectly to their antagonist, Mengs. He had been influenced by the enlightenment which was crystallized in France, perhaps instinctively preferring the witty rationality of Voltaire to the disturbed emotionalism of Rousseau; and before Voltaire's death he had produced his first tapestry cartoons.

When he died at Bordeaux in 1828 he had outlived Napoleon whose ambitions had affected his art as well as his life. David was dead; and Géricault. Europe had seen the dramatic career, and the poignant death, of Byron. Ingres was nearly fifty; Delacroix had already exhibited several times at the Salon. Goya takes his place in that 'modern' world. His ideas, his technique, his constantly deepening art, all entitle him to the double place of last of the *ancien régime* painters and first of the moderns. If his art must be examined for a message, it can perhaps be found in some further lines of Pope which certainly help to explain the eighteenth century and point also towards Goya's goal:

> *That reason, passion, answer one great aim;*
> *That true self-love and social are the same;*
> *That virtue only makes our bliss below;*
> *And all our knowledge is, – ourselves to know.*

233

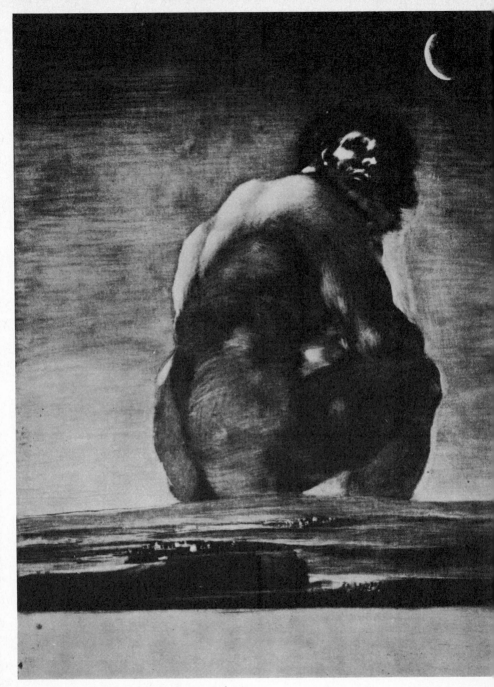

152 Francisco de Goya *Colossus*

Epilogue

Perhaps the residue of all revolutions is disappointment. Certainly the dawn in which Wordsworth claimed it was bliss to be alive lightened into a prosaic and reactionary day – adjectives which also suit the poet himself in old age. Though the Bastille had fallen, nineteenth-century Europe seemed largely concerned with propping it up again, and adding its own yet grimmer buildings, more subtle prisons of factories and slums whose environment gradually sapped the energy not only to rebel but even to live; and there was no hopeful *deus ex machina* to arrive like Don Fernando at the end of *Fidelio* with his startling egalitarian message and authoritarian humanism: '*Es sucht der Bruder seine Brüder, und kann er helfen, hilft er gern.*'

That optimistic and humanitarian concern had largely disappeared too from art. The sleep of reason has merged into a deep artistic indifference on the part of most great nineteenth-century painters – with the honourable exception of Daumier and the more complicated case of Courbet – to the social conditions of their own period. Not only had Goya kept humanity as his central concern, as much as had Voltaire, but his work speaks eloquently of the events he lived through. The tumultuous history of nineteenth-century France has been carefully excluded from the work of a Monet, or Cézanne, with its thinnest of suggestions that anyone else exists except the painter and the natural world. It is usual to suppose that society in the nineteenth century turned its back on the painter; but it might be asked who took the initiative in this snubbing match. There is more than one aspect of escapism and deliberate isolation in the preoccupation with natural appearances and a '*petite sensation*' before a mountain. Candide may have recommended cultivation of one's garden but hardly the continued depiction of the pond at the bottom of it. The social conditions of daily life in nineteenth-century Europe could certainly inspire Tolstoy or George Eliot, Flaubert or

153 EUGÈNE DELACROIX *Liberty leading the People*

Dickens, to produce art from it. There were no longer painters of comparable stature comparably concerned with mankind. The tragedy of *Work* is that Ford Madox Brown could not fuse his programme into art. Others did not try. And it may be wondered who made landscape such a comfortingly right subject for art in an increasingly urban civilization?

The usual supposition is that Goya leads on to Géricault and Delacroix; but the truth is that they are resolutely anti-social artists, convinced that their duty is to fly from reason; and, in Delacroix's case, flying into the savage irrational-ities of a largely fictitious past, all blood-flecked horses and expiring women, which is really the mirror of his own wild mental state. David may have been wrong, but it is difficult not to honour his political commitment and his efforts to produce a social art which should affect people. Delacroix has withdrawn politically as well as artistically. The slick juxtaposition of *Liberty leading the*

People (*Ill. 153*) to some picture of Goya's proves nothing except the differences between the two painters and the haunting myth of *gloire* which keeps stirring Delacroix at the prospect of battle. His ideal is always combat: man against man, man against animal, and here a bare-breasted allegorical woman heading a revolt – against what is hardly clear and hardly matters. If he had conceived *Fidelio* it would doubtless have ended in carnage, initiated by some Neronic personage.

In Géricault the obsession with the monstrous, the un-natural, is even more patent. He seizes on the insane face, the severed head, without pathos; and perhaps the most scandalous thing about the *Raft of the Medusa* (*Ill. 154*) is not its *donnée* but Géricault's delight that the ordinary prosaic fabric of life can be torn apart by catastrophe. The normal world is not stimulating enough until it provides such an event of horrific dimensions, not merely of one man alone on a raft but a whole group of desperate, alienated people, crazed father and dead son, overturned naked corpses and hysterical women. There is really no purpose to the picture beyond its intention of shocking. It betrays its provenance from a newspaper article and points the way towards Manet's strange desire to depict the far-away execution of the Emperor Maximilian. These paintings do not grow in a normal way out of their period or the painter's preoccupations, but suggest

154 THÉODORE GÉRICAULT *The Raft of the Medusa*

a certain amount of searching for a bizarre theme, for an event which is true and which is yet as frighteningly beyond nature as possible.

And, it might be said, they suggest considerable doubt about the power of art. They are stories with borrowed plots which have the built-in defence, when attacked, of replying that they are true. Géricault interviewed survivors, like a modern reporter. Yet a painter like Boucher – no doubt indifferent to the exact lights observable on snow – at least trusted in *art*: making seas of blue velvet and bodies of pearl with coral nipples that become true through their beauty.

Along with all its high achievement in decorative art, the eighteenth century had not ignored humanity. It had been following nature ever since Watteau carried his theatrically-costumed people out of doors, to achieve a new sort of relaxation and honesty. Hogarth and Chardin, even Greuze and Pietro Longhi, had captured something of the nature of their own age – sometimes with a good pinch of satire. Their art had never stopped having some sort of social base. Effortlessly, they believed that art was needed, and society agreed with them. Indeed, it is noticeable how, through all the variations of artistic style the eighteenth century produced, no really great painter was neglected by the century. For each revolution art performed, there seemed a public ready to applaud.

Even when the whole optimistic-rationalist structure collapsed, there was Goya still standing. If his own belief in reason faltered, at least there was no faltering in his attachment to the life of the period and – necessarily absent from the nineteenth century's attachment to exterior appearances – his pursuit of the internal nature that is psychology. Nor was it only human penetration that was lacking particularly in nineteenth-century romantic art; it was largely deficient in humour, so close to a feeling for humanity, and incapable of wit.

Nowadays, the vilification about the previous century that was elaborately built up by the nineteenth century (with lavish use of words like artificial, heartless, rational), is gradually being seen to be unjustified. In fact, the eighteenth century is the last period when painting was free to be exactly what it wished to be – serious or light-hearted, decorative, topical, allegorical, or actual – and yet remain consistently great art. By being committed to the widest possible concept of nature it had found, more perhaps than it realized, freedom. Not only was it the last period when painting could enjoy this; reflecting on the previous centuries makes one realise that it was also the first period.

Short Bibliography

This is intended only as a selection of the more important, or more easily available, twentieth-century books on aspects of the subject. Periodical literature is not included and monographs on individual painters have deliberately been restricted.

General

EXHIBITION CATALOGUES:

Antonio Rafael Mengs, Madrid, 1929.

European Masters of the Eighteenth Century, R.A., London, 1954–55.

De Tiepolo à Goya, Bordeaux, 1956.

The Age of Rococo, Munich, 1958.

The Romantic Movement, The Tate Gallery, London, 1959.

Il Settecento a Roma, Rome, 1959.

La Peinture italienne au XVIII^e siècle, Paris, 1960–61.

Goya and his times, R.A., London, 1963–64.

Mostra dei Guardi, Venice, 1965.

Painting in Italy in the Eighteenth Century, Chicago, Minneapolis, Toledo, 1970–71.

The Age of Louis XV (French Painting 1710–1744), Toledo, 1975.

Jean-Baptiste Greuze, 1725–1805, Hartford, San Francisco, Dijon, 1977.

C. BÉDAT, *L'Académie des beaux-arts de Madrid 1744–1808*, Toulouse, 1974.

L. DIMIER, *Les Peintres français du XVIII^e siècle*, Paris–Brussels, 1928–30.

F. FOSCA, *The Eighteenth Century, Watteau to Tiepolo*, Geneva, 1952.

W. FRIEDLAENDER, *David to Delacroix*, Cambridge, Mass., 1952.

W. VON KALNEIN and M. LEVEY, *Art and Architecture of the Eighteenth Century in France*, Harmondsworth, 1972.

F.D. KLINGENDER, *Art and the Industrial Revolution*, London, 1968 ed.

M. LEVEY, *Painting in Eighteenth Century Venice*, London, 1959.

J. LINDSAY, *Death of the Hero*, London, 1960.

J. LOCQUIN, *La Peinture d'Histoire en France de 1747 à 1785*, Paris, 1912.

P. MARCEL, *La Peinture française au début du XVIII^e siècle*, Paris, 1906.

F. NOVOTNY, *Painting and Sculpture in Europe, 1780 to 1880*, Harmondsworth, 1960.

L. RÉAU, *Histoire de la Peinture française au XVIIIe siècle*, Paris–Brussels, 1925.

A. SCHÖNBERGER and H. SOEHNER, *Die Welt des Rokoko*, Munich, n.d. but 1960.

J. THUILLIER and A. CHATELET, *French Painting from Le Nain to Fragonard*, Geneva, 1964.

R. TODD, *Tracks in the Snow*, London, 1946.

E. K. WATERHOUSE, *Painting in Britain, 1530 to 1790*, Harmondsworth, 1953.

Monographs

H. ADHÉMAR, *Watteau*, Paris, 1950.

A. ANANOFF, *François Boucher: Peintures* (2 vols.), Paris, 1976.

F. ANTAL, *Hogarth and his Place in European Art*, London, 1962.

A. DE BERUETE Y MORET, *Goya as Portrait Painter*, London, 1922.

A. BROOKNER, *Greuze: the Rise and Fall of an Eighteenth Century Phenomenon*, London, 1972.

J. DANIELS, *Sebastiano Ricci*, Hove, 1976.

D. L. DOWD, *Pageant-Master of the Republic: Jacques-Louis David and the French Revolution*, Lincoln, Nebraska, 1948.

K. GARAS, *Franz Anton Maulbertsch*, Budapest, 1960.

J. GUDIOL, *Goya* (4 vols.), Barcelona, 1971.

L. HAUTECOEUR, *Louis David*, Paris, 1954.

R. L. HERBERT, *David: Brutus*, London, 1972.

J. LOPEZ-REY, *Goya's Caprichos*, Princeton, 1953.

C. MAUCLAIR, *Greuze et son Temps*, Paris, 1926.

A. MICHEL, *Boucher*, Paris, 1907.

A. MORASSI, *G. B. Tiepolo*, London, 1955–62.
Guardi, Antonio e Francesco Guardi, Venice, 1973.

R. PALLUCCHINI, *Piazzetta*, Milan, 1956.

T. PIGNATTI, *Pietro Longhi*, Venice, 1968.

D. POSNER, *Watteau: A Lady at her Toilet*, London, 1973.

N. POWELL, *Fuseli: The Nightmare*, London, 1973.

A. SCHNAPPER, *Jean Jouvenet et la peinture d'histoire à Paris*, Paris, 1974.

E. DU GUÉ TRAPIER, *Goya and his Sitters* (American collections only), New York, 1964.

G. WILDENSTEIN, *Chardin*, Paris, 1933.

G. WILDENSTEIN, *The Paintings of Fragonard*, London, 1960.

List of Illustrations

Measurements are given in inches, height preceding width. Plate numbers in italics indicate colour plates

242

243

246

247

Index

Page numbers in italics indicate illustrations